NEW ROCHELLE

Portrait of a City

Photographs by
DAVID FINN

Preface by
ROBERT MERRILL

Introduction and history by
RUTH KITCHEN

Abbeville Press • Publishers • New York

It is very gratifying to me that this book about our city, which has been more than three years in the making, has been published during my tenure as mayor. I believe it is a landmark for a contemporary American city which is rediscovering the natural beauty of its landscape, the strength of its communal, educational, religious and working life, and the diversity and friendliness of its people.

We are grateful to those who worked hard to make the book a reality. We especially appreciate the counsel given by more than two dozen community leaders who reviewed early drafts of the book to make sure that the portrait was an accurate one. And we thank the Frank E. Gannett Newspaper Foundation, Inc., and the public relations firm of Ruder & Finn, both of which helped underwrite the cost of the publication.

We apppreciate the help of Dr. Peter Steven Gannon (President of the Huguenot-Thomas Paine Historical Association), Frederick H. Paulman, Jr. (historian), and June Schetterer (columnist of *The Standard-Star*) for their assistance in preparing the history of New Rochelle; and Jack Dowling and Westchester Federal Savings for the use of the historic photographs of New Rochelle.

It is our profound hope that *New Rochelle, Portrait of a City* will be an inspiration to our citizens as well as to other Americans who are equally proud of their communities and their heritage.

<div align="right">

LEONARD C. PADUANO
Mayor, New Rochelle

</div>

The authors wish to thank the following officials of the City of New Rochelle for their cooperation in the preparation of this book: Leonard C. Paduano (Mayor), Elly Doctorow (Deputy Mayor), Rocco Bellantoni (Councilman), Francis X. Judge (Councilman), Donald Zaccagnino (Councilman), Robert Schaefer (Councilman), and C. Samuel Kissinger (City Manager).

Library of Congress Catalog Card number: 80–69531
ISBN 0-89659-186-7

Contents

Preface

Our home is more than a house we live in; it is part of a community that has a sense of place, a tradition, a character, an awareness of the future. Too often we forget that our city is our home, and we fail to look around us as we rush here and there to fill our needs. We cheat ourselves by not studying the history of our community, knowing who our ancestors were, learning about our neighbors and what they are doing to help make our city a better home for all of us, thinking about what we can do to leave a richer heritage for those who will follow us.

New Rochelle has been my home for many years. My wife and I have loved our home because it has been a fine place to bring up our children and a fine place for us to enjoy our later years when the children have gone their respective ways. One of the qualities we like especially about our home is our privacy. New Rochelle is a quiet community where we can be by ourselves when we want to. But it is also a warm and friendly community, which encourages cooperative efforts by people who enjoy working together towards common ends. I wouldn't be surprised if we had more volunteers—for good works—per capita than any other city in America!

We love the trees of New Rochelle, the lovely houses, the parks, the streams, the playgrounds, the waterfront, the schools, the churches, the fact that Thomas Paine lived here in a little farmhouse that is still standing, the fact that today our fellow citizens are Italians, Greeks, Catholics, Jews, Protestants, blacks, whites, and just about everything else one can think of. We love being so close to New York (our town is the one George M. Cohan referred to as "forty-five minutes from Broadway"). We love the waterfront and the view of Long Island we see across the Sound.

Our city has had its share of problems. What city in modern times has not? But it is exciting for all of us to see that our political, economic, and social systems have the resiliency and the resources to solve those problems. The center of our city is in the

process of being restored to its original design; contemporary ideas of its planning are being introduced; young families are moving into our neighborhoods in droves, and we know that we have a great future ahead of us. Never, in all the years my family has lived in New Rochelle, have I seen such a sense of pride and confidence in the quality and character of the community we live in.

This book, which expresses the faith so many of us have in our community, is more than just a portrait of New Rochelle, New York. It is a portrait of an American city. Although every community in this country is unique, all are part of a family of cities that is America. The places shown in the photographs taken by my friend and neighbor, David Finn, are ours, and we love them all; but we know that there are dozens of cities in our state, and hundreds throughout our country, which have their own beautiful places and their own story to tell.

We are grateful that this book has been published to show how we feel about our home. At the same time, we hope that seeing these photographs will inspire others to look with a fresh eye on the treasures in their own towns and cities and appreciate all the fine qualities that contribute to their enjoyment of the community that is home for them.

ROBERT MERRILL

Introduction

You can stroll past the corner of North and Paine avenues in New Rochelle and span two centuries at a glance. On the grounds of the Huguenot Historical Association, the Thomas Paine Cottage, now a Museum, overlooks the recently installed modern, computerized traffic-signal system. The fiery architect of the American Revolution lived in this historically significant city and a fine bronze bust gazes serenely from the spot where he was originally buried.

A little further down North Avenue, New Rochelle High School is reflected in the twin lakes with their border of cherry trees that dominate its foreground. Patterned after a French chateau, the school is architecturally unique in the United States. So admired is it that after heavy fire damage several years ago, the Board of Education, at the insistence of the community, decided to rebuild it in its original form rather than take the opportunity to construct a building of more modern appearance. A Japanese Garden, a Parcourse with jogging trails, a children's playground offering imaginative equipment, and bright red and yellow paddle boats berthed in the lakes, complete the picture. Just visible in the rear is the new all-city sports stadium.

Continuing along this main north-south artery, one discovers Iona College, one of two excellent institutions of higher learning that form an integral part of the city's life and give it an unmistakable flavor of academia. Once a private Catholic college for boys, Iona today is co-educational, open to all qualified students and places a strong focus on adult education. A few blocks away is Holy Family Church and Elementary School, one of several lovely old structures that serve the city's large Catholic population.

Beautiful residential districts are to be found nearby, many of them with homes that are of considerable historical importance. The architecture throughout the city is distinctive; sprawling Tudors, white-painted Spanish stuccos with red tile roofs,

and immense frame houses from a bygone day when families of thirteen were common. In the newer sections, ranch and colonial styles grace manicured quarter acres; while the vintage parts of the city display smaller homes of distinctly individual design maintained with meticulous care. Shore Road overlooking the Sound is lined with large, spacious apartment buildings.

The residential sections of New Rochelle mirror the history of its long and diverse ethnic past. In the north end of the city, where within the memory of many residents farm land was still extensive, several religious institutions with striking architectural features are to be found. Among these, Beth El Synagogue, Temple Israel, Holy Trinity Greek Orthodox Church, Christ United Methodist Church, and Young Israel of Westchester are notable. Still farther north, in the direction of White Plains, is Ward Acres. A unique, sixty-nine-acre area of wilderness, it is the site of a spectacular Country Fair, planned and staged annually by a broadly based citizens' committee. The Wildcliff Museum Craft Center is also situated there.

The southern boundary of New Rochelle is Long Island Sound. Here nine miles of beautiful waterfront, with a major marina, Hudson Beach, Davenport Park, and a series of shore and yacht clubs, give that section of the city a distinctly nautical character. There is a sail-maker's shop and a daily excursion fishing boat. On any summer day, one can observe scores of anglers casting from the public walkway overlooking the waters of the Sound. Flounder, snapper, porgie, and striped bass are abundant there, and farther out, in their season, the blues run. Here also is Wildcliff Museum and Greenhouse, a children's participatory institution that has gained state-wide recognition for innovative programs.

Located off the coast of New Rochelle are five islands: Oakwood, Big Hassock, Little Hassock, Big Harrison, and Little Harrison. In 1979–80, a $1.3 million project to convert islands into a recreational

project was initiated with the development of Oakwood Island. The complex will offer residents nature paths, overlooks, play meadows, ball fields, family and group picnic areas, an outdoor amphitheater, and a park pavilion.

To the southwest is the College of New Rochelle. One of the oldest liberal arts institutions for women in the state, it is located on a beautiful campus dominated by buildings of special interest. At the heart of the complex is the Castle, recently designated a national historic landmark. Open to all qualified students, the College of New Rochelle has developed an adult program that has gained national notice. Nearby is the Presbyterian Church of New Rochelle whose manse was once the home of Lewis Pintard, an active American patriot of Huguenot descent. Built in the 1760s, it has also been given landmark designation.

City Hall, a distinctive structure that was once a high school, is now part of a group of public buildings that includes the old North Avenue Presbyterian Church. This massive stone edifice, of striking appearance, has been acquired by the City Council. Nearby on Lincoln Avenue, there are many of the very active and substantial black churches: Bethesda Baptist, St. Catherine AME Zion, Shiloh Baptist, and St. Luke's Methodist—all with long, proud histories. WESTCOP (the former Community Action Agency), the Martin Luther King Child Care Center, and dozens of social programs are located in the heart of this area, across the street from the Lincoln Park pool and playground. Two blocks south, on Guion Place, is New Rochelle Hospital Medical Center, a voluntary, not-for-profit community hospital serving both the city and several of its neighbors.

The west end is one of the oldest areas of the city. Here many families can trace generations who have lived in the same house. St. Gabriel's, a private high school, is located here, along with St. Joseph's, a parochial elementary institution. Ethnic feasts and

festivals are held throughout the year and add their own cultural richness to this close-knit, venerable section.

New Rochelle is proud of its public school system, one of the finest in Westchester County. Ten elementary and two junior high schools lead to the centrally located senior high, which every year claims many honors. For example, in one recent year New Rochelle High School placed first in Westchester County in the New York State Regents Scholarships competition, first in County High School Physics Teams, and first in the Foreign Language Competition sponsored by Iona College. That same year New Rochelle High School teams also took first place in boys varsity swimming team and boys varsity winter track in both county and state competitions. To cap it all, the school football team took top position in the New York State rankings. Adding diversity to the educational system are seven parochial and six private schools.

The character of the city is distinctly heterogeneous. Established in 1688 by French Huguenots fleeing religious persecution, New Rochelle was named for their home in La Rochelle, France, and cordial relations between the cities, with regular student exchange visits, are maintained to this day. Originally a farming community, New Rochelle has moved from agriculture to small town, to summer resort, to suburban city. Its location on Long Island Sound, just seventeen miles from the center of New York City (thirty minutes by Conrail to Grand Central Station) in the immediate vicinity of every major regional highway, has made it desirable for commuters.

New Rochelle has long-established and strongly defined neighborhoods where third and fourth generations of families still live. A community of great cultural richness and diversity, it is one of the oldest cities in the Northeast and the second largest in Westchester County. It was christened many years ago the "Queen City of the Sound."

In the early 1960s, the first "de facto" segregation case in the nation's history was fought successfully in New Rochelle. As a result an all-black elementary school was closed and busing instituted to achieve integration. The case received national publicity and identified New Rochelle as a community that was well ahead of its time in resolving a problem that faced the entire nation.

A recent census undertaken as part of a broadly based citizen-directed program to aid in long-term revitalization plans, identified more than five hundred community organizations in New Rochelle. Their scope of concerns ranges from religious, social, and educational to sports, fraternal, political, medical, neighborhood, and civic. A vast reservoir of human resources, these groups have been brought together in major conferences whose aim has been a cooperative effort in the service of the city.

New Rochelle is a city that is "rediscovering" itself. A full-scale renewal program is now well underway and it is operating on two levels—physical redevelopment and a revitalization of public spirit. A twenty-million-dollar downtown rebuilding project is changing the face of the central business district. Its keystone is a magnificent new public library with auditorium, meeting rooms, and exhibit space. In front of the building is a plaza with a fountain, reflecting pool, and a network of pedestrian walkways that fan out through the entire downtown area.

Working on a second level are a series of citizen task forces, each led by a prominent resident, devoted to developing community cooperation in a number of areas. In these efforts the community has been strongly served by its principal news media: *The Standard-Star,* a Gannett newspaper, radio stations WVOX and WRTN and UA-Columbia Cablevision of Westchester.

This book seeks to describe the composite New Rochelle from the shoreline with its nearby scenic islands, to Ward Acres with its lovely stretches of open, wooded, untouched land. The story that

emerges is a source of pride to its residents and a model for other cities that may be inspired to tell their stories as well. For New Rochelle is a symbol of what smaller cities throughout America can do in shaping their own destinies. This city offers evidence of how dedicated citizens can look to the future while preserving the heritage of the past.

RUTH KITCHEN

History

In 1685, Louis XIV of France revoked the Edict of Nantes, a document assuring freedom of religion in that land, issued by his predecessor, Henry IV. This marked the beginning of the heavy Huguenot (French Protestant) exodus that led this persecuted group to several parts of the world and eventually to new settlements on the American continent. Many of these exiles were from the Province of Annis, sometimes referred to as "the birthplace of American Huguenots," and from the ancient walled city of La Rochelle. Some thirty-three families established the community of New Rochelle.

Thirty-one years earlier, in 1654, the Siwanoy Indians, of Algonquin stock, sold their land to Thomas Pell. The Siwanoys, also known as "one of the tribes of the seacoast," occupied twenty-four miles of the northern shore of the Sound from Norwalk to the neighborhood of Hellgate. Their deeds of sale covered the manor lands of Morrisania, Scarsdale, and Pelham, from which New Rochelle, Eastchester, Westchester, New Castle, Mamaroneck, and portions of White Plains have been formed. A village on Davenport's Neck (now a section of New Rochelle) and near the entrance to Pelham Neck was one of the Siwanoy burial grounds.

Thomas Pell's land patent was confirmed by his nephew, John Pell, who became the lord of Pelham Manor—a feudal domain with its own civil and criminal courts. It was from John Pell and his wife Rachel that the celebrated Jacob Leisler, acting as agent for a group of Huguenots in New York, purchased the land upon which they would settle. Negotiations were entered into on September 20, 1689. "In consideration of the sum of sixteen hundred and seventy five pounds sterling, current silver money of this province," there was conveyed to him "all that tract of land lying and being within said Manor of Pelham, containing six thousand acres of land." Also, "one hundred acres of land more, which the said John Pell and Rachel his wife do freely give and grant for the French church erected, or to be erected,

by the inhabitants of the said tract of land." This is the site of the present Trinity Episcopal Church.

In addition to the purchase money, Jacob Leisler, his heirs and assigns, were to yield and pay "unto the said John Pell, his heirs and assigns, lords of the said Manor of Pelham, to the assigns of them or him, or their or either of them, as an acknowledgment (of their feudal obligation) to the lords of said manor, *one Fat Calf on every four and twentieth day of June, yearly and every year forever"*—if demanded. The ceremony of the "Fat Calf" was carried out for many years and is still observed at times, being the occasion for a community-wide celebration. A number of amusing incidents can be recounted in connection with this event, including the year the calf got away.

From the language of the deed itself, it appears that Leisler entered into a purchase agreement with Pell on July 2, 1687, and the sale was consummated on September 29, 1689. There is some question about earlier tenancy, however, and the year 1688 has been settled upon as the official founding date for New Rochelle. The sum paid, 1,675 pounds, was unusually large, compared with the amounts generally given in those days for unimproved land.

Jacob Leisler figures importantly in both New Rochelle's and the nation's early history. He arrived in America as a mercenary in the army of the British and eventually became one of the foremost merchants in New York. He also served for a time as mayor of New York City. In 1688, the British king consolidated the New York, New Jersey, and New England colonies into the Dominion of New England and placed it under the viceregal control of Sir Edmund Andros. This caused an uprising that brought about the imprisonment of Andros a year later, and Jacob Leisler became the leader of a group of restless spirits in New York and on Long Island. After several military ups and downs, Leisler took the first step toward colonial union. At his call, delegates from Massachusetts, Connecticut, and Mary-

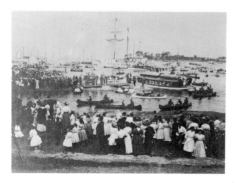

Reenactment of the landing of the Huguenots during the city's 225th Anniversary celebration in 1913.

land met in New York City with delegates from New York to consider concerted action against the enemy. He was subsequently appointed acting-governor of the province, and it was at this period that he acted for the Huguenots.

A man of strong liberal principles, his sympathies were engaged by the history of his clients. It is unfortunate that Leisler, angered at not receiving the appointment as governor in 1690, refused to give up Fort James and was arrested and executed. A post facto pardon cleared his name and perhaps some consciences, but as always in such cases it was of little value to the principal character. Leisler is remembered in New Rochelle by a fine bronze statue at the corner of Broadview and North Avenue, one of Solon Borglum's outstanding sculptures.

Census data for the settlement's first ten years is unfortunately missing. In 1698, however, the records show that forty-four families lived in New Rochelle. Thirty-nine were French, three Dutch, one German, and one English. The list, still in existence, indicates that the inhabitants of the town consisted of "232 men, women and children, white and colored, free and bond." Names and ages appear for each, except that of the constable who took the census but omitted his own name. Forty-four of these first settlers were black.

While the refugee Huguenots made the first agreement for land, many of the early settlers came from places other than La Rochelle. However, the choice of name was significant and binds New Rochelle in history's long memory to her sister city in France. A handsome Huguenot monument, erected in 1898 in Hudson Park, stands where tradition says those first settlers landed. The tale is probably aprocryphal. The memorial bears the names of 151 Huguenot families identified with the community.

That community was distinctly French. French was spoken, and it was common practice for people in neighboring areas to send their children to New Rochelle to learn the language. John Jay, Chief

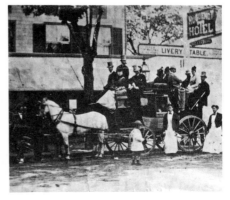

A Tally Ho Coach seen in front of the old Huguenot Hotel in 1878. The Hotel was located on what is today Main Street.

Justice of the Supreme Court, is one of the notables who was taught in a private New Rochelle boarding school at Trinity Church. Washington Irving and General Philip Schuyler were also among the illustrious alumni of that school.

During the War for Independence, New Rochelle was in an uncomfortable geographic situation. Located on the Boston Post Road, a main thoroughfare for the British and Continental armies. At least one skirmish actually took place on the old Post Road near Main Street and Lispenard. On August 5, 1779, American soldiers, led by Colonel Anthony Walton, fired on the British, killing sixteen. The Post Road (then called Huguenot Street) was the first to be laid out, and community life centered around it. Originally the old trail between New York and Boston, this road became in later colonial days the route of the post riders and stage coaches.

Thomas Paine, writer, patriot, and architect of the Revolution, was probably New Rochelle's most famous resident (although in 1806 he was denied the right to vote because the village fathers claimed that, since he had recently been awarded honorary citizenship for his part in the French Revolution he was a French citizen). At the close of the war he was given, for his services to the nation, the Deveau farm, which had been taken because of its owner's alleged Tory activities. Paine's restored cottage stands in a two-acre park at Paine and North Avenue owned by the Huguenot Historical Association. It is now a museum open to the public. Nearby is the Paine Monument, erected in his memory near the place he was once buried (and later disinterred by an admirer who wanted to return the remains to England). Paine's final resting place today is unknown. Another noteworthy resident of revolutionary times was Paul Revere's grandfather.

By the early 1800s, New Rochelle had settled down to a peaceful and prosperous life of farming, road-building, and small commercial enterprises. In 1820, the second federal census gave the population

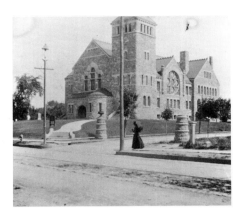

St. John's Methodist Episcopal Church as it appeared in 1910. The Church was located on the northeast corner of Main and LeCount streets.

as 1,135. Life continued at a leisurely pace, with steady, predictable growth, until 1849 when the New York and New Haven Railroad opened a line that stopped in New Rochelle. Then the era of suburban living began. It was during this period that New Rochelle became famous as a summer resort.

In 1879, John H. Starin acquired the property now known as Glen Island and turned it into a select summer resort. He operated steamboats to and from New York City bringing people to Starin's Isle, which was hailed along the entire Atlantic coast as tops in entertainment. Featured were a restaurant offering the finest of German food and wines, called the "Grand Cafe" (now the Casino), and an internationally acclaimed castle that was a copy of an ancient Rhine fortress. There were bathing pavilions to accommodate eight hundred people, bridle paths, a miniature steam train and a zoo of exotic animals which included lions, elephants, and trained seals. The castle still stands, sole remaining building of the Starin regime. Today, Glen Island is a 105-acre facility with a salt-water beach, shaded walks, picnic grounds, and the well-known Glen Island Casino, famous nation-wide during the days of the big bands.

Near it is the 80-acre David's Island. Only three-quarters of a mile from mainland New Rochelle, the island was originally named for a local ink manufacturer, Thaddeus David. It served during the Civil War as a General Hospital in which wounded Confederate prisoners of war were confined. Rechristened Fort Slocum in honor of Major General Henry W. Slocum, it was important as an army base during World War I and II.

New Rochelle was formally established as a village in 1857 and became a city in 1899, the same year that a horse and wagon were purchased for use in police patrol. By this date the great waves of immigration had begun, and the community began to take shape as a modern suburban city. Today the majority of the people in New Rochelle reflect that

demographic fact. More than four out of ten residents were either born in another country or have parents who were. With a populaton of approximately 73,000, the major ethnic breakdown according to the 1970 census was: Italian 29.2%, nonwhite 15.7%, German 9.2%, English 7.7%, Irish 7.5%, Polish 6.5%, Austrian 4.4%. The religious profile has changed, too. Founded by Protestants, New Rochelle today is 39.3% Catholic and 37.5% Jewish. Of the remaining 23%, white Protestants now number only a small portion and there exists a strong black Protestant community. The observably growing Hispanic, Portuguese, and Oriental population will undoubtedly appear in the 1980 census.

Education has always been a major consideration in New Rochelle. Even before the first public school was built in 1795, a number of small, private classes were conducted either by a licensed teacher or in schools sponsored by the Church. Some descriptions of those eighteenth-century schools remain in the records of the city. Small unpainted shanties, located on surplus land too poor for cultivation, they were crudely finished inside with rough boards. Most were heated by small pot-bellied stoves. Their benches were long oaken slabs with legs driven into holes at each end. The Brewster School building, used as a private school in the 1830s, still stands on Paine Cottage grounds and is typical of the period. A list of the textbooks of the day includes *The New Testament, The Sequel, The American Preceptor, The New York Reader* (a pioneer text in New Rochelle), and for older pupils, *The Child's Instructor.* These, augmented with a few primers, made up the entire curriculum. At one point during the mid-1800s, Susan Brownell Anthony, writer, feminist, abolitionist, and temperance worker, taught in a New Rochelle private boarding school. Her motto, still current, was: "The True Republic—men, their rights and nothing more; women, their rights and nothing less."

Free education for the entire population did not

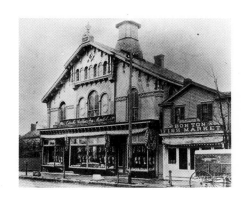

Charles Hoffmeister's Market was built in 1883. A Masonic Temple is located on the second floor.

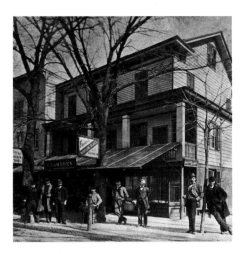

E. Lambden Building, one of New Rochelle's largest general stores, as it appeared in the 1880s. It was located on the southwest corner of what is today Main and Division streets.

come about until 1849, and by 1896 New Rochelle had five public schools with a total enrollment of more than one thousand. Today, New Rochelle has one of the finest and most extensive educational systems in Westchester County with ten elementary schools, two junior highs, and one high school, all offering diverse programs for all ages and levels of development. In addition, there are seven parochial schools, six private schools, and two excellent colleges, Iona and the College of New Rochelle.

One of the oldest liberal arts colleges for women in New York State, the College of New Rochelle was established in 1904 by Ursuline nuns. It is a private Catholic college located on the grounds of a nineteenth-century estate, dominated by the Castle —a remarkable work of architecture that serves both college and community and was recently designated an historic landmark. Iona, a four-year liberal arts college open to men and women, was founded in 1940 by the Congregation of Christian Brothers, and takes its name and heritage from the Island of Iona, just off the west coast of Scotland. Both institutions are open to qualified students of all denominations and are involved with the community.

As the city grew so did its services. Law enforcement dates back to the earliest years, with references in records of 1699. New Rochelle used constables to patrol its streets until 1885. Their duties consisted of keeping livestock, particularly hogs, from running at large. However, thievery, street fights and intemperance were also listed as causes for constabular concern. It wasn't until 1899 that a patrolman named Peter Brown became the first man assigned to a horse, a creature named "Cricket." Together they patrolled North Avenue.

Formal fire protection was much later in arriving. On March 29, 1861, shortly after the inauguration of Abraham Lincoln, the Enterprise Hook and Ladder and Bucket Company No. 1 was established. It was composed mainly of male leaders in the community, many of whom traced their ances-

try back to its Huguenot founders. Today, fully modern and computerized fire and police services are provided by the city of New Rochelle. Each is under the direction of a professional commissioner.

In the spring of 1891, a railroad accident in New Rochelle resulted in the death of several passengers and severe injury to many others. It also sparked the movement for a hospital by community leaders, including Mr. and Mrs. William R. Pitt. The New Rochelle Hospital Association, a nonprofit membership corporation, was organized; a small yellow frame house on Huguenot Street was rented; and on July 1, 1892, the hospital was opened. Its first patient was Mr. Gus Schaembs, who had been badly burned in the Trinity Street fire. Shortly thereafter, it was called upon to care for the sick volunteers returning from the Spanish–American War. Today, New Rochelle Hospital Medical Center is a sophisticated health care complex serving the city and the communities of Larchmont, Mamaroneck, Eastchester, Scarsdale, and the Pelhams.

New Rochelle has long been the home of major artists in areas of culture and entertainment. Immortalized by George M. Cohan's play, "Forty-Five Minutes from Broadway," the Gershwin song, "Mademoiselle from New Rochelle," and more recently as the home of the family portrayed in the Dick Van Dyke and Mary Tyler Moore television series, New Rochelle can claim such celebrities as Eddie Foy, Irene Castle, and Norman Rockwell. The unusual signs that appear at many of the city's entrances were painted by nine local artists including Rockwell. He often drew his illustration subjects from members of the community. Prominent artists of various persuasions continue to live in New Rochelle, including such celebrities as singers Robert Merrill, Jan Peerce, and Renata Scotto; artist Lumen Winter; sculptor Michael Lantz; author E.L. Doctorow; and actor, author, producer, playwright Ossie Davis and his wife, Ruby Dee.

There are a number of landmark buildings and

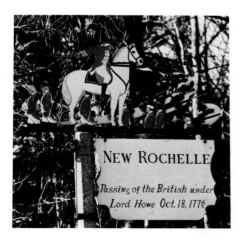

homes rich in the history of this city, many reminiscent of its Huguenot heritage. One is Trinity Church located at Huguenot and Division Streets. It represents the part of the French Calvinistic congregation that conformed to the Church of England in 1709. Built in 1710, it has been replaced twice, once in 1823 and again in 1862 and has a number of valued heirlooms in its possession. Among the other historic structures are the Lewis Pintard Home, presently the manse of the Presbyterian Church of New Rochelle and recently awarded a landmark designation; the Parcot-Drake House, Eastchester and Clove roads, built in the mid-eighteenth century and still inhabited by descendants of the original owner; the Bonnet House on Old Wilmot Road; the Israel Seacord House at the northeast corner of North Avenue and Quaker Ridge Road; and the Rodman House on Davenport Neck. There are several ancient cemeteries whose tombstones display many of the names central to the history of the city.

One of the most important cultural facilities in the county is the Wildcliff Museum. It is housed in a large architecturally significant, Gothic revival building that overlooks Long Island Sound. The house was designed for Sarah Lawton by Alexander Jefferson Davis. Construction began about 1860 and the stones on the front facade were originally brought as ballast for sailing ships from England. The structure was given by the Prince family to the City of New Rochelle in the 1930s to be used as a youth museum. Earlier attempts to establish this facility failed, but in 1970 the present incorporators took over and have made it into a youth participatory museum that serves over 300,000 young people yearly and is acclaimed throughout the area.

An outgrowth of the museum has been the establishment of a Craft Center at Ward Acres, a 69-acre tract of land located in the north end of New Rochelle. The New Rochelle Public Library established in 1892, has grown from some 1,800 volumes housed in the old Trinity School to a three-facility complex

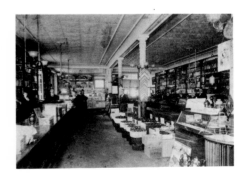

Interior of the Lambden store as it appeared in the 1880s. The store sold everything from "soup to nuts."

with 155,000 books and a circulation of half a million yearly. In the fall of 1975, ground was broken for a new Main Library at Lawton Plaza. The complex, completed in 1979, includes an auditorium, community rooms, display space, a park, fountain, and plaza. It serves as the nucleus for a twenty-million-dollar downtown redevelopment program.

This, then, is New Rochelle. Already eighty-eight years of age when the nation was born, it is one of the oldest cities in the Northeast and the second largest in Westchester County. The city embraces an area of 10.4 square miles, including 9 miles of waterfront, 102.5 acres of inland waters, 231.51 acres of public parks, 168 acres of parklets. It has clearly defined and very substantial residential neighborhoods, a rich and varied cultural heritage, an innovative recreational program, harmonious ethnic diversity, a dynamic downtown revitalization program, strong religious and educational institutions, a progressive council-manager form of government, great physical beauty and a unique place in American history. To its residents, its visitors, its admirers new and old, New Rochelle remains "Regina"— the Queen City of the Sound.

RUTH KITCHEN

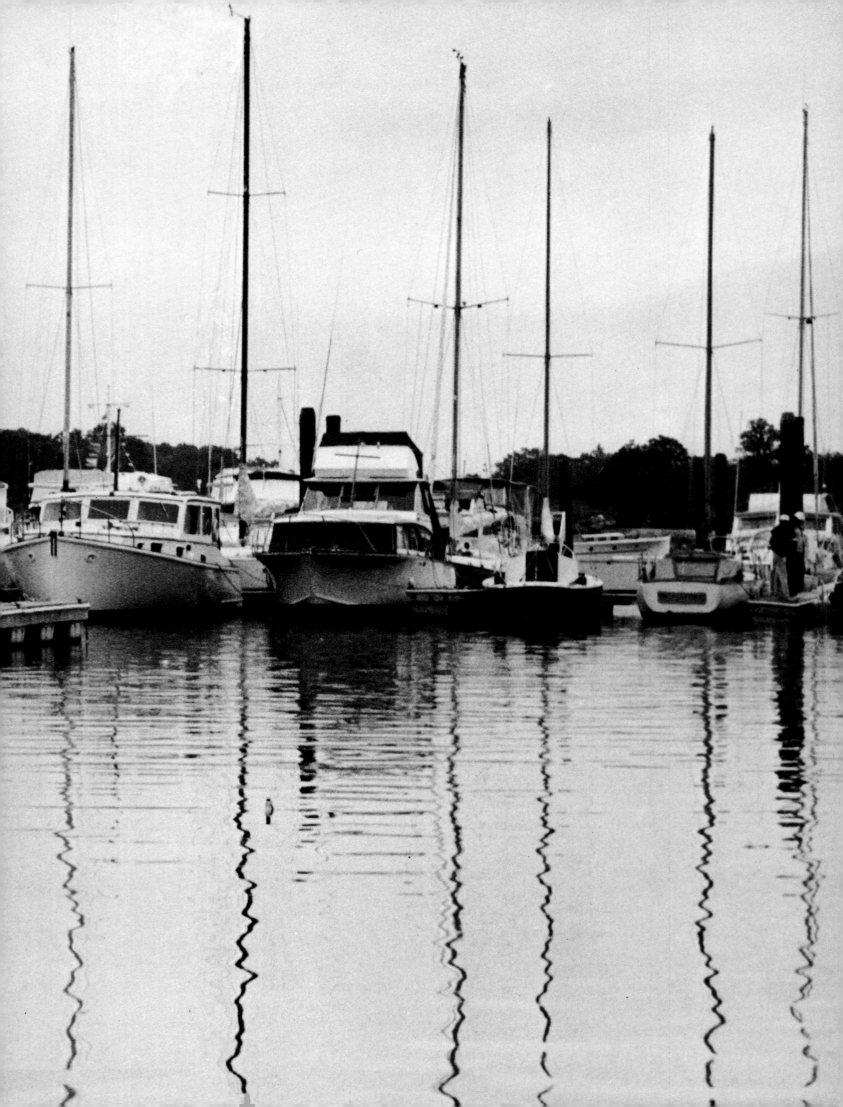

The Waterfront

New Rochelle's beautiful waterfront stretches nine miles along the coastline. It includes inlets for boats, several public and private beaches, a cluster of islands, parks, rustic scenes, and historic landmarks. "Queen City of the Sound" was its traditional description because its unique features make it the prize of the Westchester shoreline. The public marina accommodates more than six hundred fishing and boating vessels. New Rochelle also has many private marinas (left). The rippling reflections of masts are magnets for the photographer's eye.

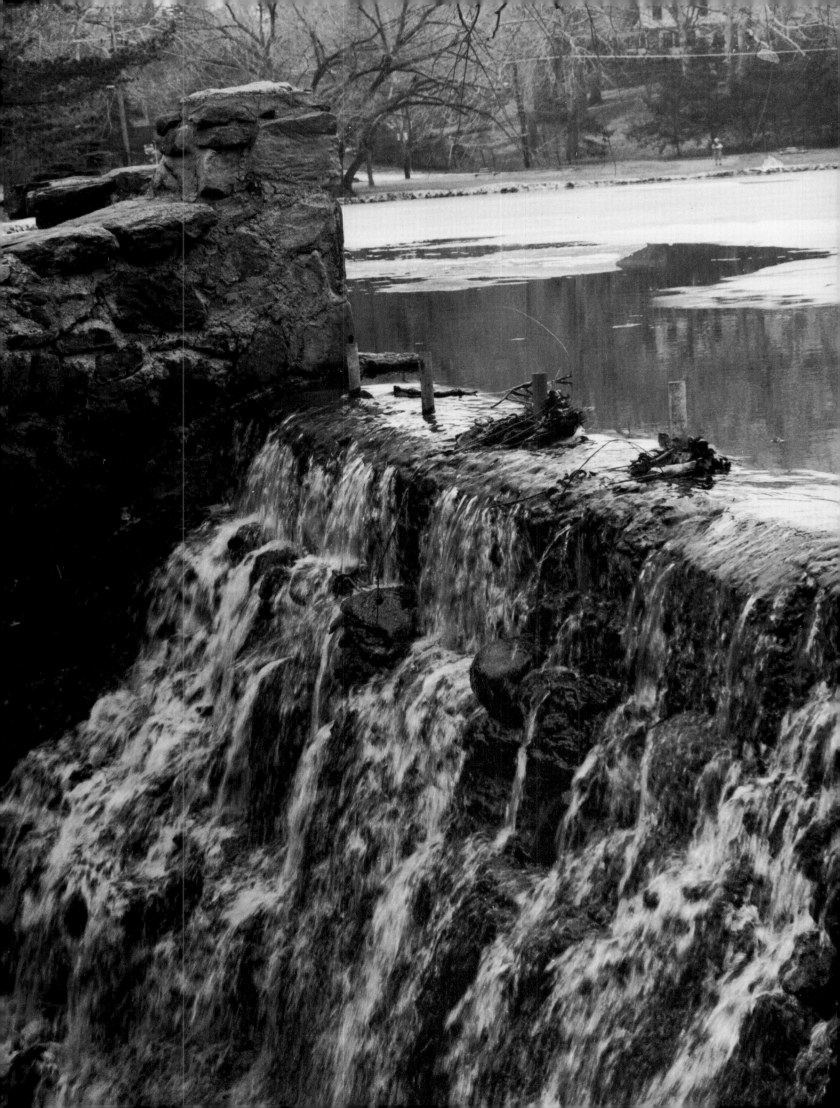

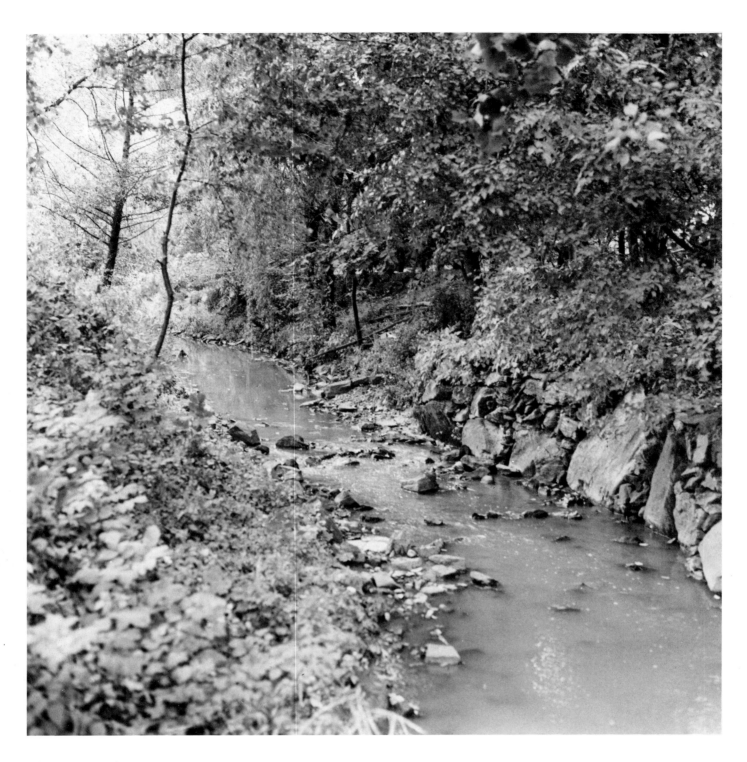

The upper Pine Brook
(above) in the north end of
New Rochelle winds its way
through the underbrush.
Spanned by a rustic bridge
(right), it flows through the
center of Pinebrook Boule-
vard.

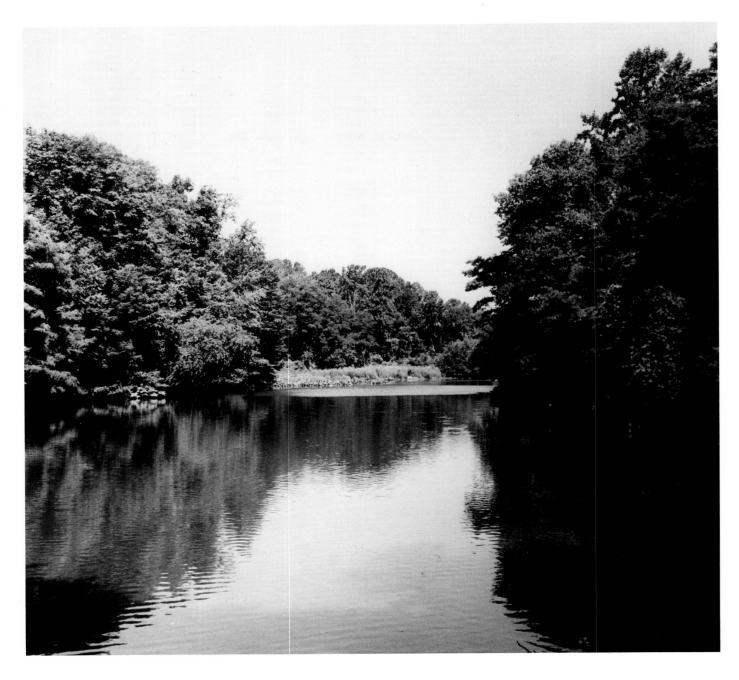

Carpenters Pond (above) provides an ideal setting for summer walks. In the winter, this and other New Rochelle lakes provide popular resting places for mallard ducks and ring-bill gulls (right).

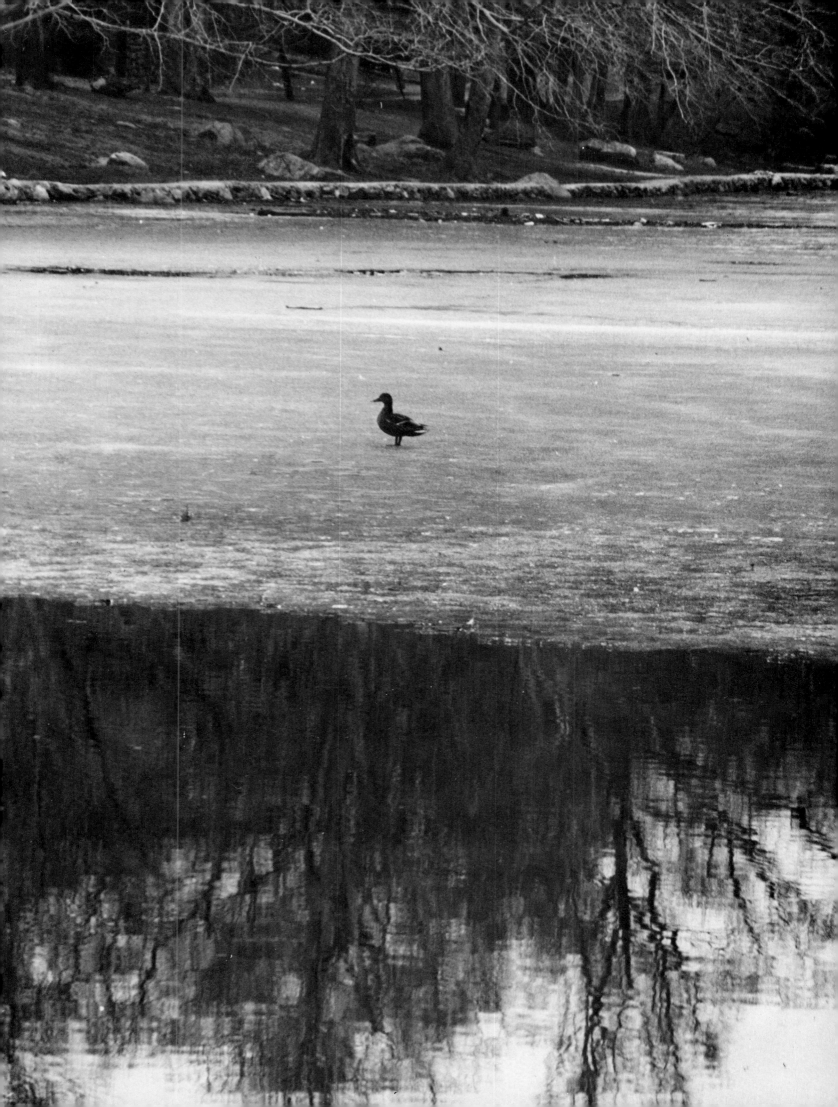

Stephenson Brook, with its
ancient willows overhanging
the flowing water, winds its
way through Huguenot Park
bordering the high school's
Twin Lakes.

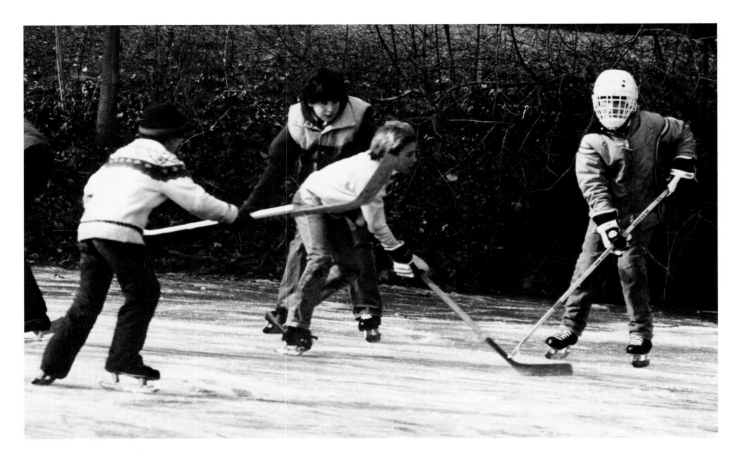

Young hockey enthusiasts try their skill with the puck on Paine Lake.

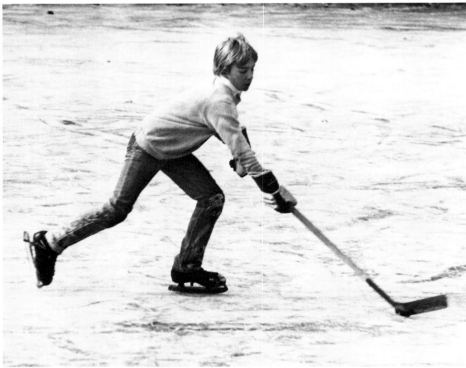

Page 65: In the Revolutionary era Thomas Paine became New Rochelle's most famous citizen, and his spirit can still be felt on the grounds of his cottage, now preserved as an historical landmark.

Page 66: The Brewster Schoolhouse stands next to the stream that passes by Paine Cottage.

Page 67: In 1922 the Chamber of Commerce commissioned well-known New Rochelle artists to design and paint these historical markers.

Page 68: New Rochelle's present City Hall was originally New Rochelle High School. Built in 1906, it subsequently became a junior high school and was remodeled in 1963 to house the offices of the municipal government and the Board of Education.

Page 69: The North Avenue wall mural painted by Wade Williams is an expression of the community's traditional interest in the visual arts.

Page 70: Shoppers on the Anderson Street Walkway rest for a few moments beneath the cluster of birch trees.

Page 71: The stables at Ward Acres are considered architectural landmarks.

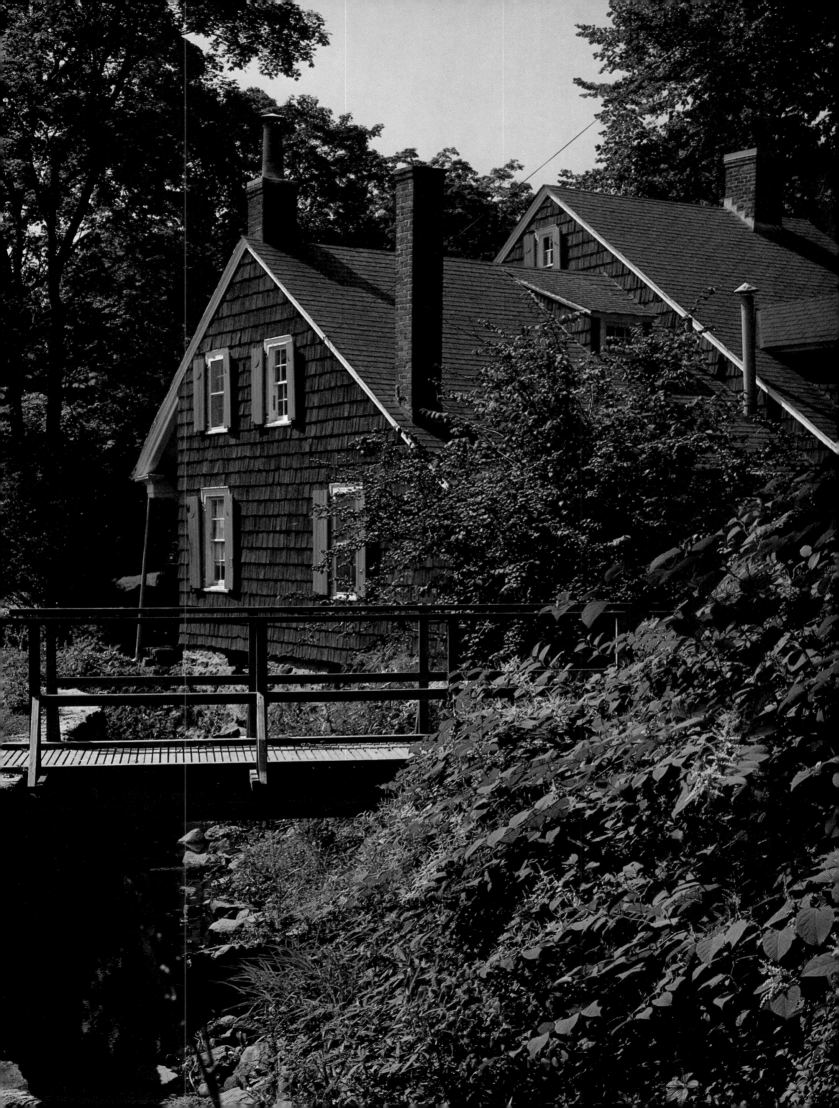

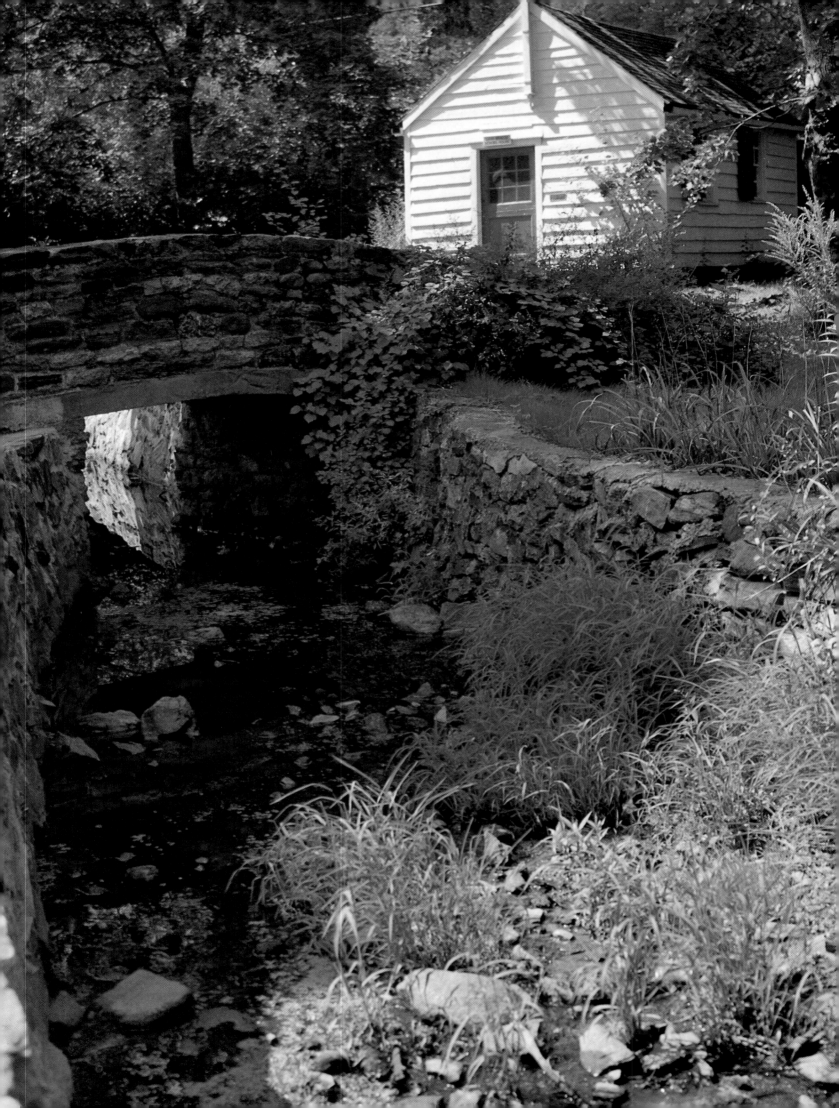

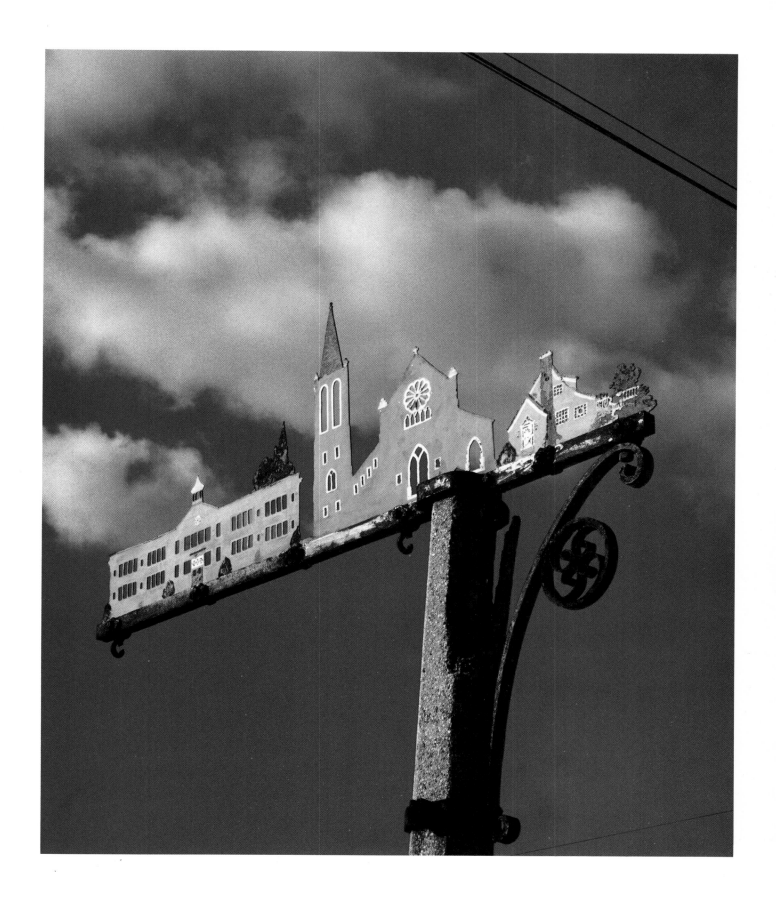

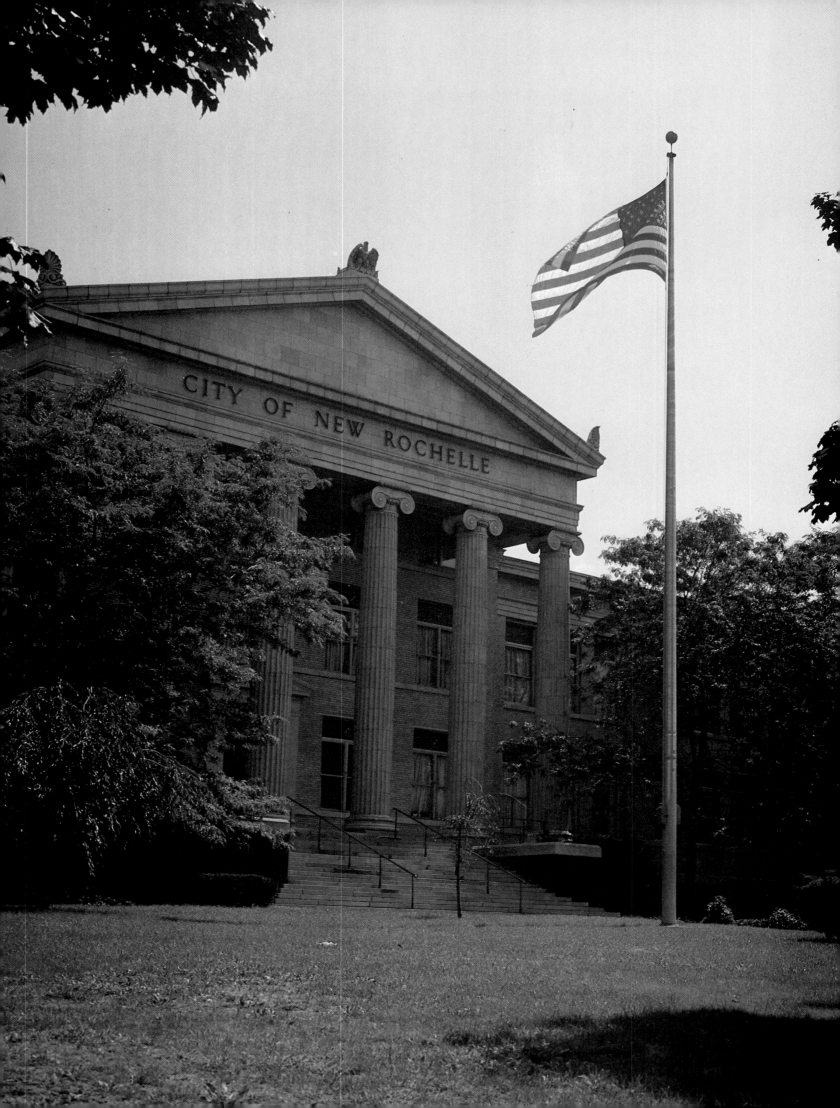

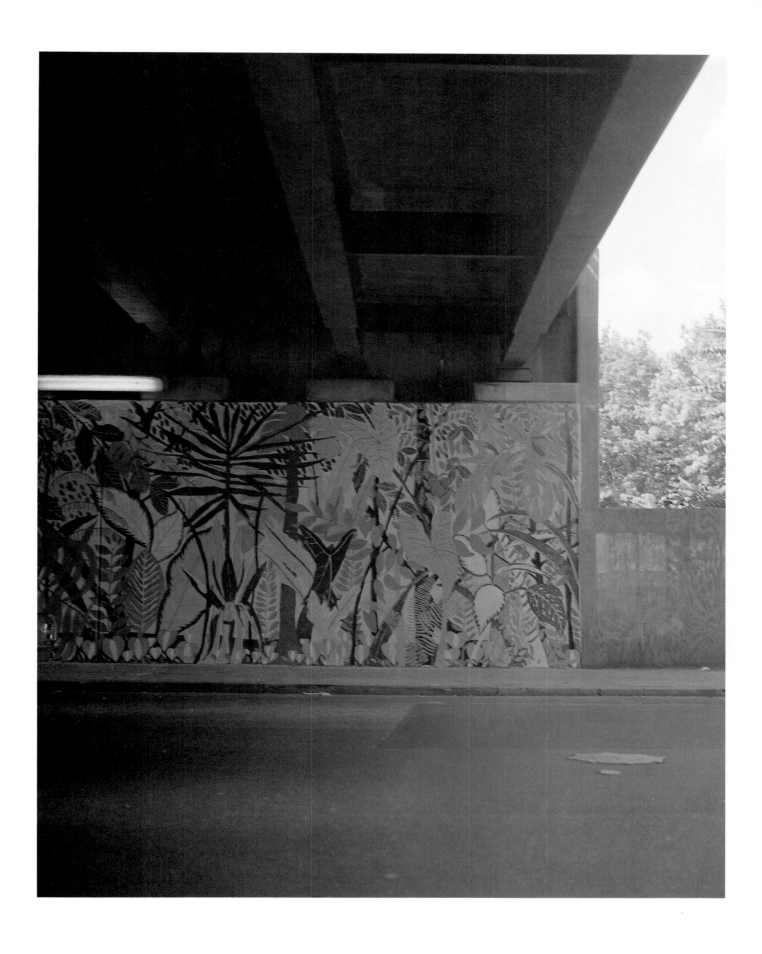

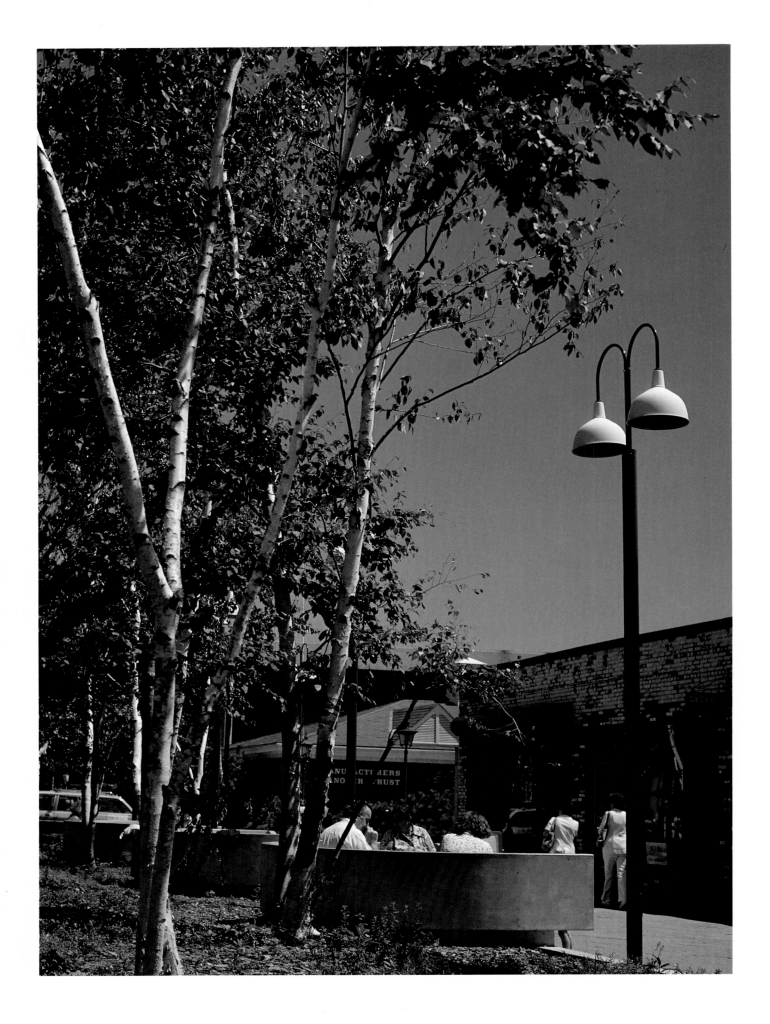

70

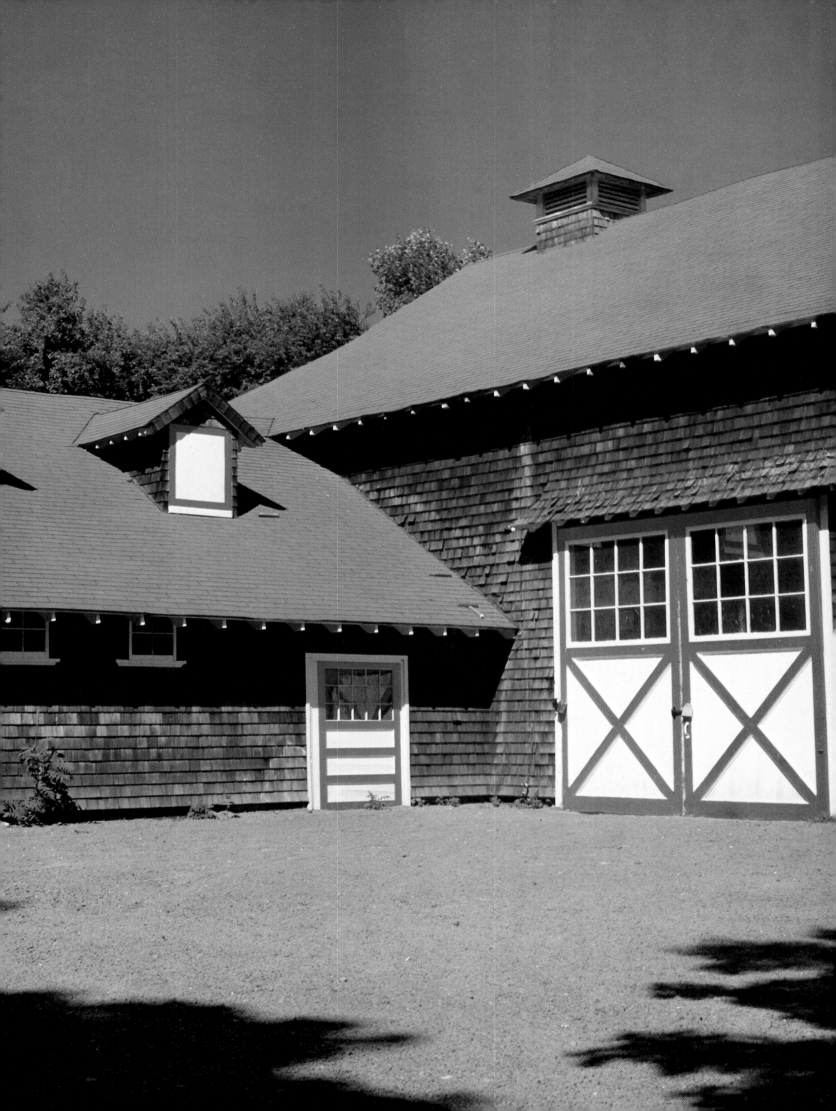

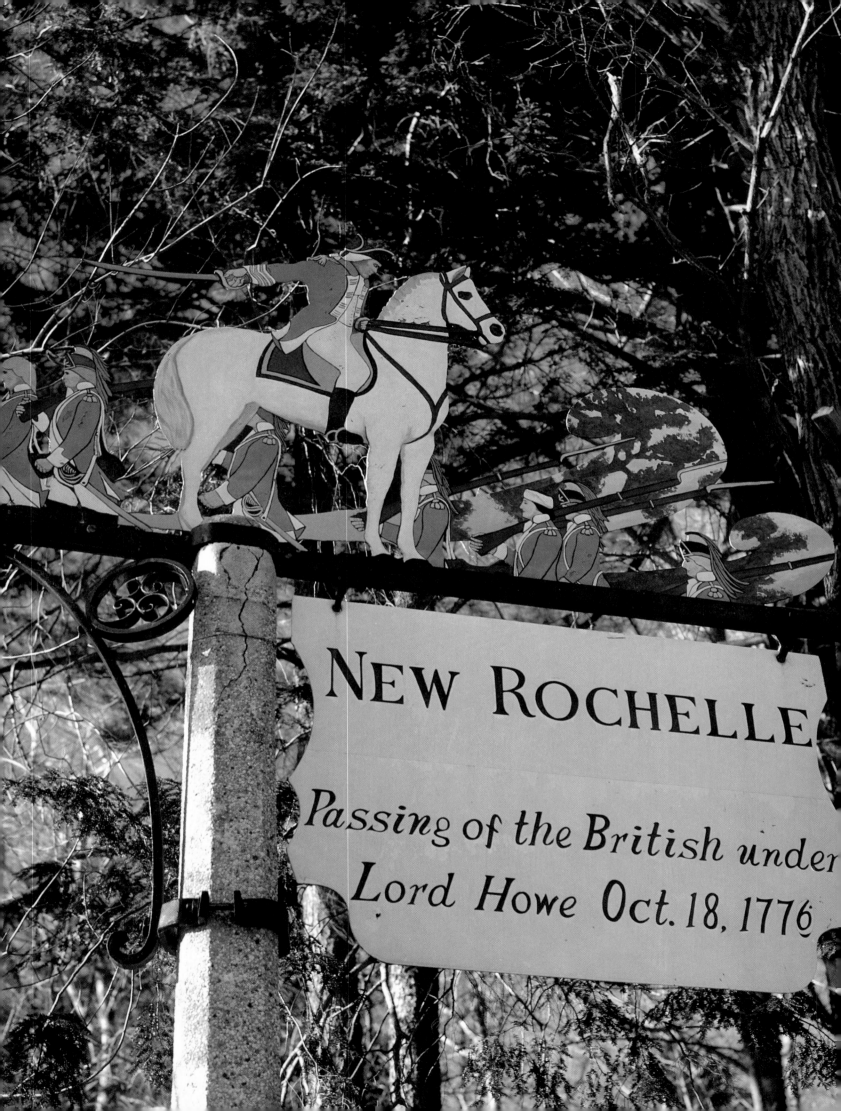

American History

New Rochelle lives with a deep sense of history. The Siwanoy Indians were here before the Europeans "discovered" the land. The first immigrants from abroad were thirty-three Huguenot families who came in 1688 in search of religious freedom. They named their home New Rochelle after La Rochelle, their place of origin. One of the illustrated signposts on the borders of New Rochelle commemorates the passing of the British in 1776 (left).

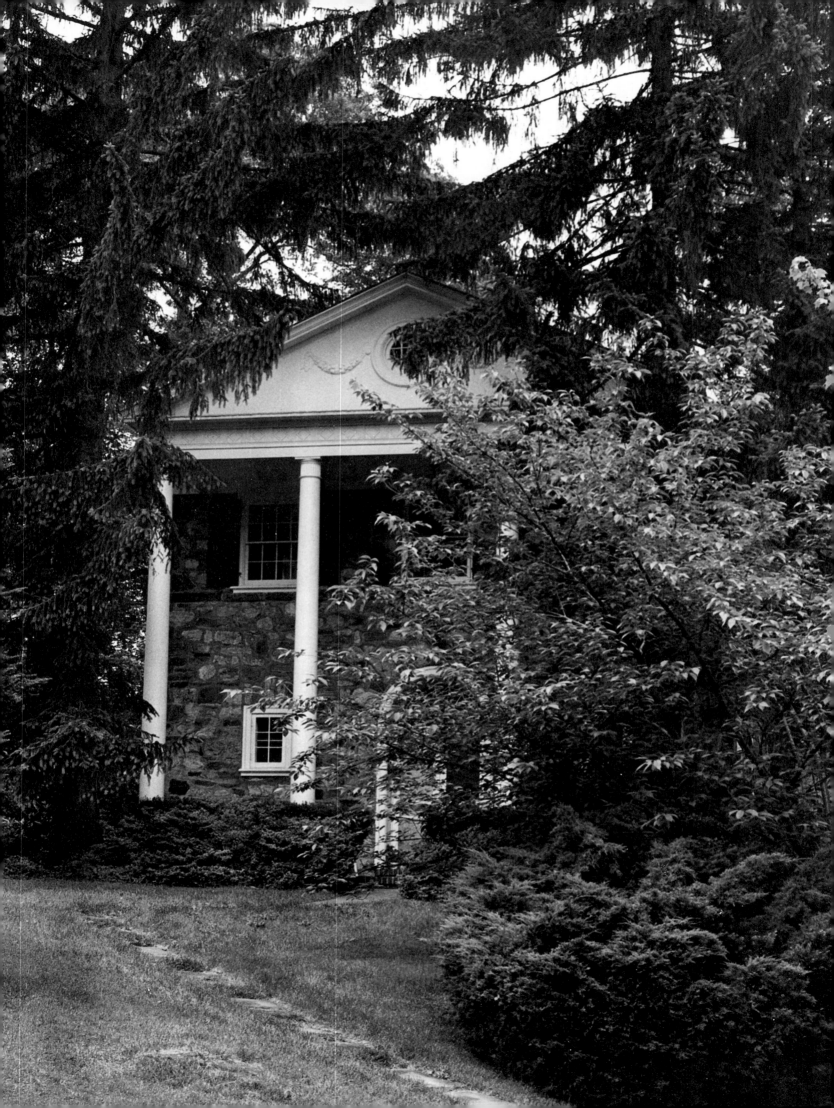

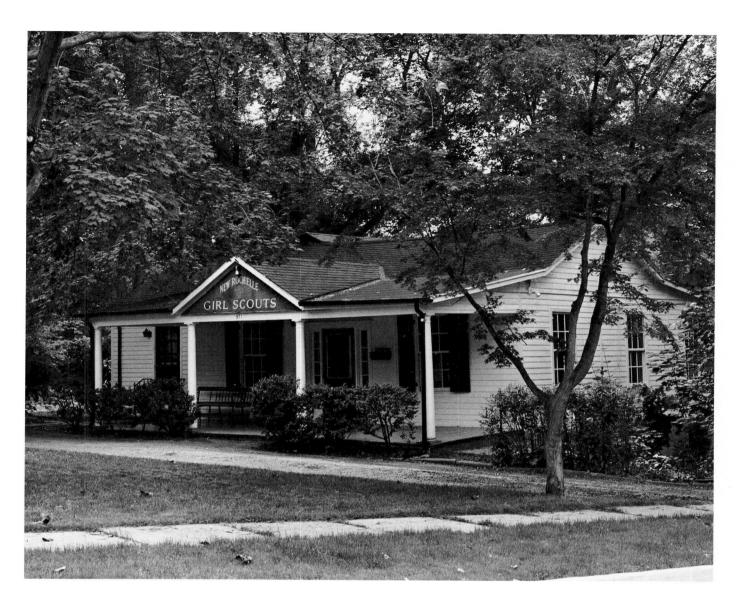

Thomas A. Edison turned the
first shovel of earth for the
Paine Museum (left) in 1925.
Located at North Avenue
and Valley Road, it contains
Paine memorabilia, exhibits,
a comprehensive Thomas
Paine Library, artifacts con-
nected with the Huguenot
settlers, the Hufeland Li-
brary, a collection of books,
manuscripts, maps, and
photographs all relating to
New Rochelle and the history
of Westchester County and
New York. Nearby, on the
shore of Paine Lake, is the
New Rochelle Girl Scout
House (above).

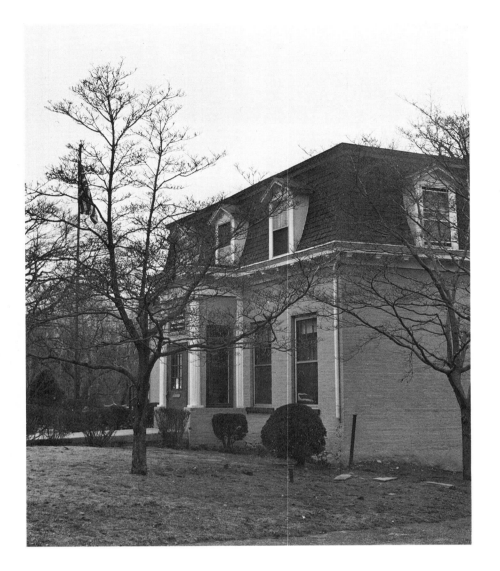

The Huguenot Branch of the
New Rochelle Public Library
on North Avenue (above)
was built in 1869 for the
Mahlstedt family. The statue
of Jacob Leisler (right) oppo-
site the high school is by the
sculptor S. H. Borglum. This
statue of an American patriot
was erected in 1913 by the
Huguenot Chapter of the
Daughters of the American
Revolution.

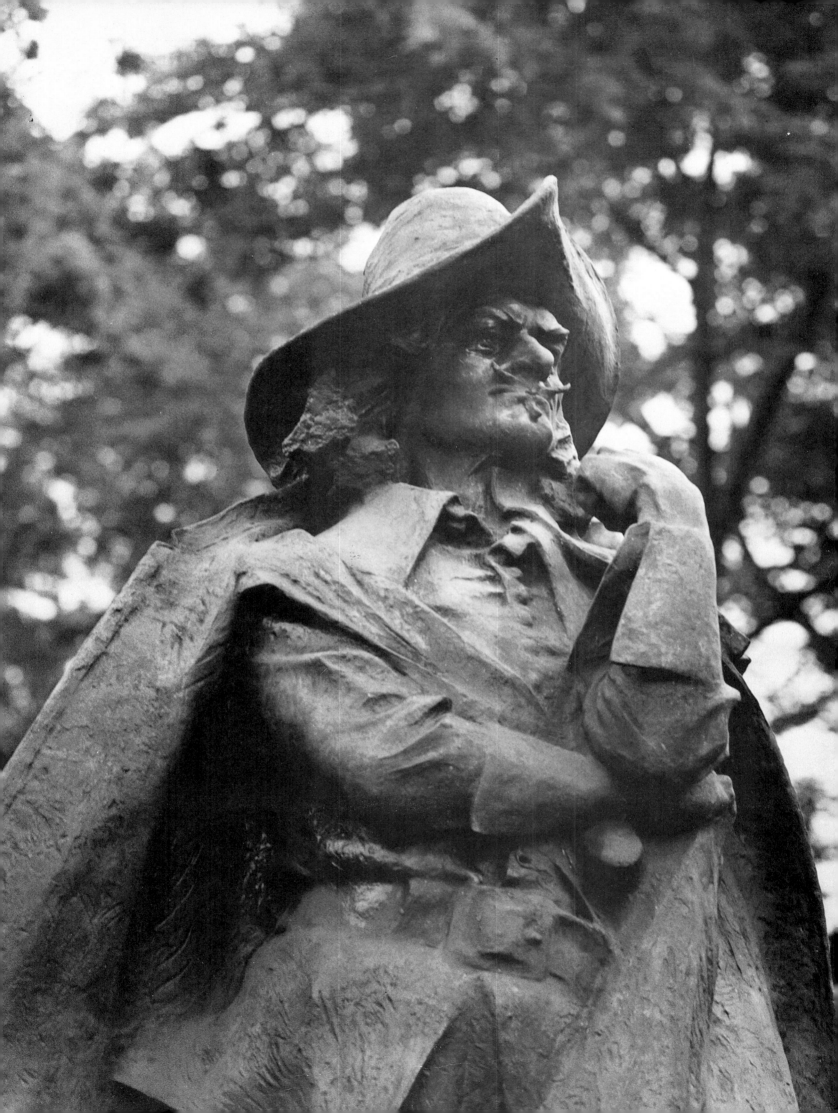

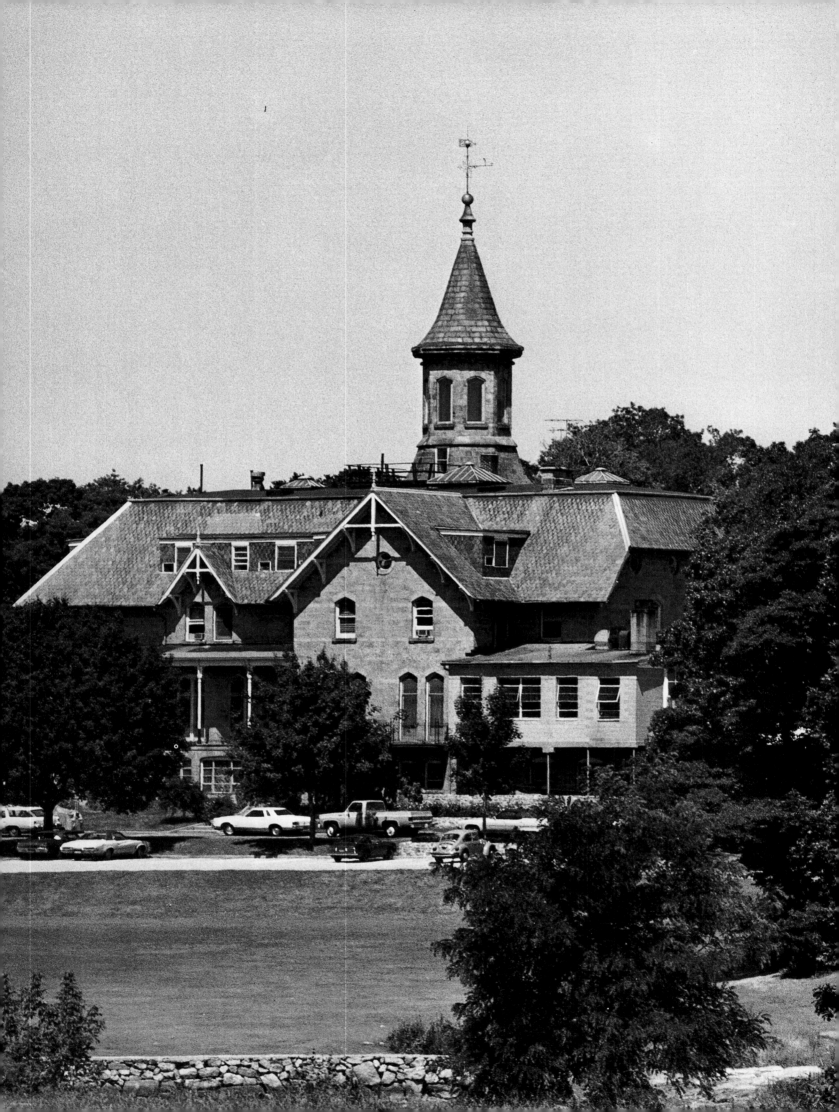

The Salesian Provincial
House (left), headquarters of
the Eastern Province of St.
John Bosco, was once the
home of John Stephenson,
the inventor of the trolley.
An old frame house on East-
chester Road (above) is one
of many private houses in
New Rochelle with a long
history.

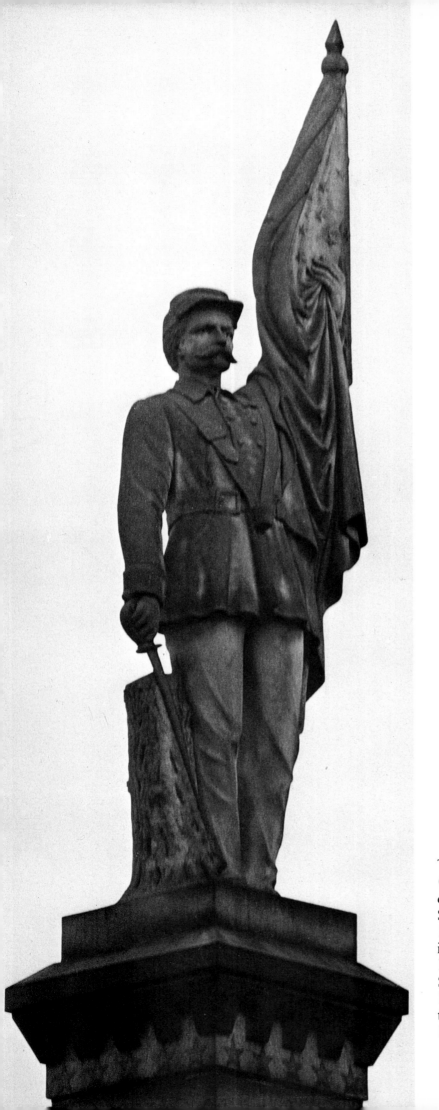

The Civil War Monument
(left) at the western junction
of Main and Huguenot
Streets was dedicated May 9,
1896. The bronze plaque ded-
icated to men from New
Rochelle who served in the
Spanish-American War,
1898-99 (right), is located at
the entrance to Rochelle
Heights on North Avenue.

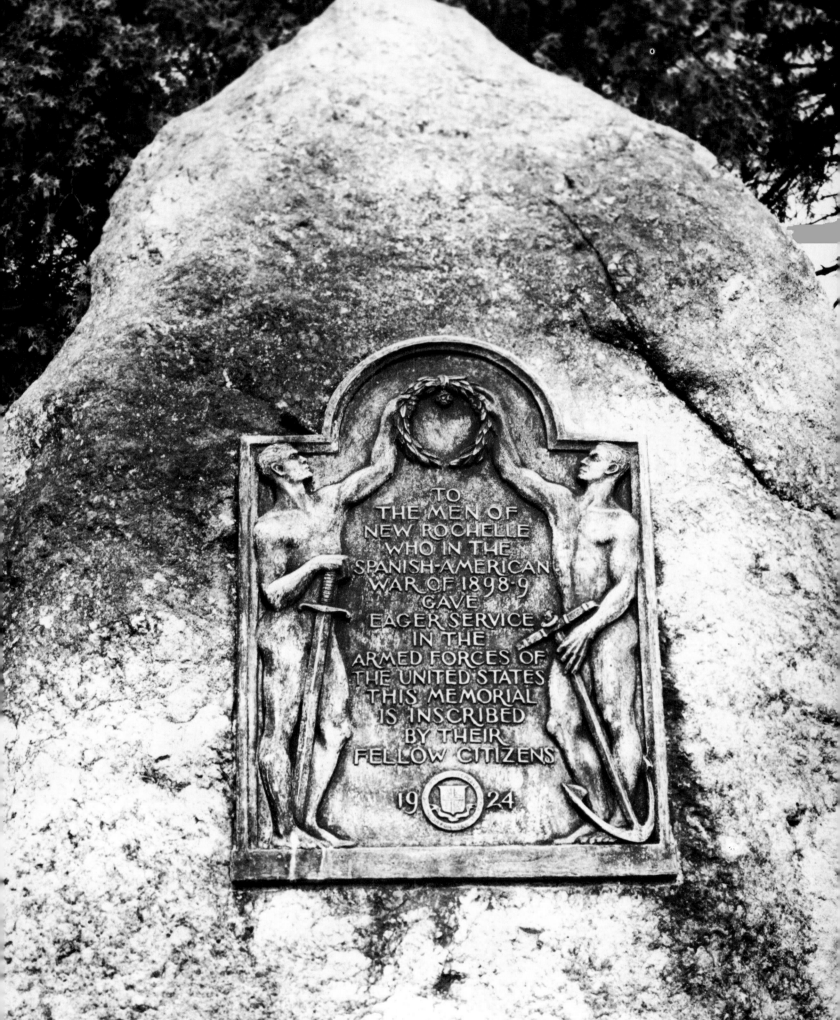

TO
THE MEN OF
NEW ROCHELLE
WHO IN THE
SPANISH-AMERICAN
WAR OF 1898-9
GAVE
EAGER SERVICE
IN THE
ARMED FORCES OF
THE UNITED STATES
THIS MEMORIAL
IS INSCRIBED
BY THEIR
FELLOW CITIZENS

19 24

The bust of Thomas Paine at the intersection of North Avenue, Paine Avenue, and Valley Road is mounted on a tall cement pedestal on which is carved some of his most memorable sentences.

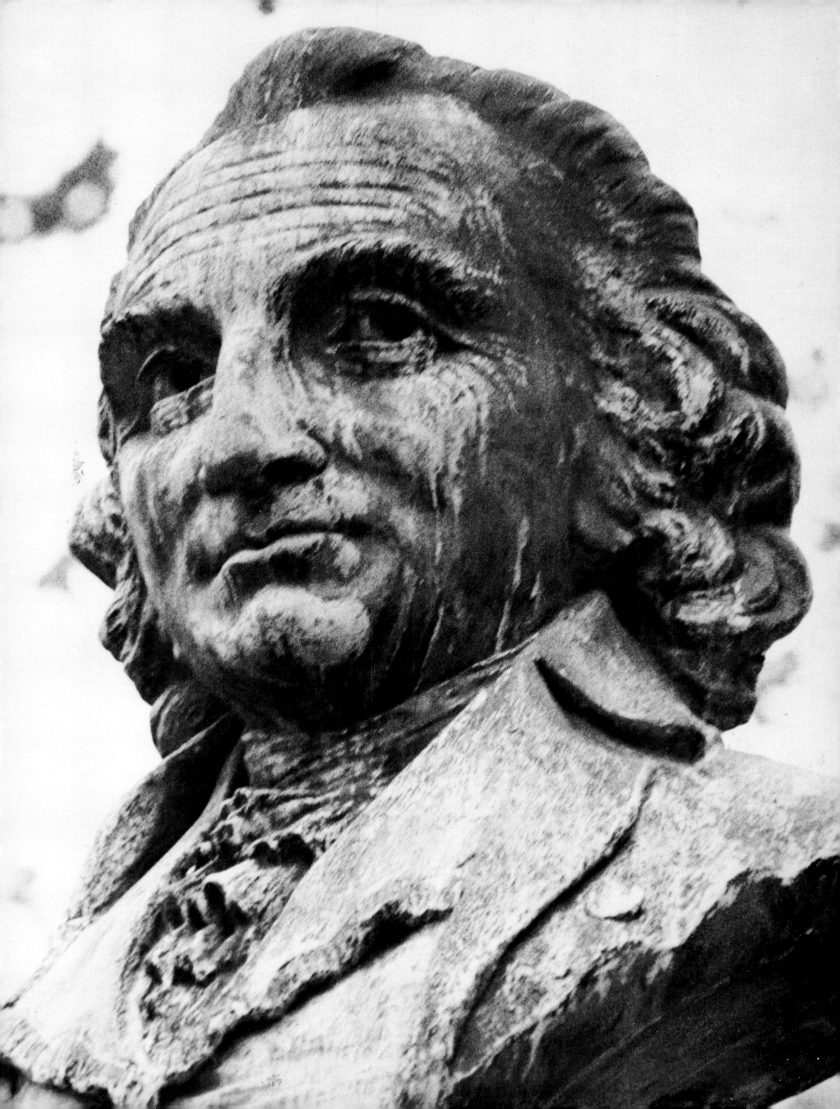

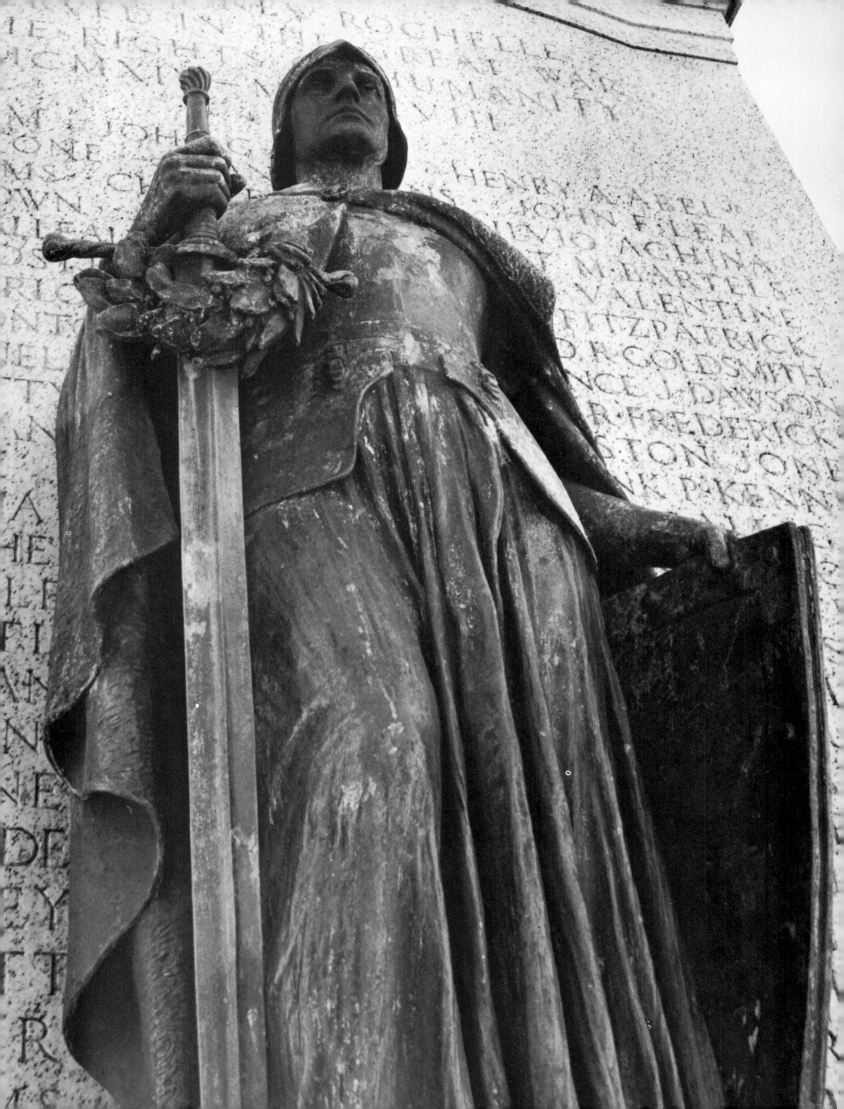

The World War I Monument at the eastern junction of Main and Huguenot Streets (left) memorializes all those who served from New Rochelle. The Korean War, World War II, and Vietnam War memorials (above) stand in front of City Hall.

The decoration on top of the animal drinking fountain (above) at the western junction of Main and Huguenot Streets is a memorial to Eliza Moulton, "A Friend of Dumb Animals," 1827-1894, and to her father, Doctor Peter Moulton, a "beloved physician." Coutant Cemetery (right), at Webster and Eastchester Roads, dates from 1776. This cemetery is still governed by a Board of Directors, descended from Isaac Coutant and his wife, in accordance with his will and the 1845 Statute Law of the State of New York under which it was incorporated. It is one of the few remaining private cemeteries in the United States.

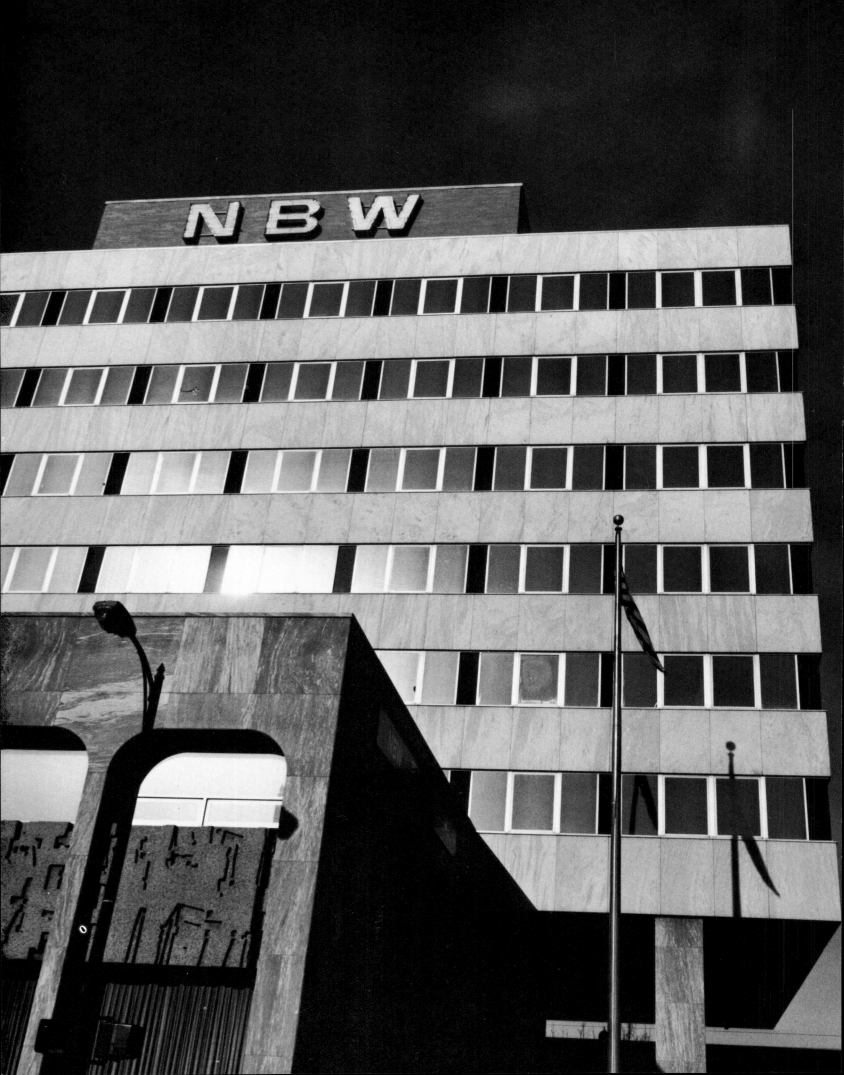

The City

The downtown area of New Rochelle consists of shops, banks, office buildings, restaurants, theaters—most of which cluster around Main and Huguenot Streets and North Avenue. The National Bank of Westchester (left) stands at the crossroads of North Avenue and Huguenot Street and is one of the major banks located in the center of the city.

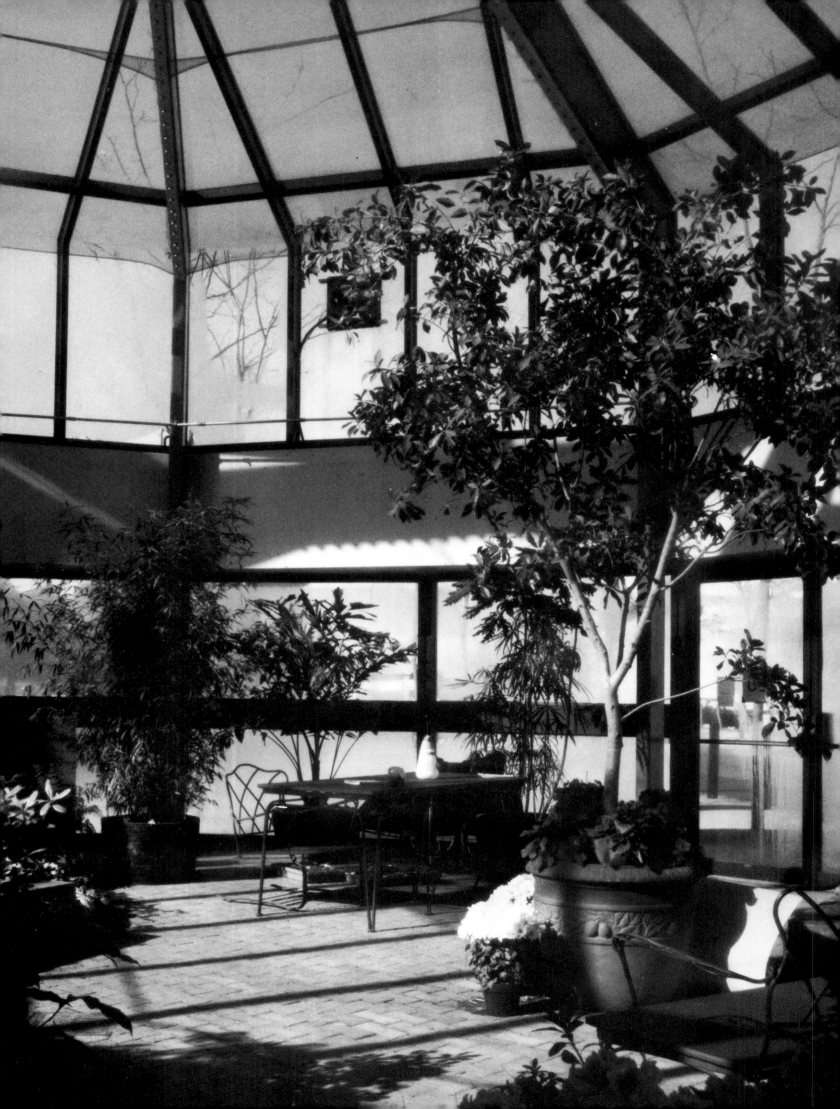

The Wintergarden (left) on
Memorial Highway is a de-
lightful resting place for
downtown shoppers. A few
blocks away is New Ro-
chelle's major hotel facility,
The Sheraton Plaza Inn
(above).

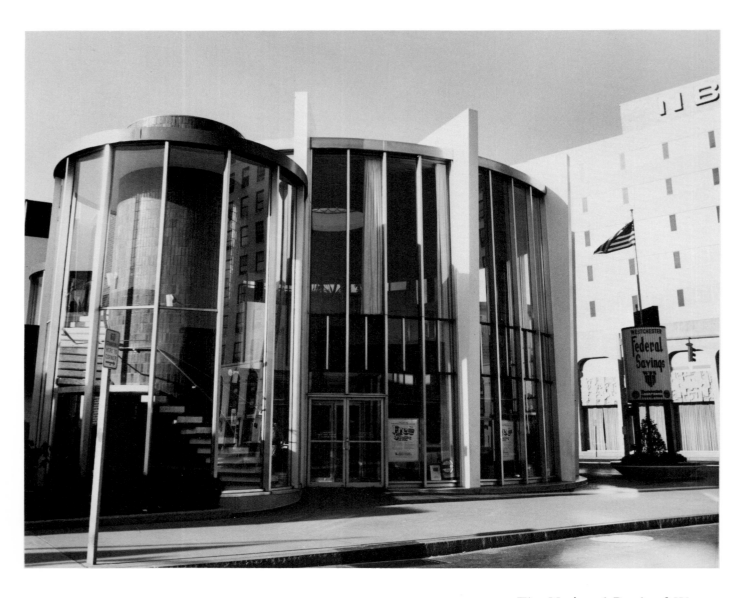

The National Bank of Westchester is reflected in the glass front of the Peoples' Bank for Savings (right). The Westchester Federal Savings Bank (above) is at the opposite corner. All three banks are located at North Avenue and Huguenot Street.

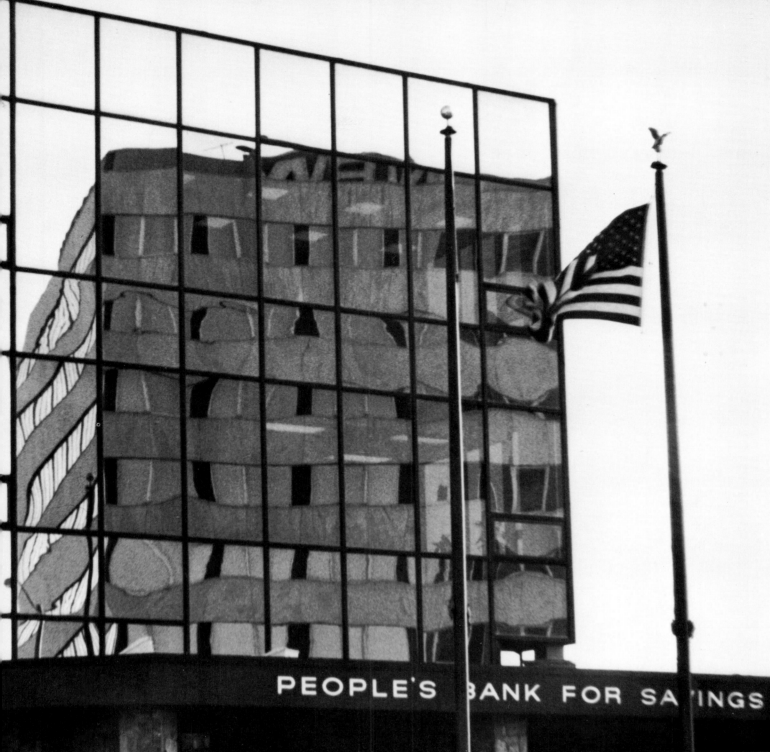

PEOPLE'S BANK FOR SAVINGS

The elegant facade of Barclays Bank of New York faces Main Street at Lawton Street (below). The classical facade marking the entrance to the imposing building at the corner of North Avenue and Railroad Plaza (right) was originally the old Huguenot Trust Company. Today it is the world headquarters for Spoken Arts and Luce Klein Antiquaire.

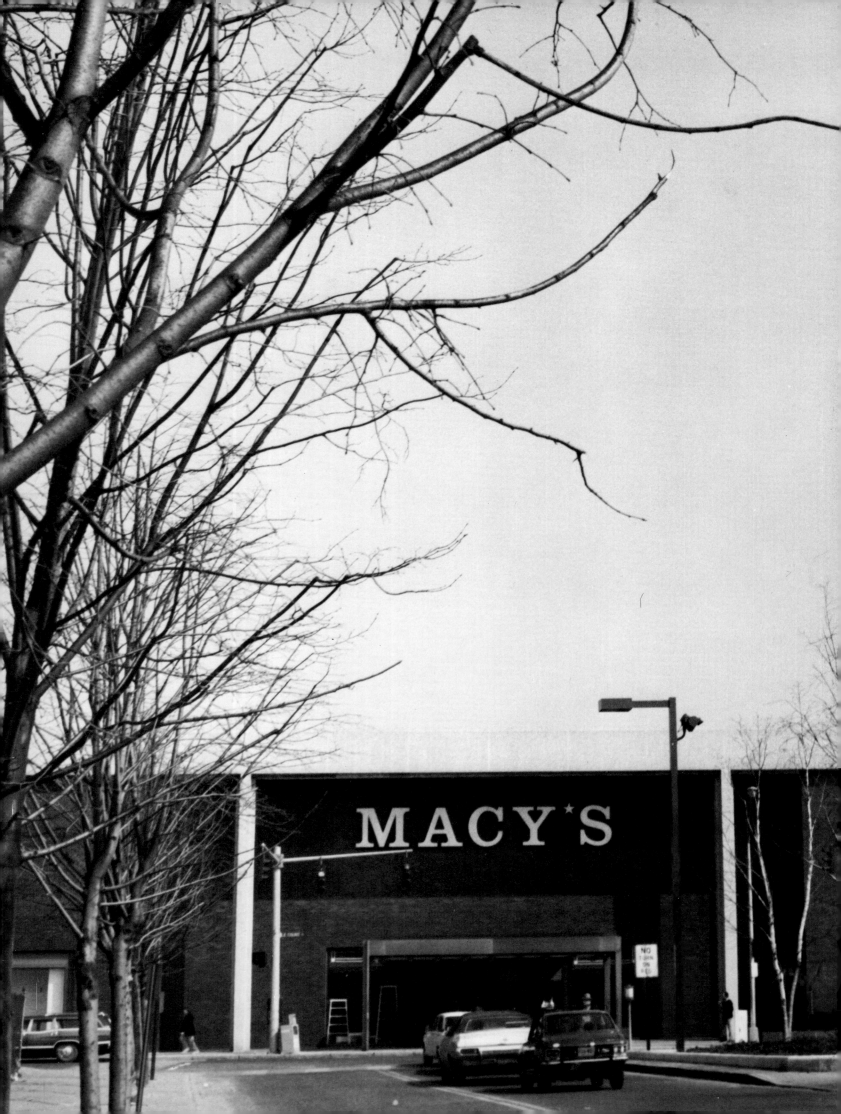

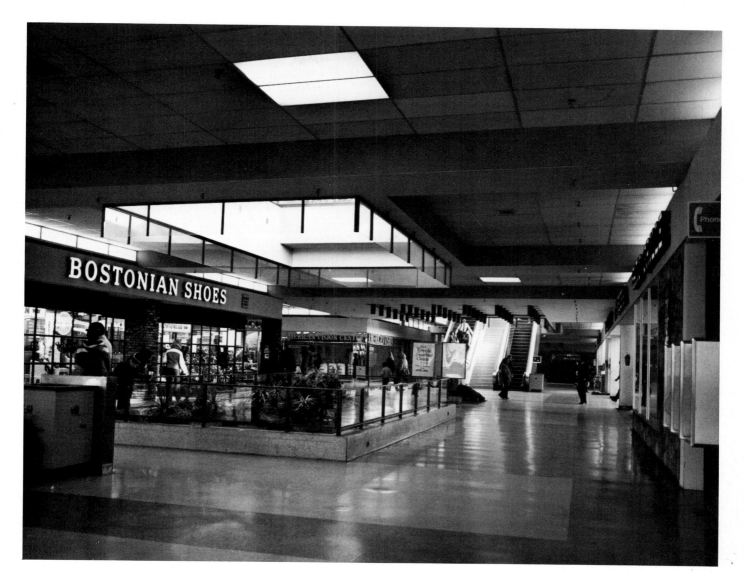

Macy's Department Store
(left) in the downtown area is
part of the Mall complex
which includes more than
600,000 feet of floorspace.
Some 50 stores are located in
the well-designed interior
space of the Mall (above).

Headquarters for stations WVOX-AM, the hometown radio station of New Rochelle, and WRTN-FM. It is estimated that the listening audience of the combined stations is in the neighborhood of 650,000.

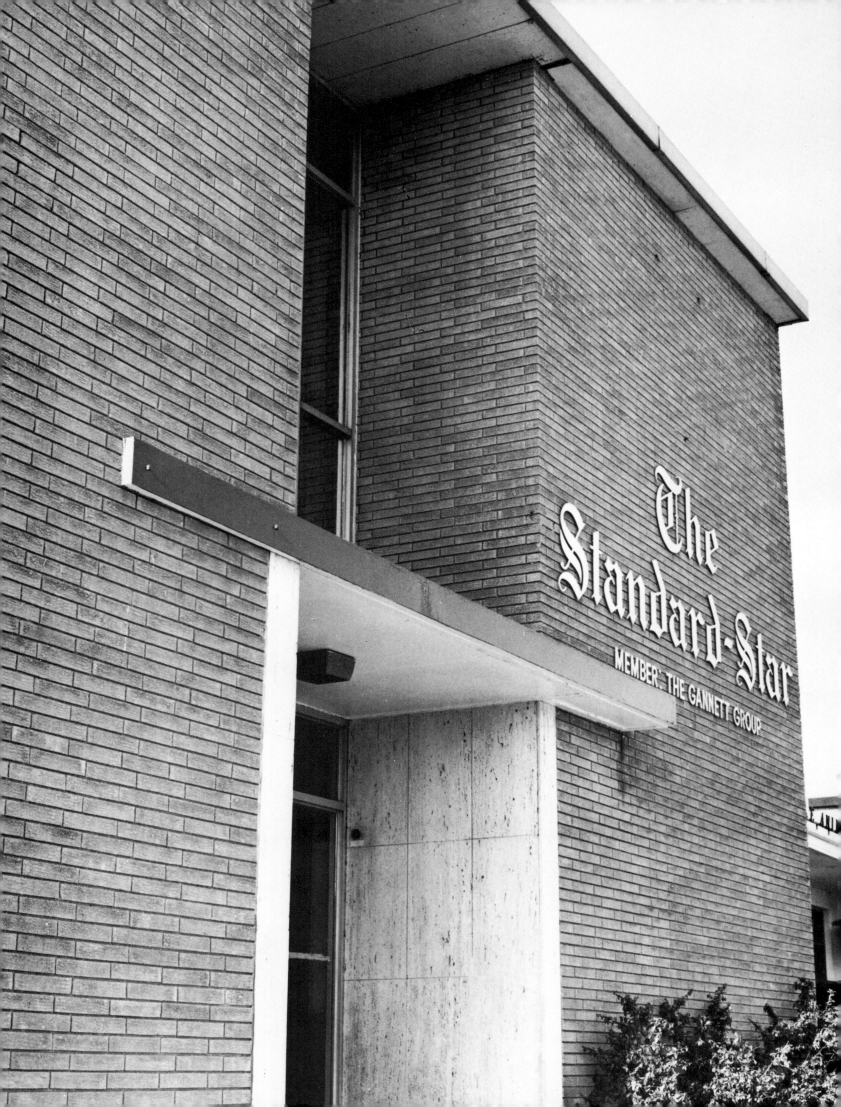

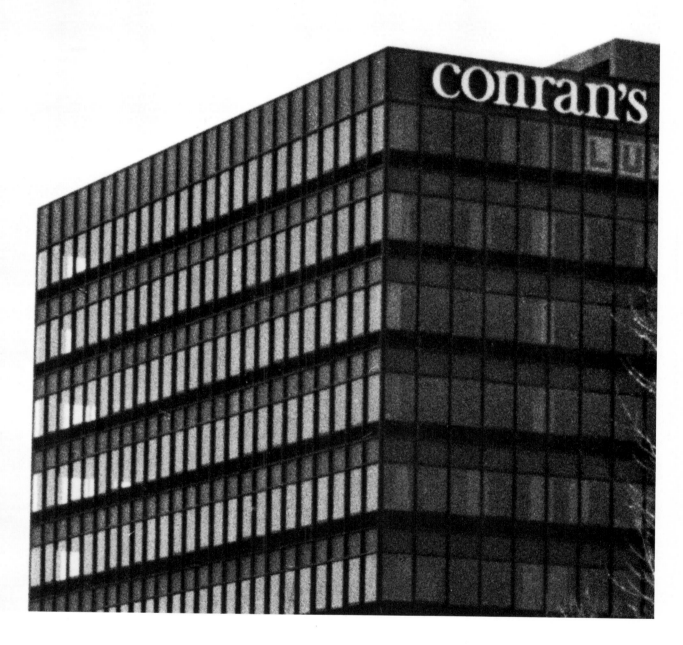

Headquarters for *The Standard-Star* (left), hometown newspaper of New Rochelle, are located at the south end of North Avenue. The corporate and U.S. headquarters of Conran's International (above), one of the few total home furnishings companies in the world, is located in downtown New Rochelle.

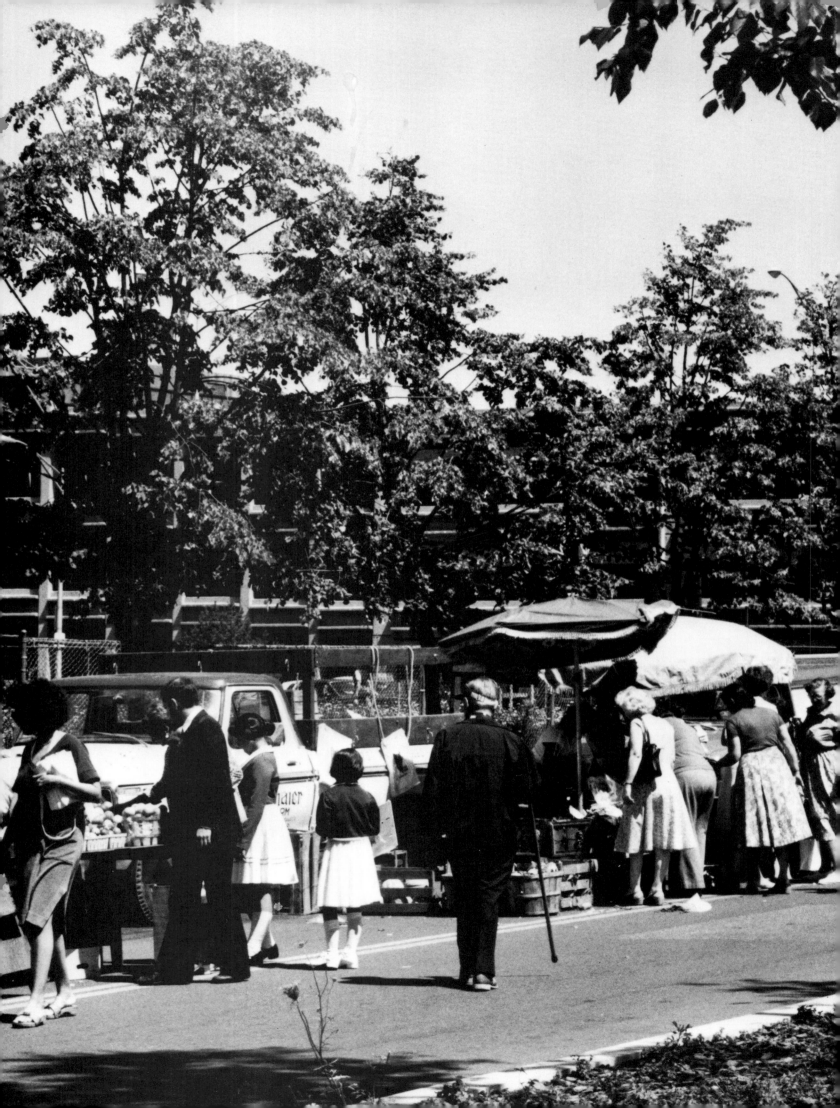

Each Friday during the warm summer and fall months shoppers pour into the weekly Green Seasons Farmer's Market on the Anderson Street Walkway to buy freshly picked fruits and vegetables.

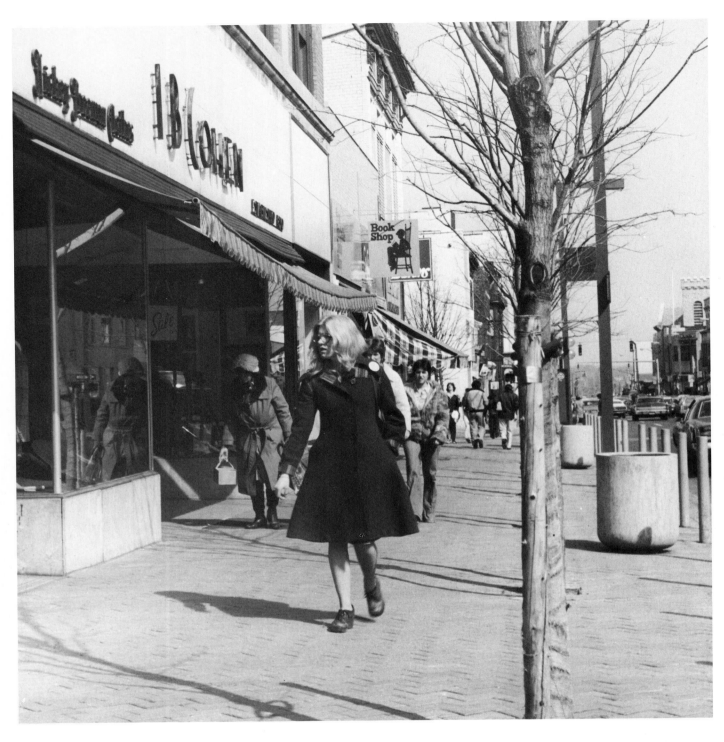

Shoppers enjoy wide side-
walks and tree plantings
(above). Children bring cheer
with their Easter Seal bal-
loons (right). Two young-
sters sit happily on the
spacious plaza fronting the
prize-winning Central Library
(overleaf).

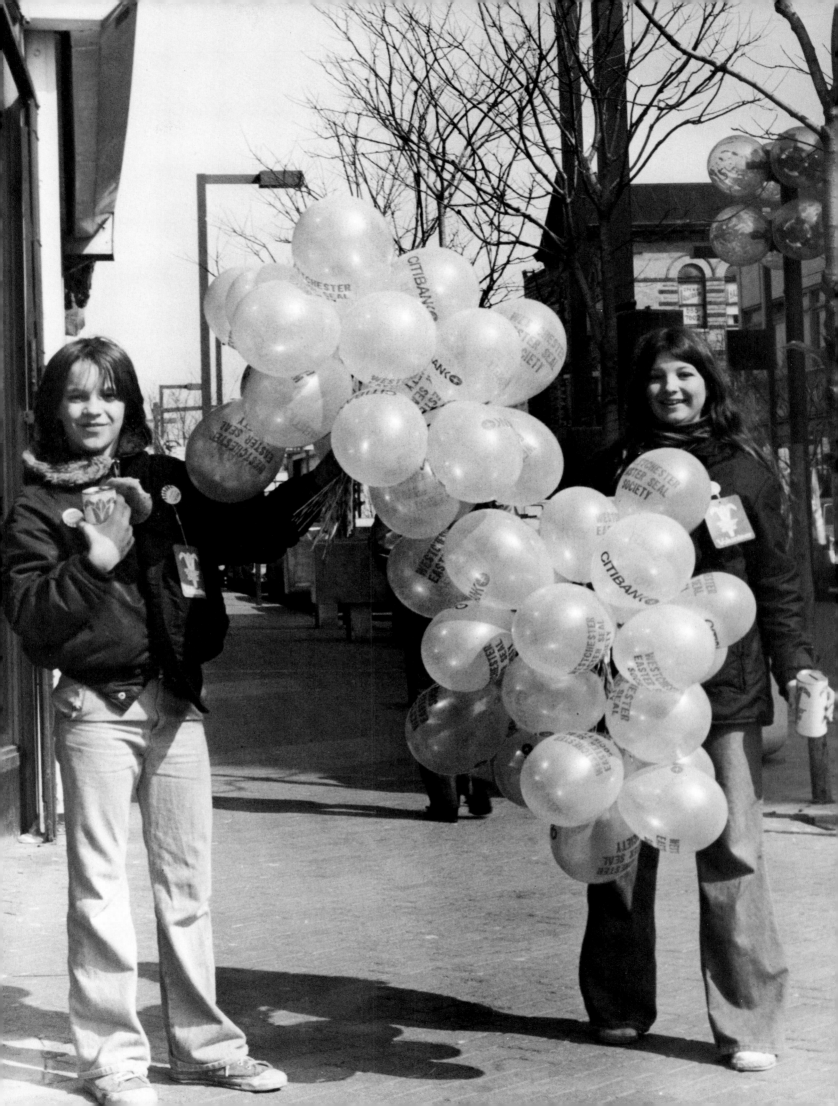

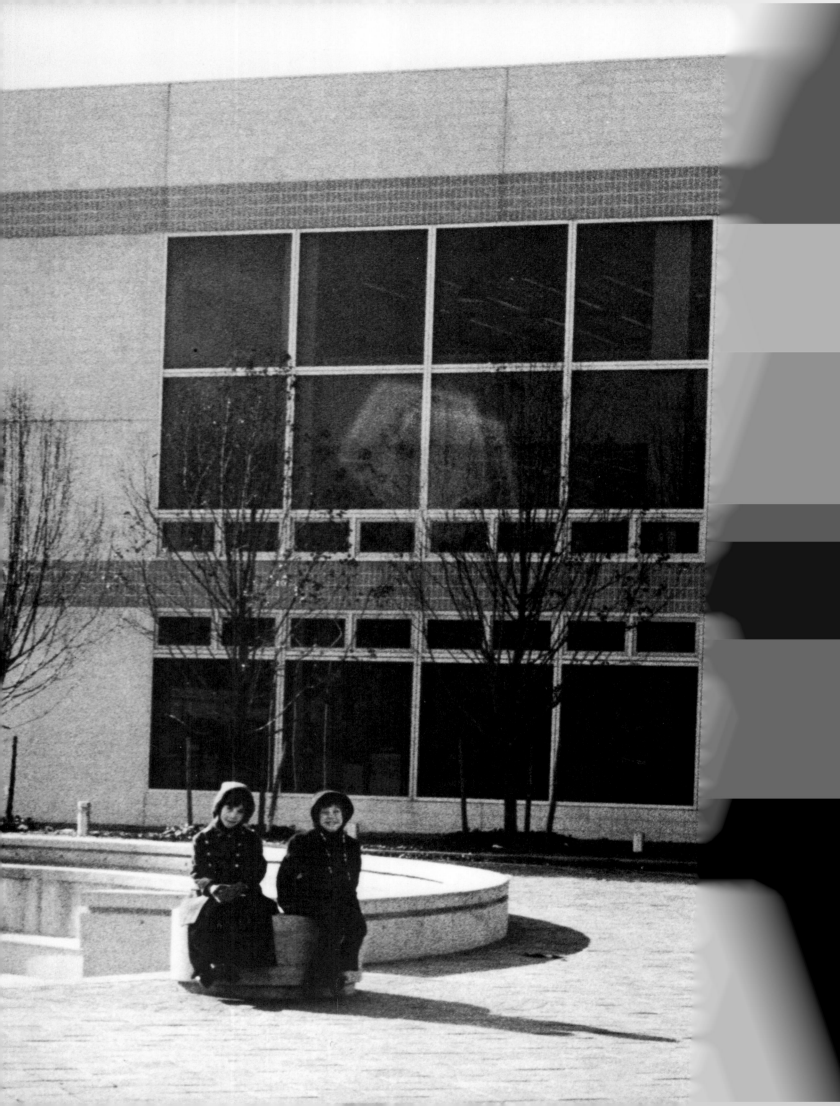

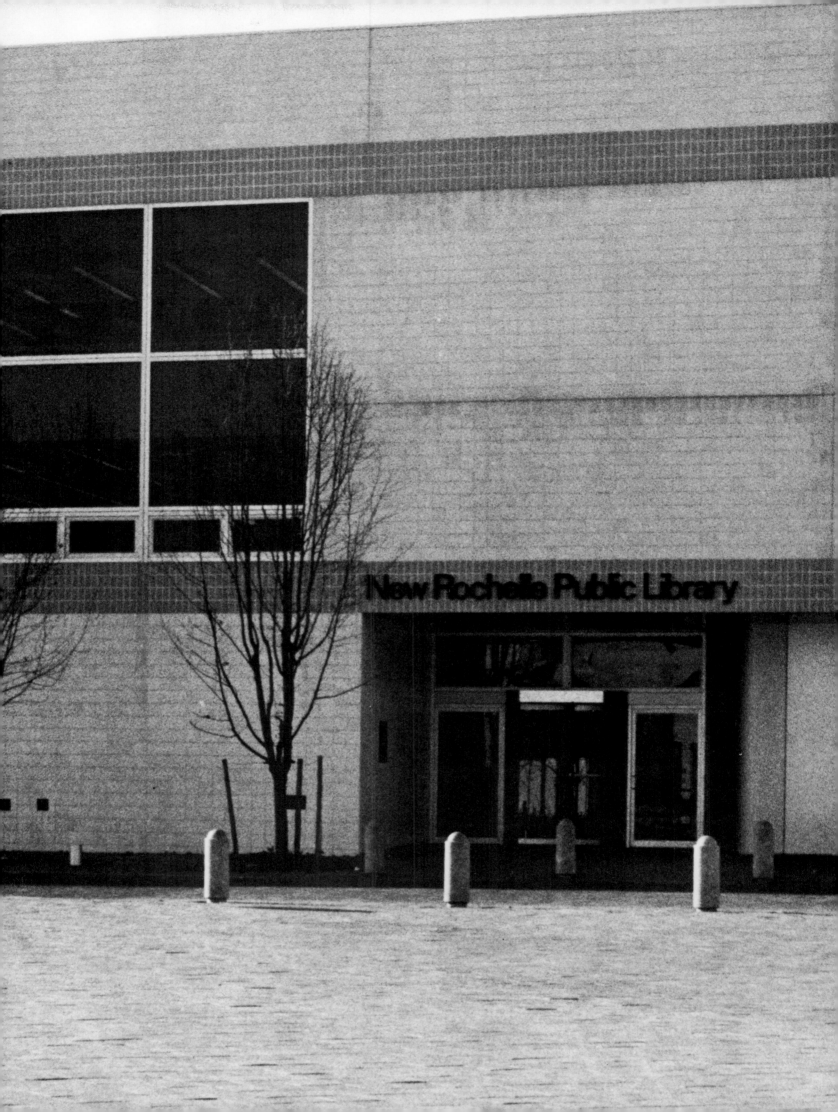

On Main Street and Pintard Avenue is the 1912 building, erected with funds provided by Andrew Carnegie, which served for many years as the City's main library (above). At the intersection of Huguenot Street and North Avenue, New Rochelle's busiest corner, is the landmark Kaufman Building (right).

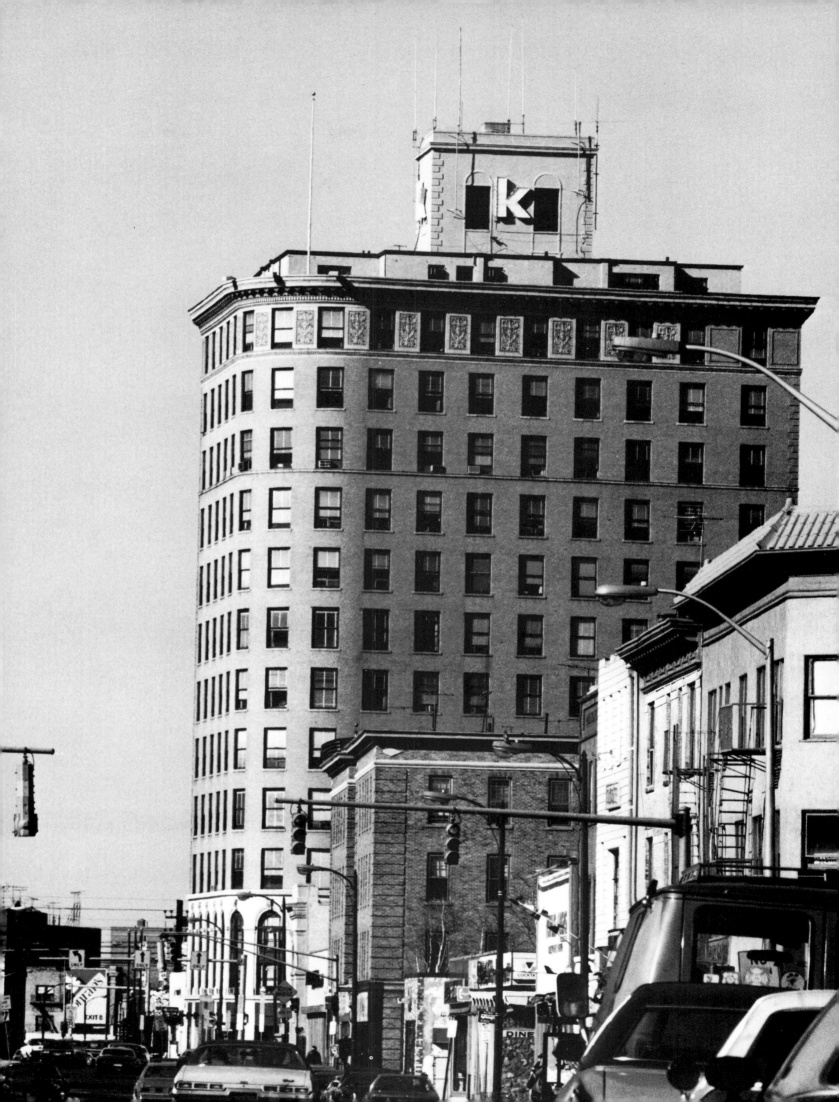

Headquarters offices of major companies located in New Rochelle include Joyce Beverages (above), the world's largest distributor of 7-Up; Rawlplug Company, a leading manufacturer of anchoring devices for masonry (upper right); Wideband Jewelry Corp. (lower right), the world's largest manufacturer of gold chain jewelry. Harold Castor's memorial to the Raizen family of New Rochelle (overleaf, left) stands near the Wintergarden. The sculpture by Bogden Grom is sited at the Main Street entrance to the Mall (overleaf, right).

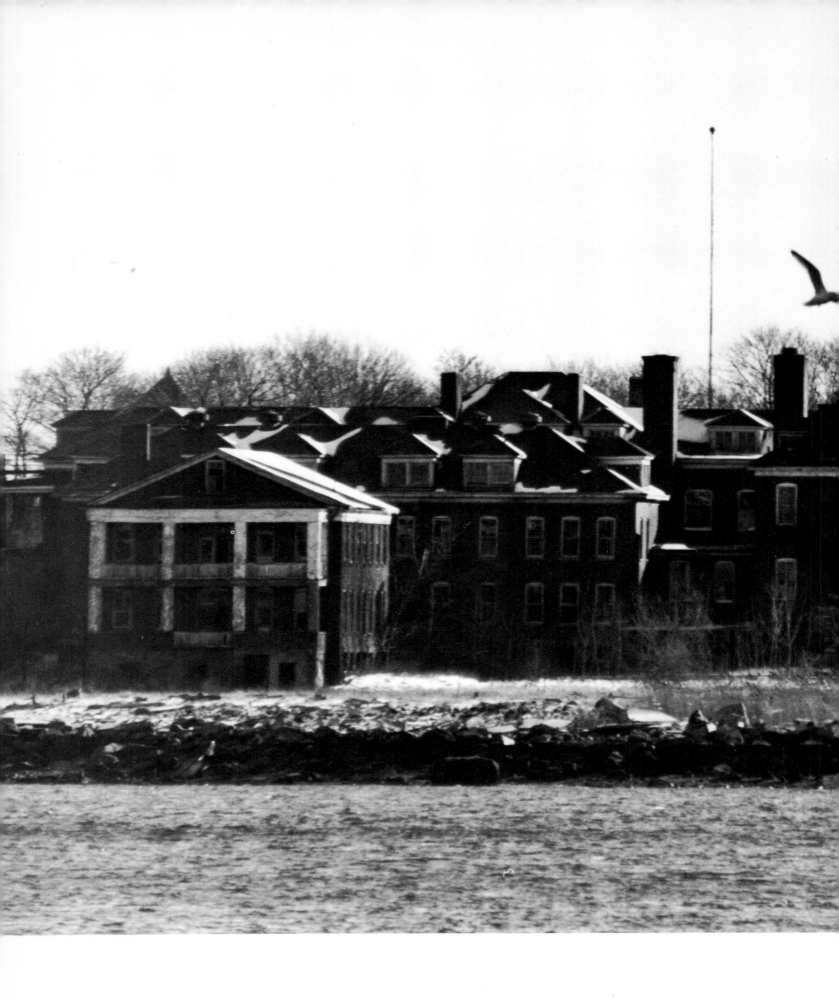

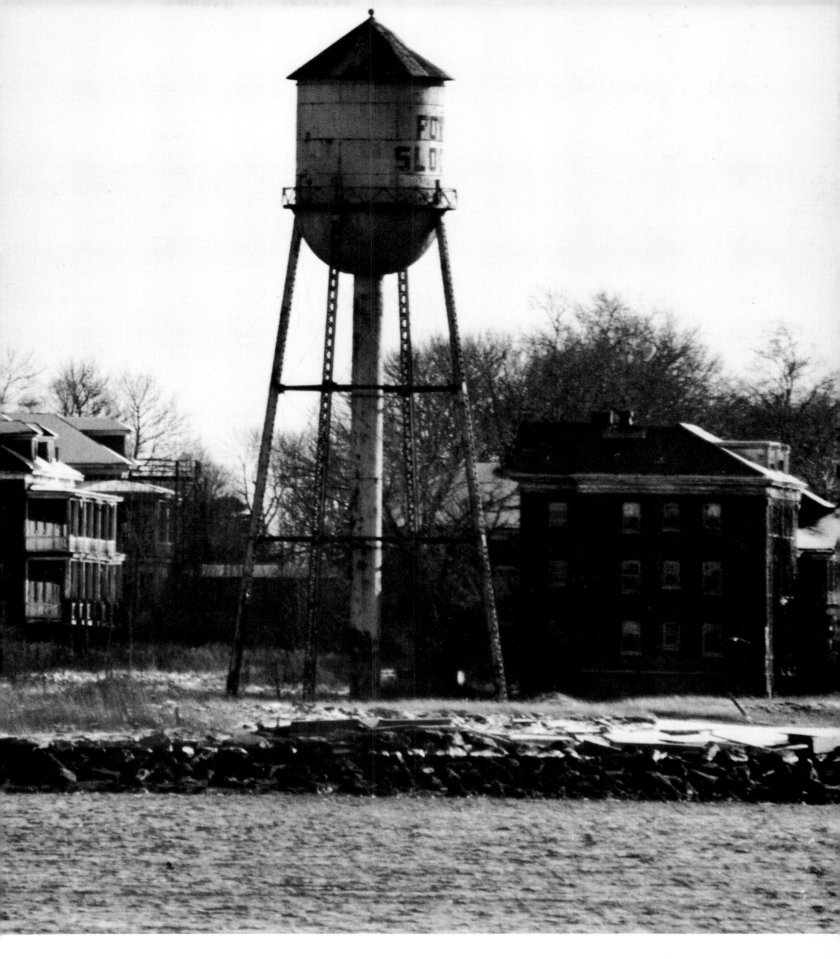

David's Island, located a
short distance off the shore
of New Rochelle, once
housed Fort Slocum.

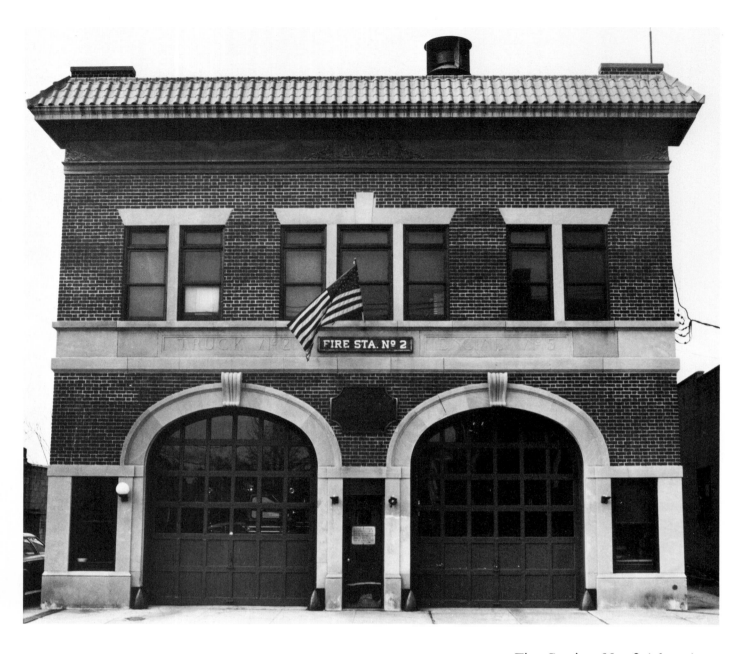

Fire Station No. 2 (above) on Webster Avenue near Union Avenue accommodates two 1000-gallon pumpers and a 100-foot aerial ladder truck together with a complement of professional fire fighters. The railroad, a division of Conrail, intersects North Avenue near the city center; a pedestrian trestle (right) connects with the station platform.

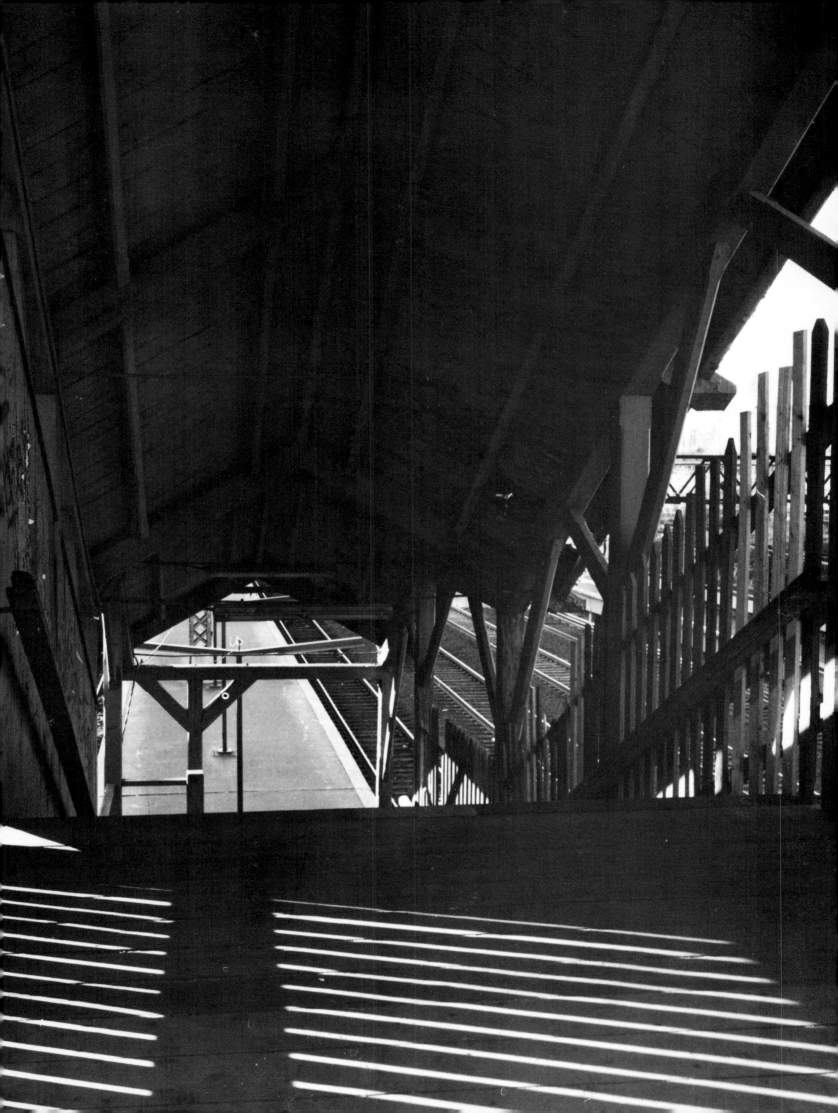

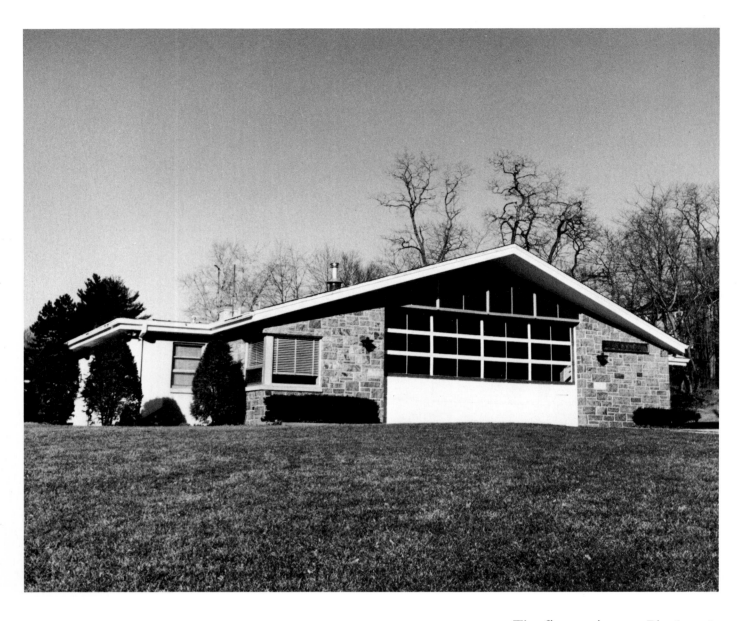

The fire station on Pinebrook Boulevard (above) was designed to blend in with the surrounding residential area. The newest fire station (right) is located near the Mall and houses the Emergency Services Department of the City of New Rochelle.

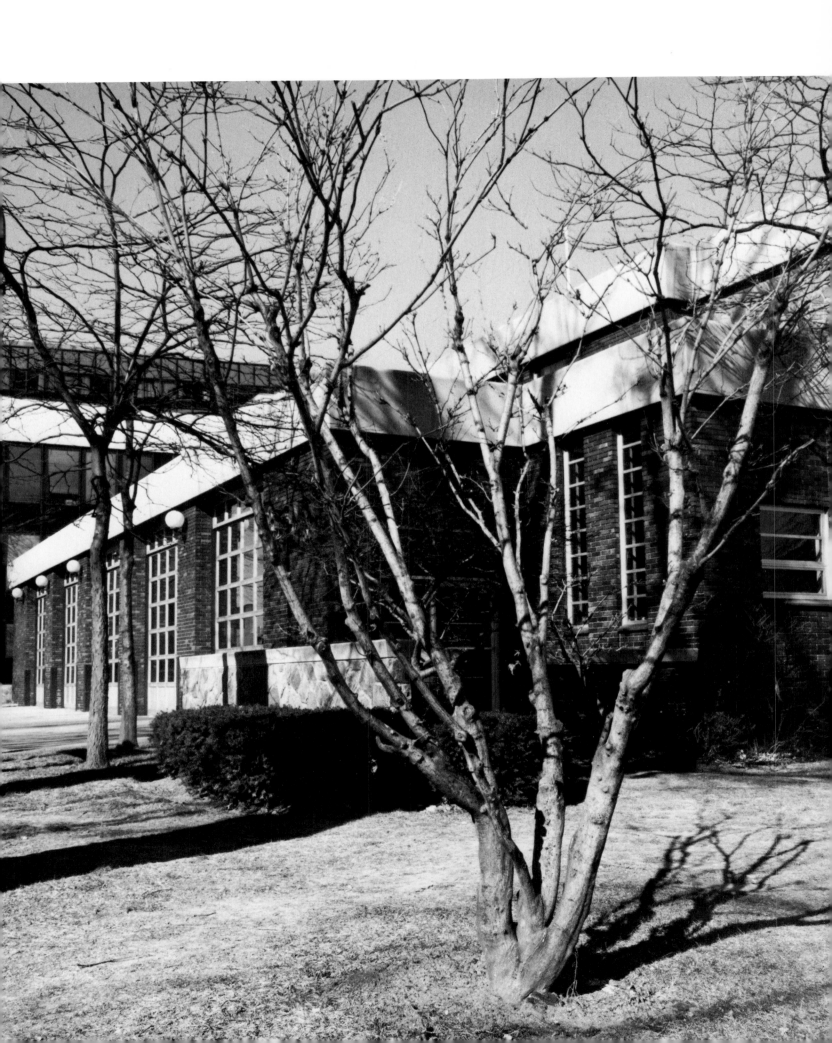

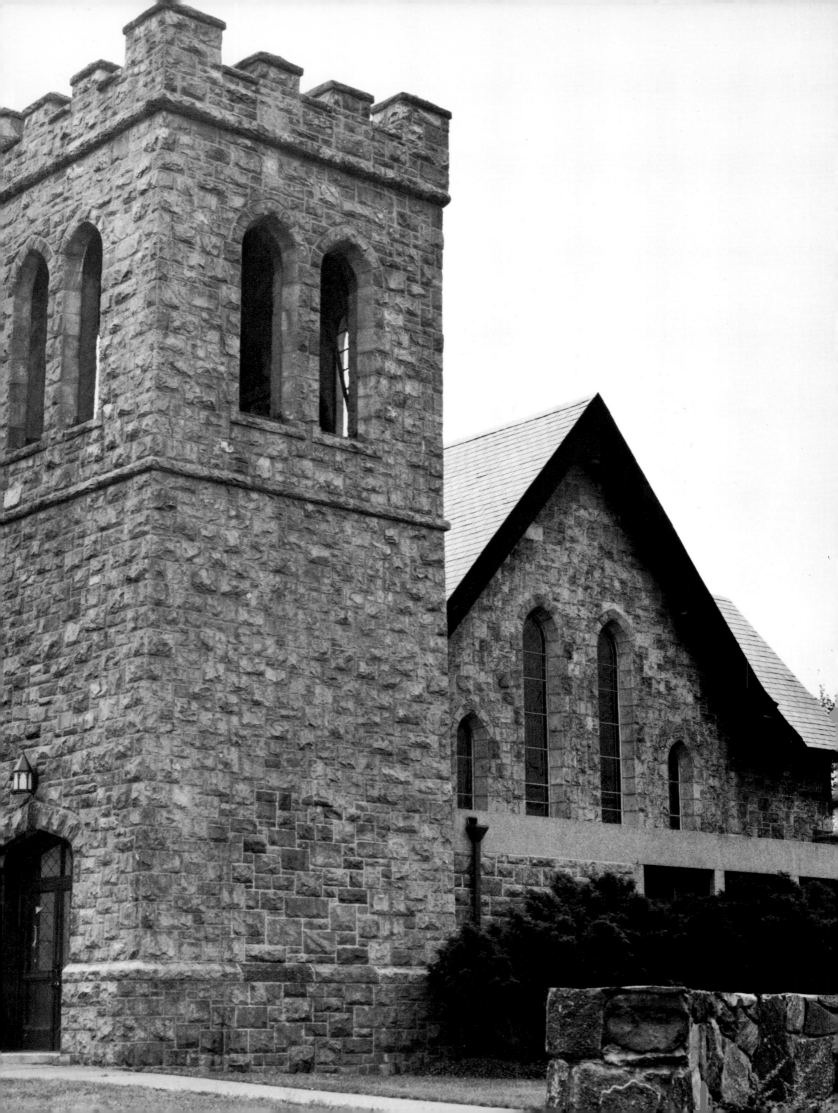

The former Presbyterian
Church on North Avenue is
now owned by the city. It
was the setting for the
famous North Avenue
irregulars.

Voluntary Sector

One of the great strengths of New Rochelle is the extensive and dynamic community activity stimulated by its many nonprofit organizations. A variety of institutions, centers, clubs, and associations provide outstanding services and programs for residents. The Wildcliff Craft Center (left), located in a rural setting in Ward Acres, organizes workshops and exhibitions in a variety of creative arts.

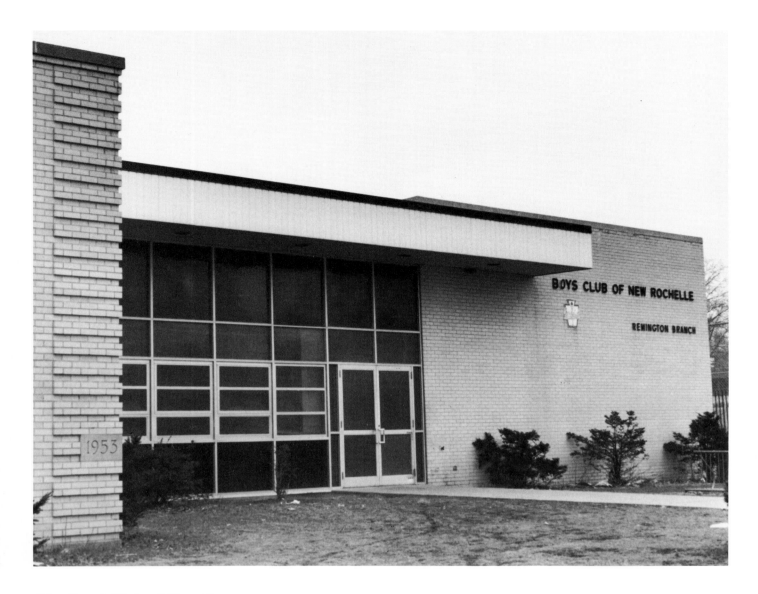

The Boys' Club of New Ro-
chelle, including the Rem-
ington Branch (above),
founded in 1929, opens its
doors to more than seven
hundred fifty neighborhood
boys. The New Rochelle Day
Nursery, one of the oldest
daycare facilities in the
City, was established in
1895. The imaginative sign
at its entrance (right) ex-
presses the brotherhood of
races that has marked New
Rochelle's history.

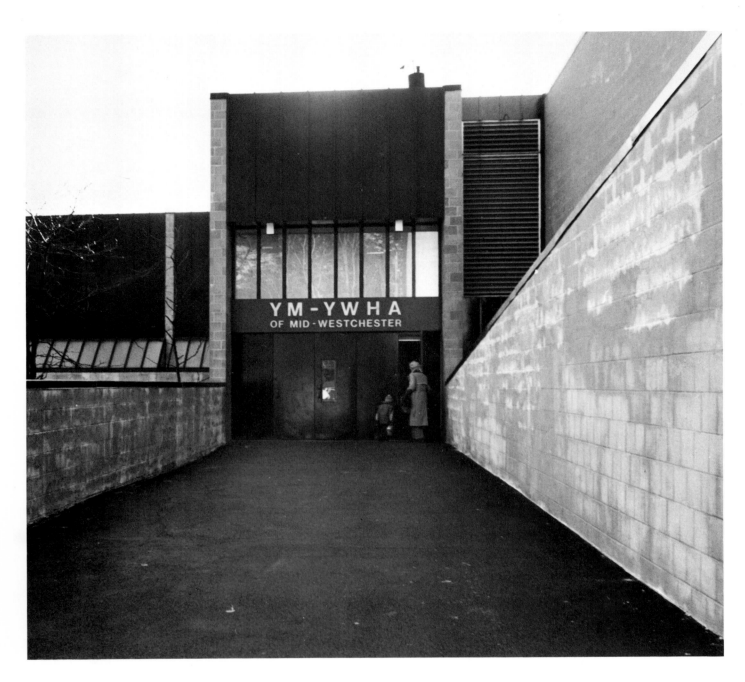

The YM-YWHA of Mid-
Westchester on Wilmot Road
in New Rochelle is a full-
service facility including
steam and sauna baths,
raquetball and squash courts,
and arts and crafts rooms.
The Y also offers an ex-
tensive program of activi-
ties and courses.

The New Rochelle YMCA
on Memorial Highway has a
fully equipped gymnasium,
pool, sauna, basketball
court, and other facilities.
It provides meeting space for
community organizations in-
cluding The United Way.

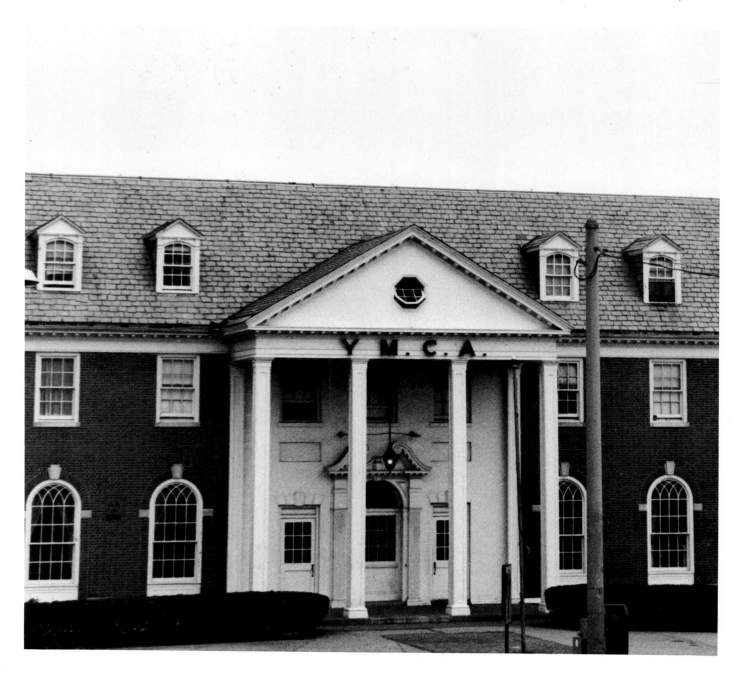

Wildcliff Museum is a non-
profit educational institution
concerned with promoting a
greater understanding of the
earth sciences through ex-
hibitions, lectures, audio-
visual techniques, and
student participation. The
building, in Hudson Park,
was designed by the early
American architect Alex-
ander Jefferson Davis.

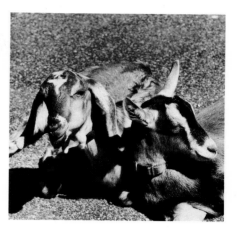

Children come from all over the community to play with the goats and geese and other animals in the Wildcliff Zoo.

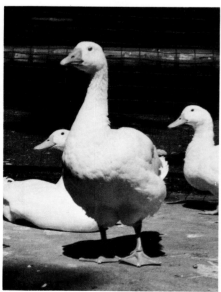

The American Legion Post
#8 (above), on North
Avenue, was built in 1950.
Any veteran of a wartime
period is eligible for mem-
bership. The New Rochelle
Armory (right) on Main
Street is used as a Marine
Corps and Naval Reserve
training facility.

The newly constructed August E. Mascaro branch of the Feeney Park Boys Club was dedicated in 1980. Replacing the older structure, the current building houses a complete gymnasium, an arts and crafts room, special activities rooms, a weight room, private showers, and a large dining area with two kitchens. The club offers many activities for senior citizens.

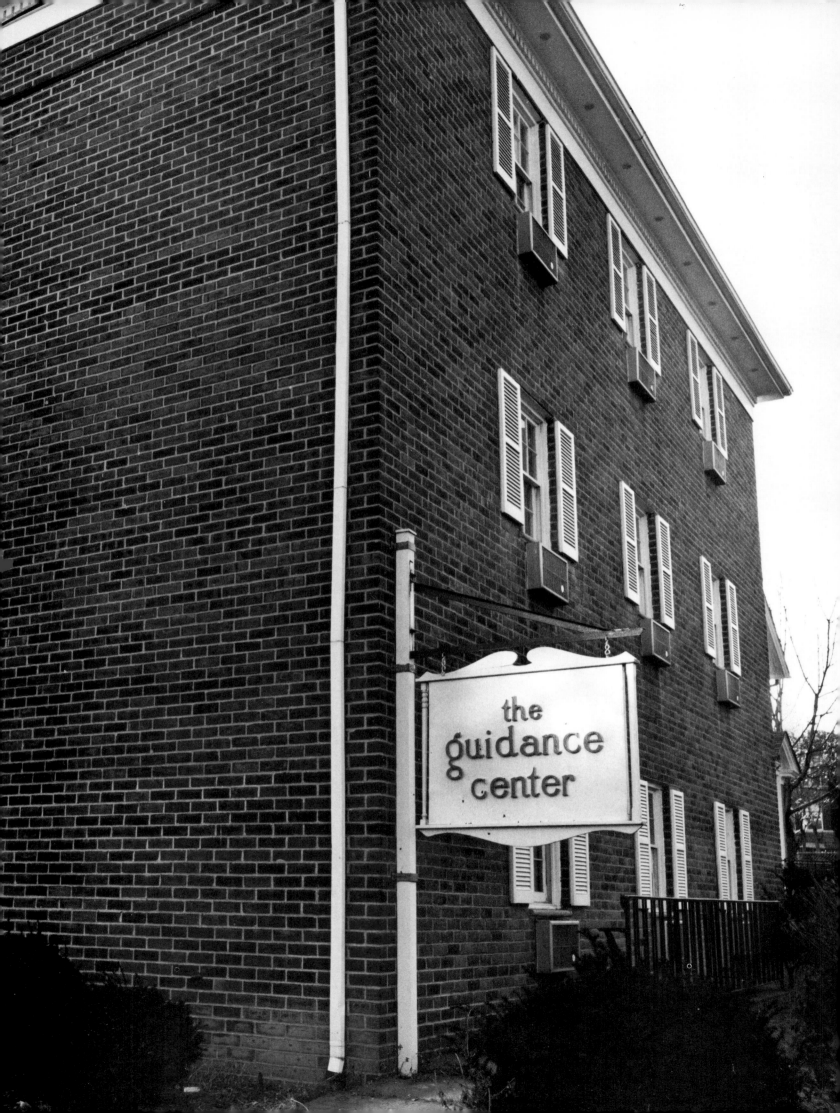

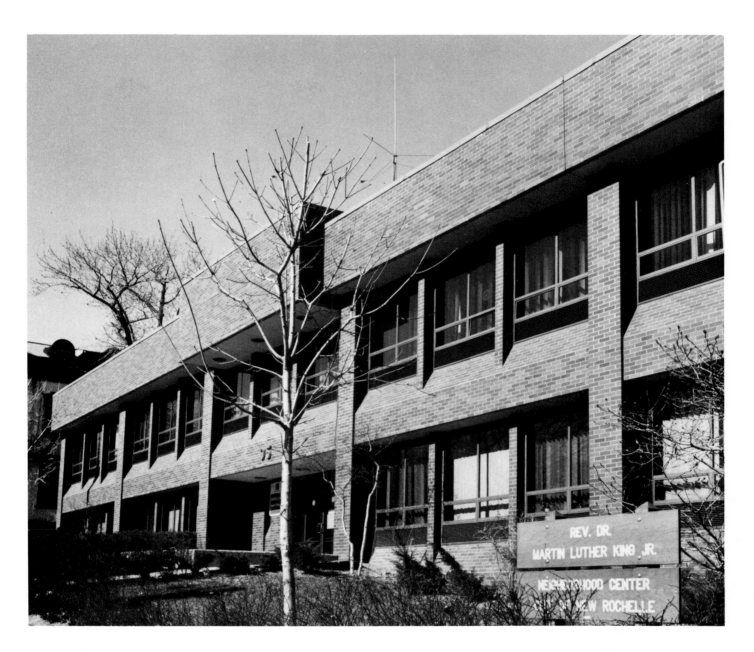

The Guidance Center (left)
on Grand Street has been
providing mental health care
since 1945. Its services in-
clude psychiatric therapy,
family counseling, drug
treatment, a day hospital,
and rehabilitation services.
The Center treats over twelve
thousand patients a year. The
Rev. Martin Luther King,
Jr. Neighborhood Center on
Lincoln Avenue (above),
which is owned by the city,
includes a child develop-
ment center, a health clinic,
a senior nutrition program,
a branch of the Guidance
Center, and legal aid services.

The Hugh A. Doyle Senior
Citizens Center on Davis
Avenue, which is owned by
the city, has been in ex-
istence since 1972. A new
addition, completed in 1979,
expanded the facilities to in-
clude game rooms and a
larger dining area. The
Center is run by the city
and provides senior citizens
with such activities as danc-
ing, bingo, arts and crafts.
The Doyle Center serves
more than eighty people
a day.

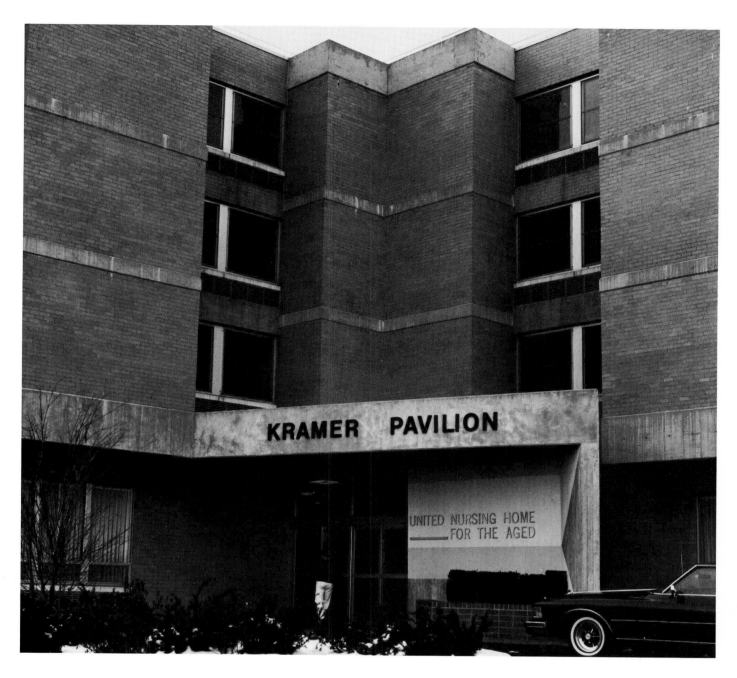

The United Home for Aged Hebrews on Pelham Road was first opened in 1919 and is today the second largest facility of its kind in Westchester County. It accommodates 272 patients and is nonsectarian.

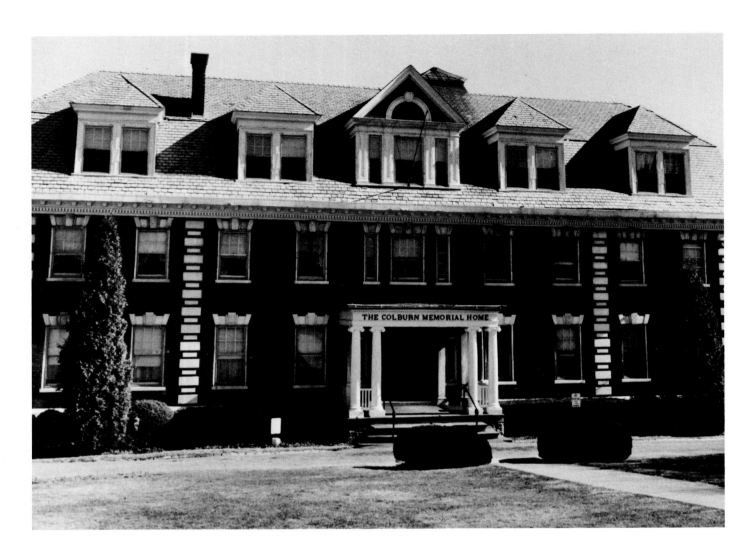

The Colburn Memorial
Home for the Aged (above)
on Clinton Avenue is open to
those senior citizens who are
ambulatory and mentally
alert. The home accommo-
dates thirty adults and
provides total medical care.
The Salvation Army (right)
has been in New Rochelle for
eighty years. The structure
formerly housed the Hugue-
not Trust Company.

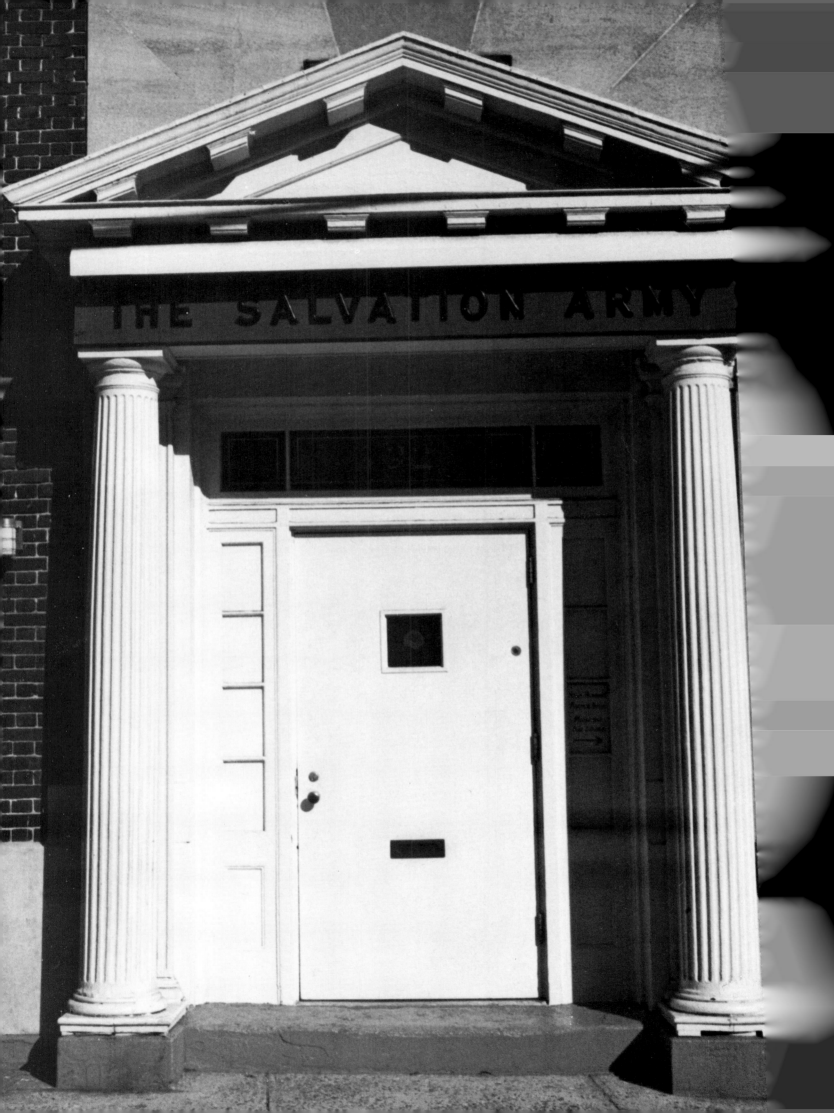

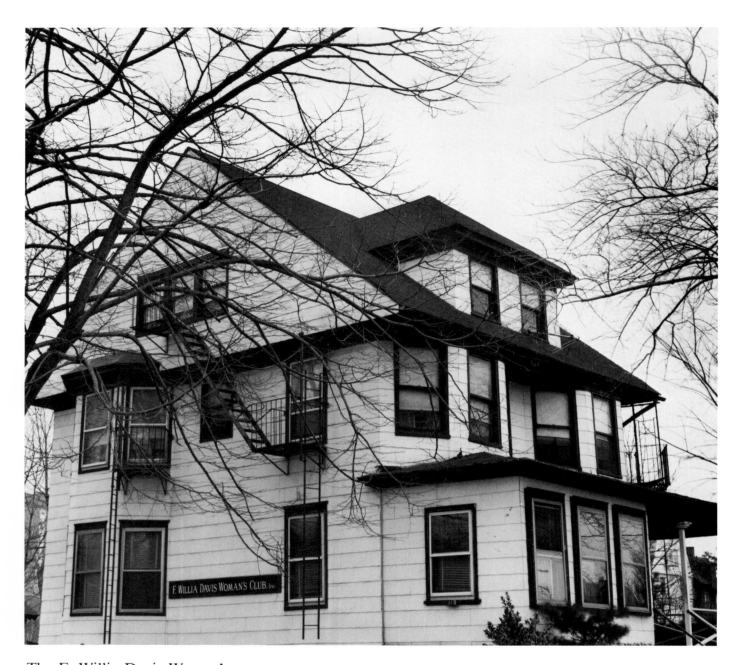

The F. Willia Davis Women's
Club (above), founded in
1909, was New Rochelle's
first black women's club. The
Calabria Mutual Aid Society
(right) on Union Avenue in
the West End of New
Rochelle was established
in 1937 by a group of
immigrants from Calabria,
Italy. For the last 43 years
the group has provided social
and financial support to the
Italian-Americans in the city.
With a membership of more
than four hundred, the So-
ciety is the largest mutual
aid society of its kind in
Westchester County. This
society is only one of many
serving the Italian-Amer-
ican community in New
Rochelle.

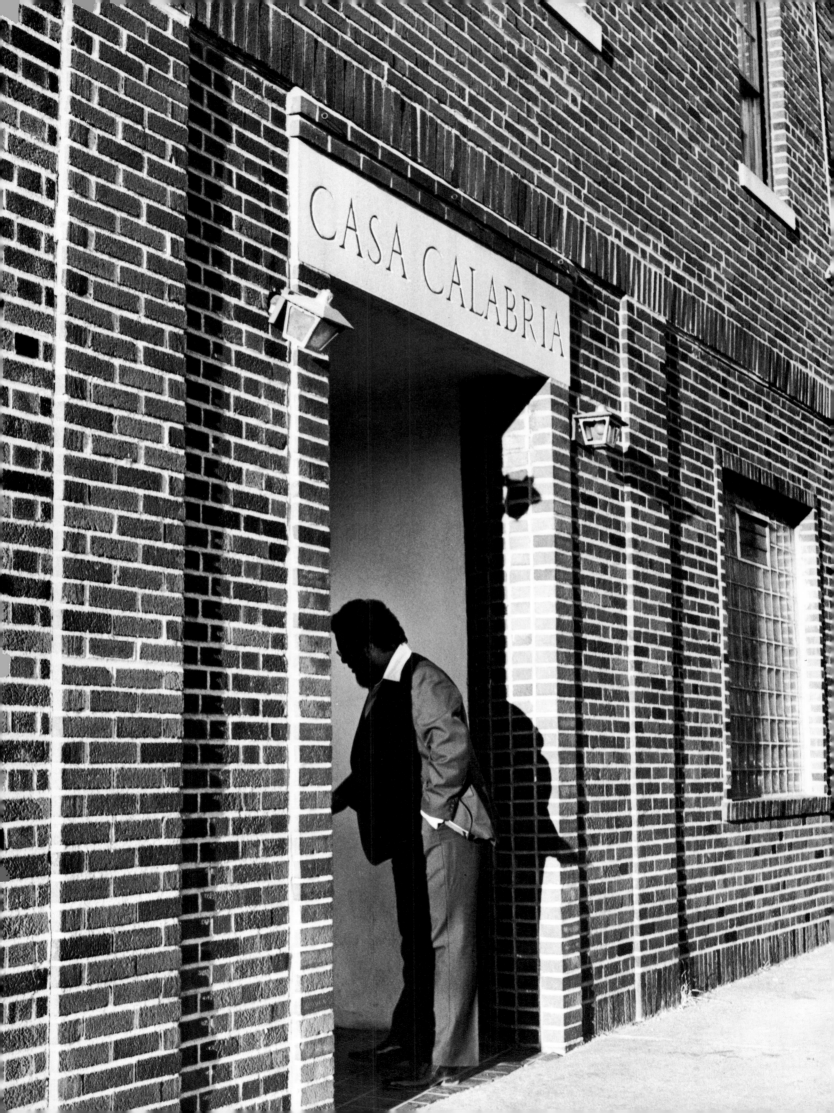

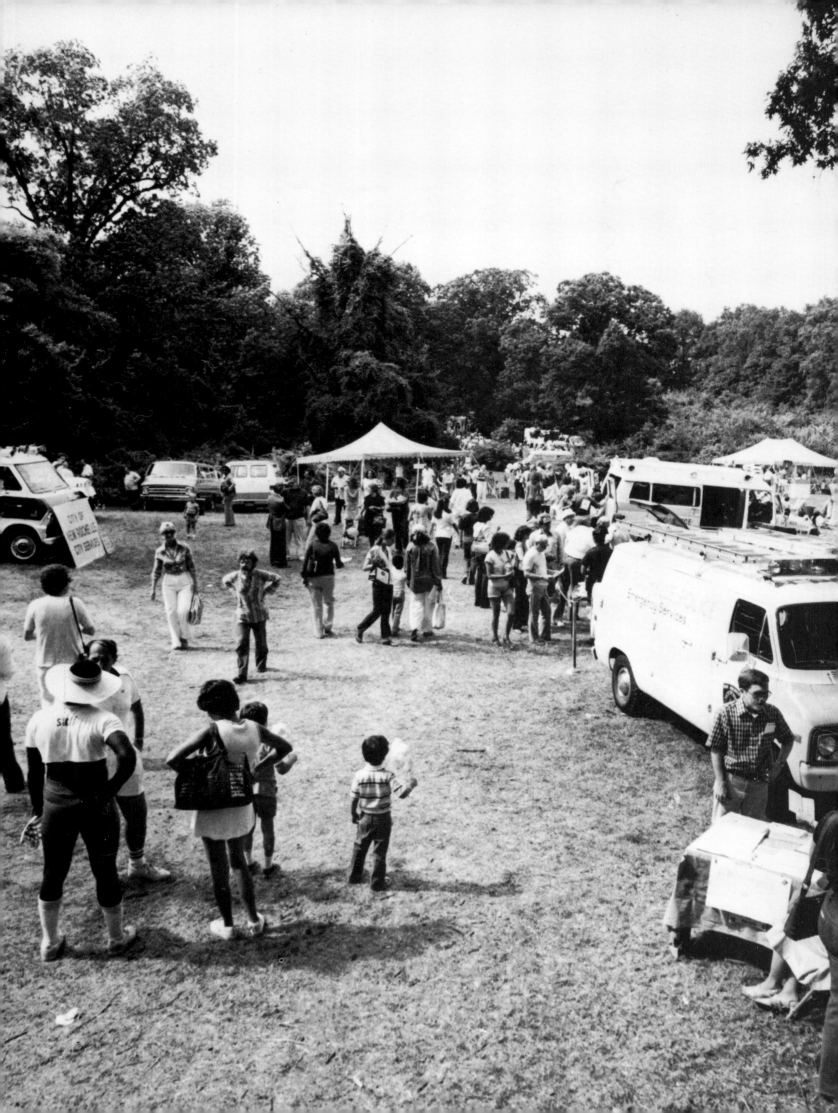

The New Rochelle Country Fair each year brings over forty thousand spectators. Live country music, square dancing, feats of strength, crafts, the Wildcliff Petting Zoo, and just "good old fashioned fun" characterize this yearly event at Ward Acres. (Photos by Charles Hammond)

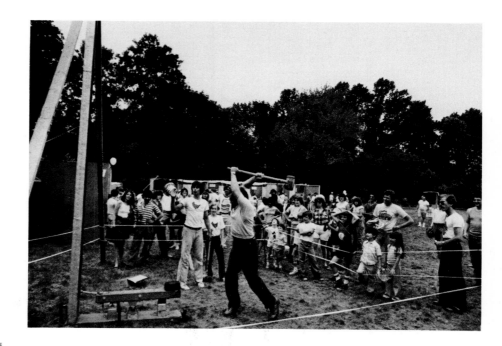

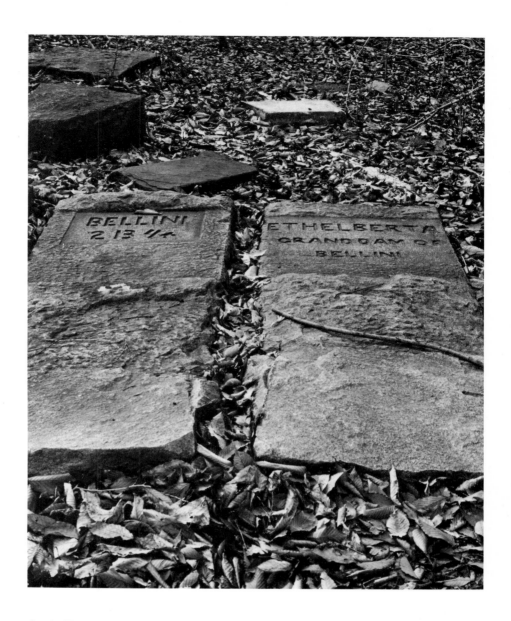

Jack Ward kept his prize show and harness racing horses in these handsome stables (left) now owned by the city and used for craft workshops and displays during the Country Fair.

The horse graveyard in Ward Acres (above) is the resting place of Jack Ward's famous thoroughbreds.

New Rochelle Hospital Medical Center (above), established in 1892, is a voluntary, not-for-profit, community institution serving the people of New Rochelle, the Pelhams, Larchmont, Mamaroneck, Eastchester, and Scarsdale. More than two hundred physicians, surgeons, and dentists comprise the high-quality professional staff who practice a wide variety of medical specialities at the Center, both in the acute care facility and the Extended Care Pavilion. A multi-million dollar expansion program will soon provide for the addition of a new south wing and renovation of the present plant.

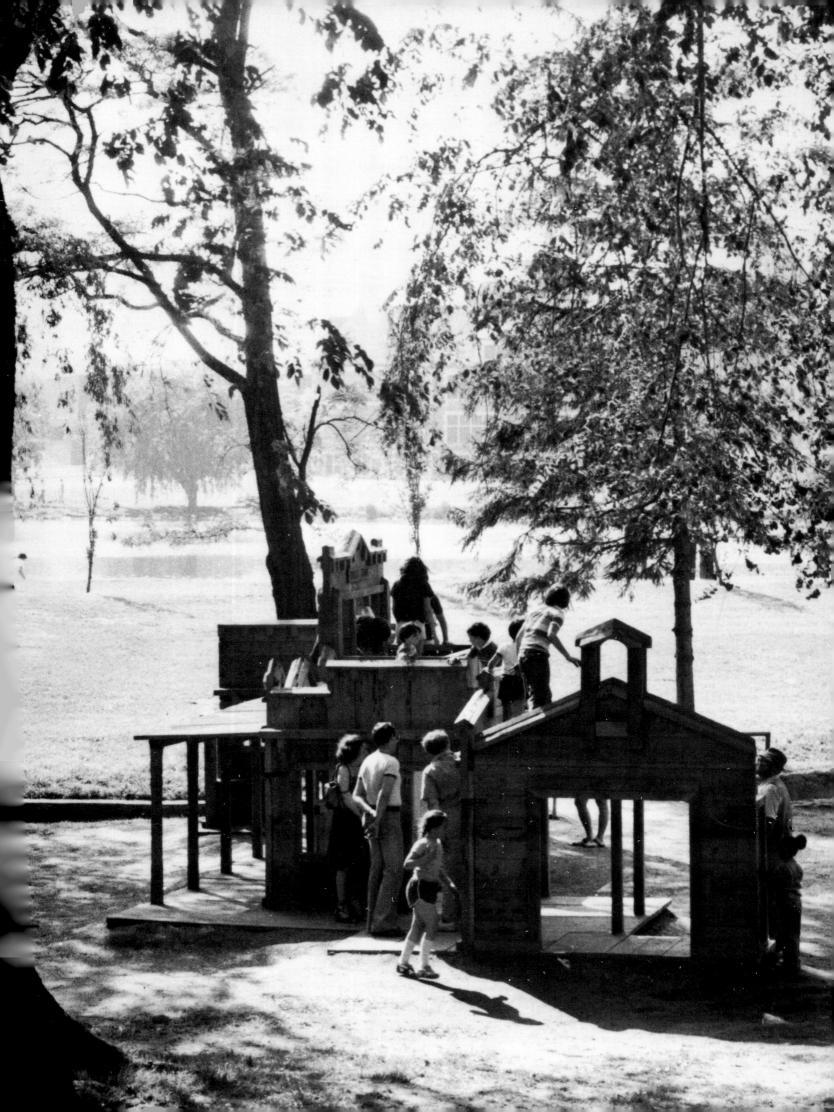

Playgrounds

New Rochelle's playgrounds are delightful areas set apart for children of all ages. Numerous playgrounds and "tot-lots" can be found all over the city. Many feature imaginative structures like the "Old Frontier Town" (left) in Huguenot Park in front of the high school.

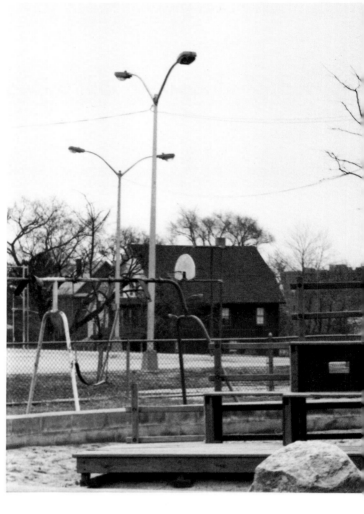

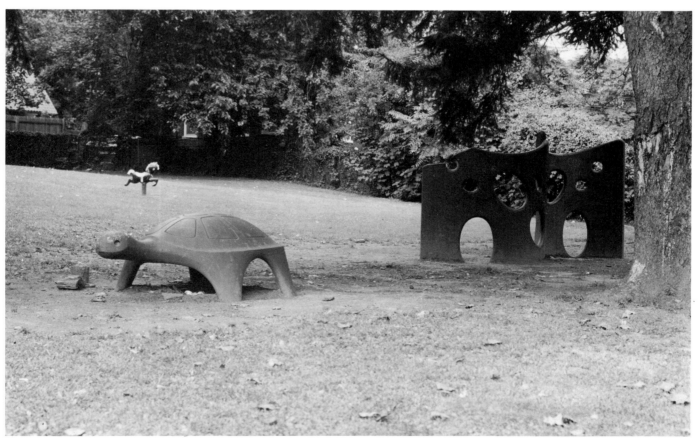

Eddie Foy Park (left), located at the foot of Neptune Avenue at Pelham Road, was the gift of the famous Foy family which, headed by the father, Eddie, topped vaudeville bills throughout the nation early in the century. The Foys were residents of New Rochelle for many years. Lincoln Avenue playground (above) awaits warmer weather to attract its patrons.

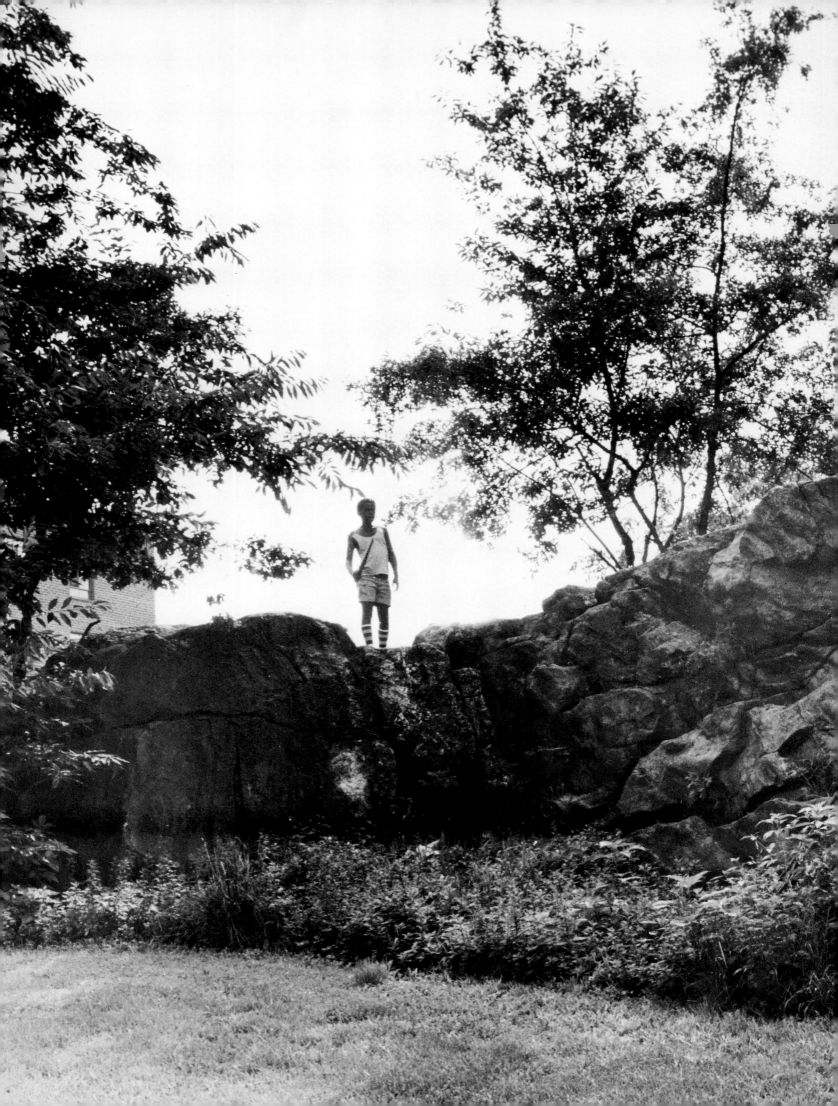

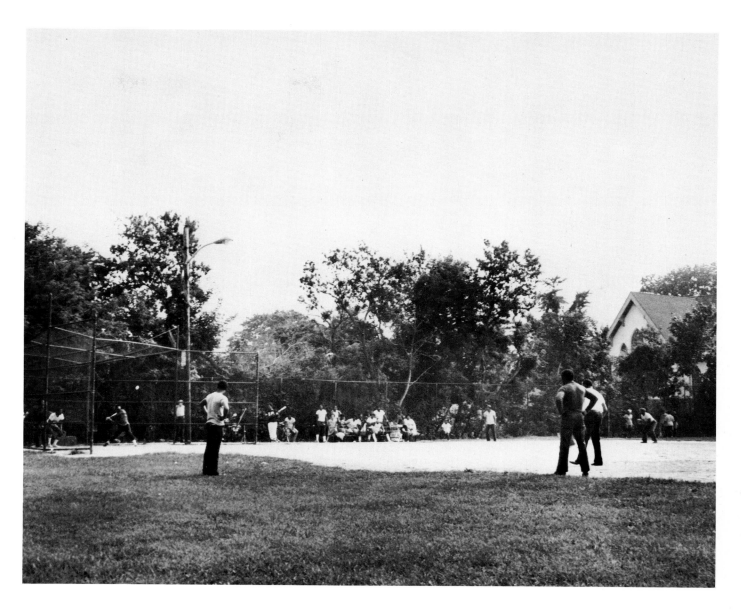

A lively game of softball is in
progress in the park at
Lincoln Avenue (above). The
park was once the site of
Lincoln Elementary School.
Rock outcroppings at Horton
Avenue and Brook Street
(left) are an invitation for
youngsters to go exploring in
the world of fantasy.

Schools

New Rochelle has one of the finest and most extensive educational systems in Westchester County, including an excellent public high school, two junior high schools, ten elementary schools, and many private and parochial schools. St. Gabriel's High School for girls (left) on Washington Avenue is directed by the Sisters of Charity.

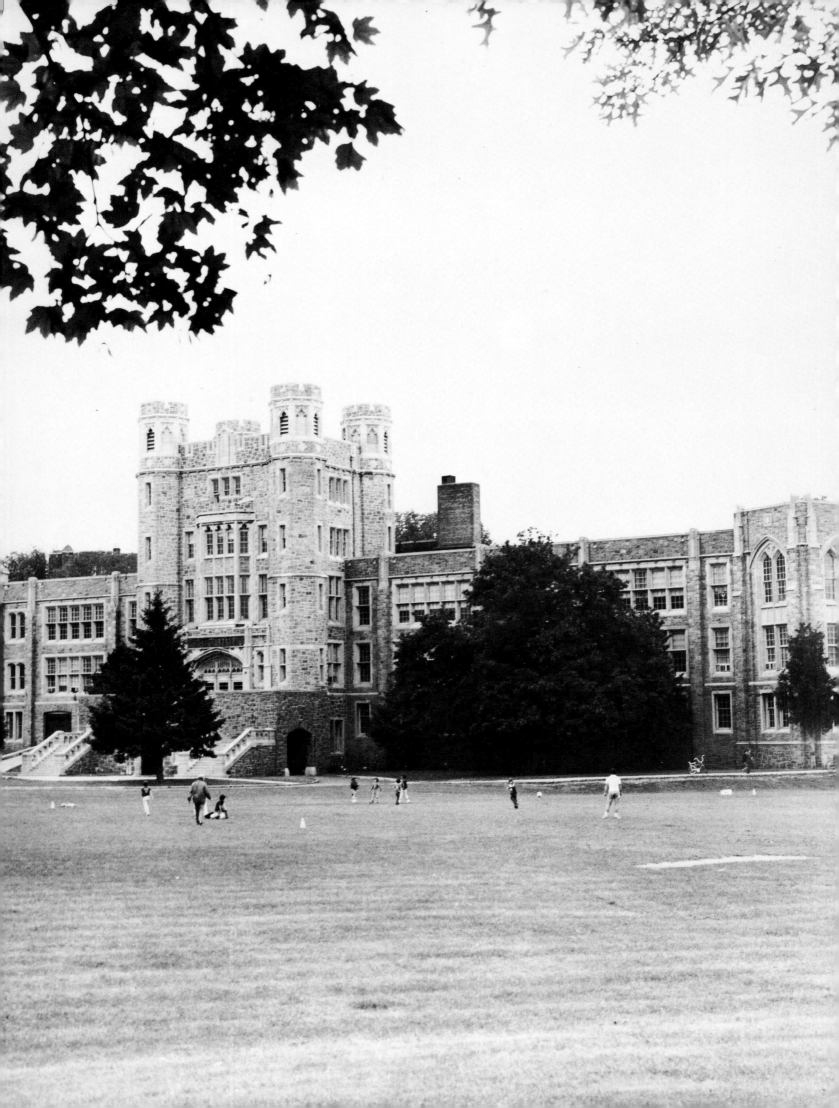

Isaac E. Young Junior High School on Pelham Road (left) was modeled after a building at Princeton University. It is considered by many to be one of the most beautiful buildings in the county. The school was named after the city's first superintendent of schools. Albert Leonard Junior High School (right) is a contemporary building serving students in the north end of the city.

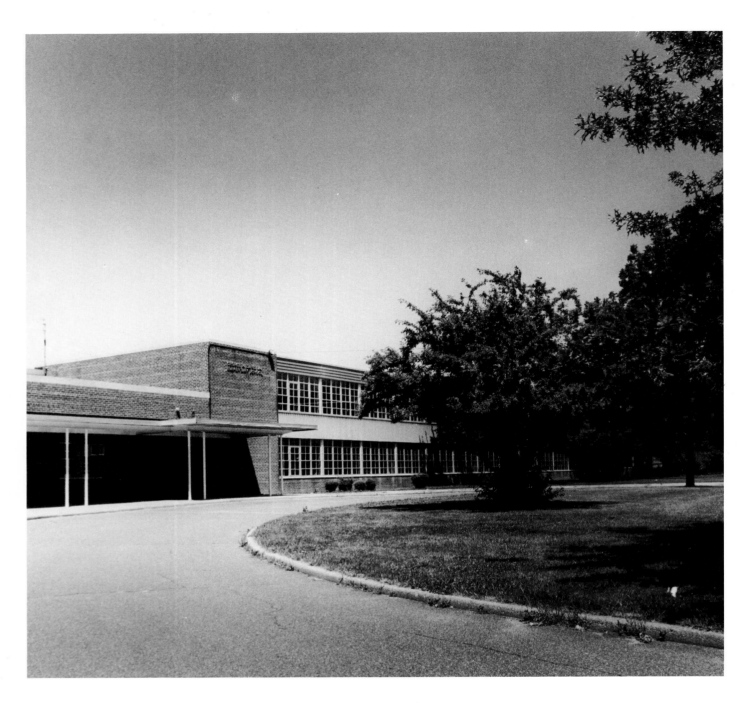

The George M. Davis, Jr.
Elementary School is located
on Iselin Drive on spacious
grounds in a beautiful resi-
dential area in the northern-
most section of New
Rochelle.

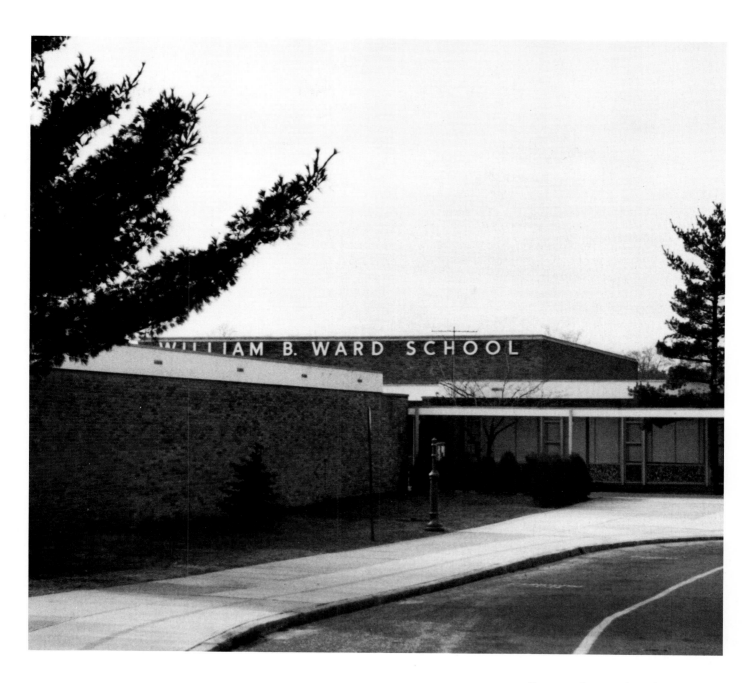

Located near lovely rolling fields of Ward Acres is William B. Ward Elementary School on Broadfield Road.

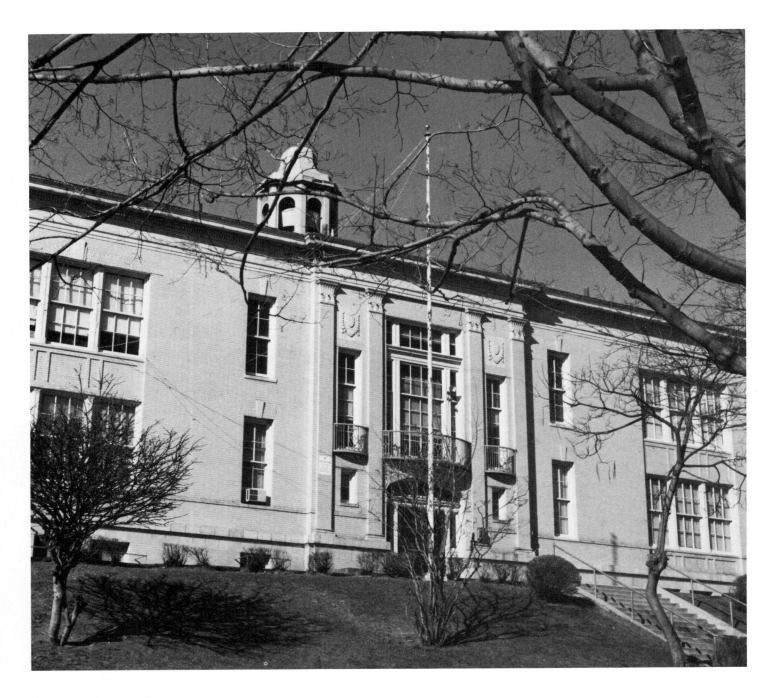

The Stephenson Elementary
School (left), New Rochelle's
smallest public elementary
school as well as its second
oldest, serves the east end
residential area. The Daniel
Webster Elementary School
(right), on Glenmore Drive,
is acclaimed for the beauty
of its Norman-Tudor
architecture.

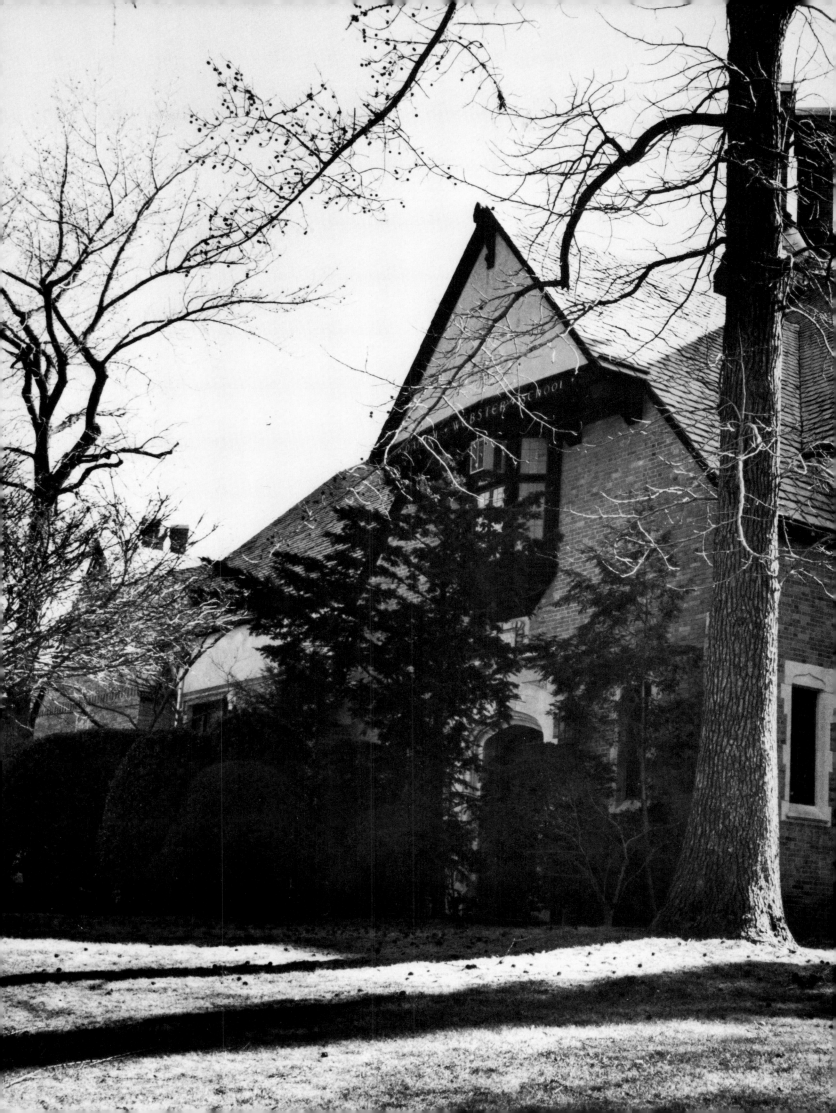

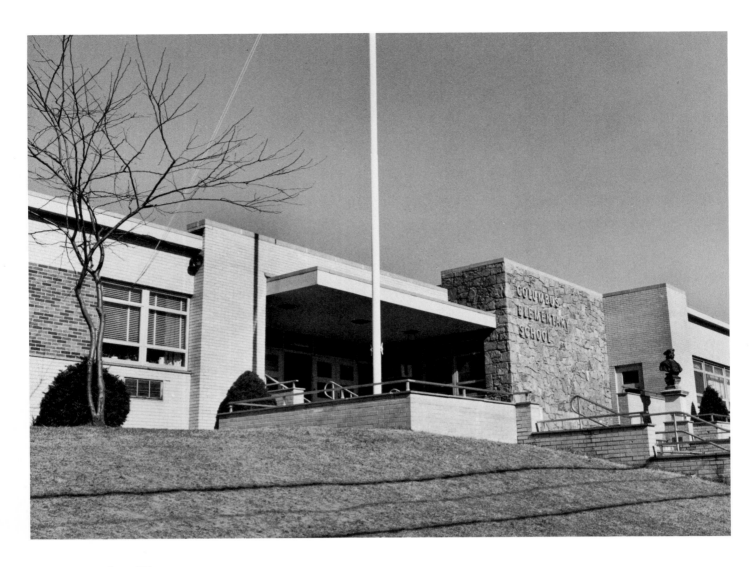

The Columbus Elementary
School (above), with its bust
of Christopher Columbus in
front of its entranceway, is a
contemporary building in the
west end of the City. Roose-
velt Elementary School
(right) is on North Avenue
in the Wykagyl Park area.

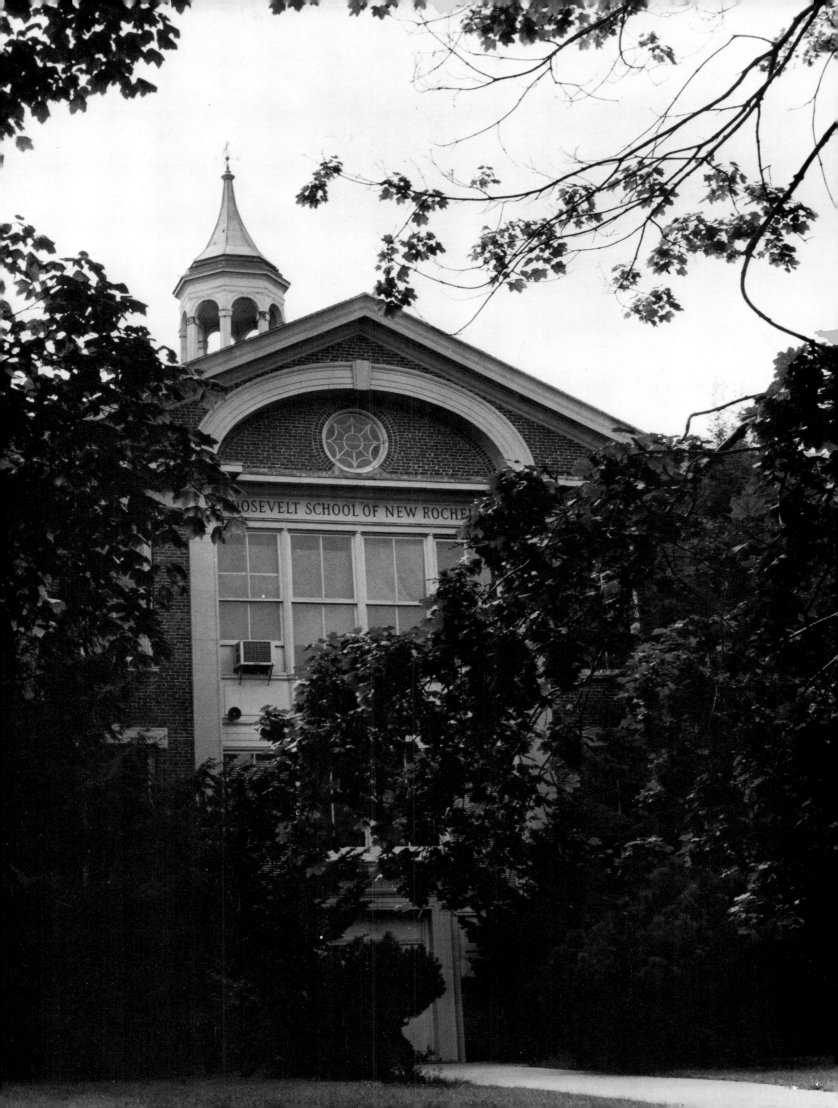

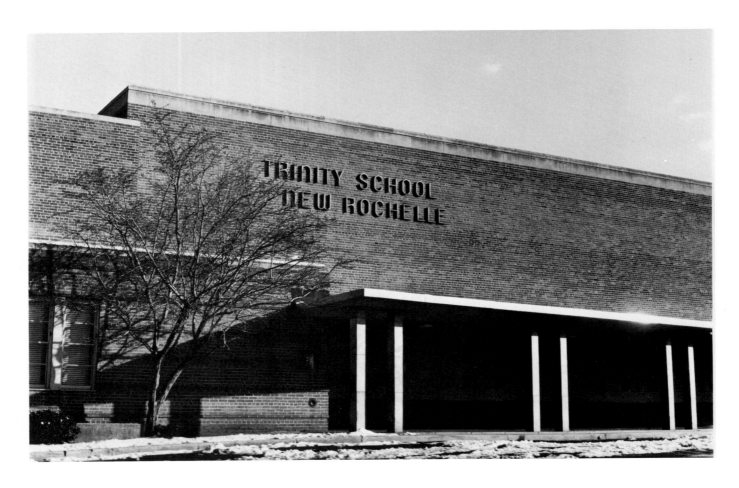

The Trinity Elementary
School on Pelham Road
(above) was named after the
old brick school built on
Trinity Place in 1855-56.
The Mayflower Elementary
School (right) is located in
the center of New Rochelle.

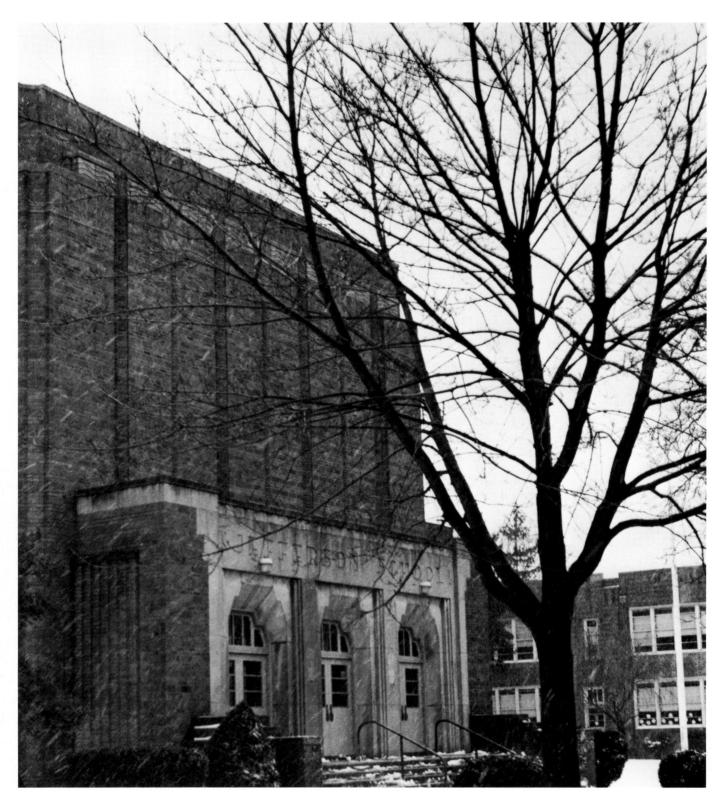

Situated in the shore section of southernmost New Rochelle, the imposing Jefferson Elementary School (above) can be seen amidst a mid-winter snowfall. Of modified English Tudor design, Henry Barnard School (right) seems especially suited to its woodland setting near Beechmont Lake.

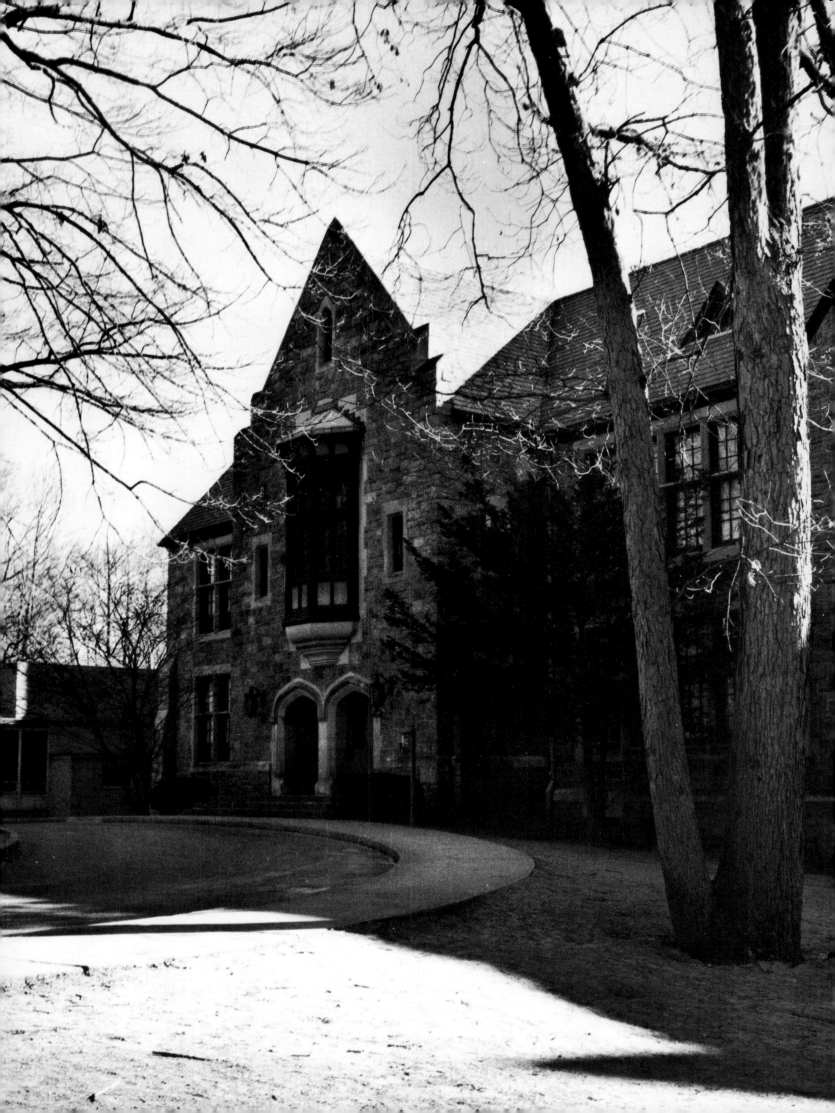

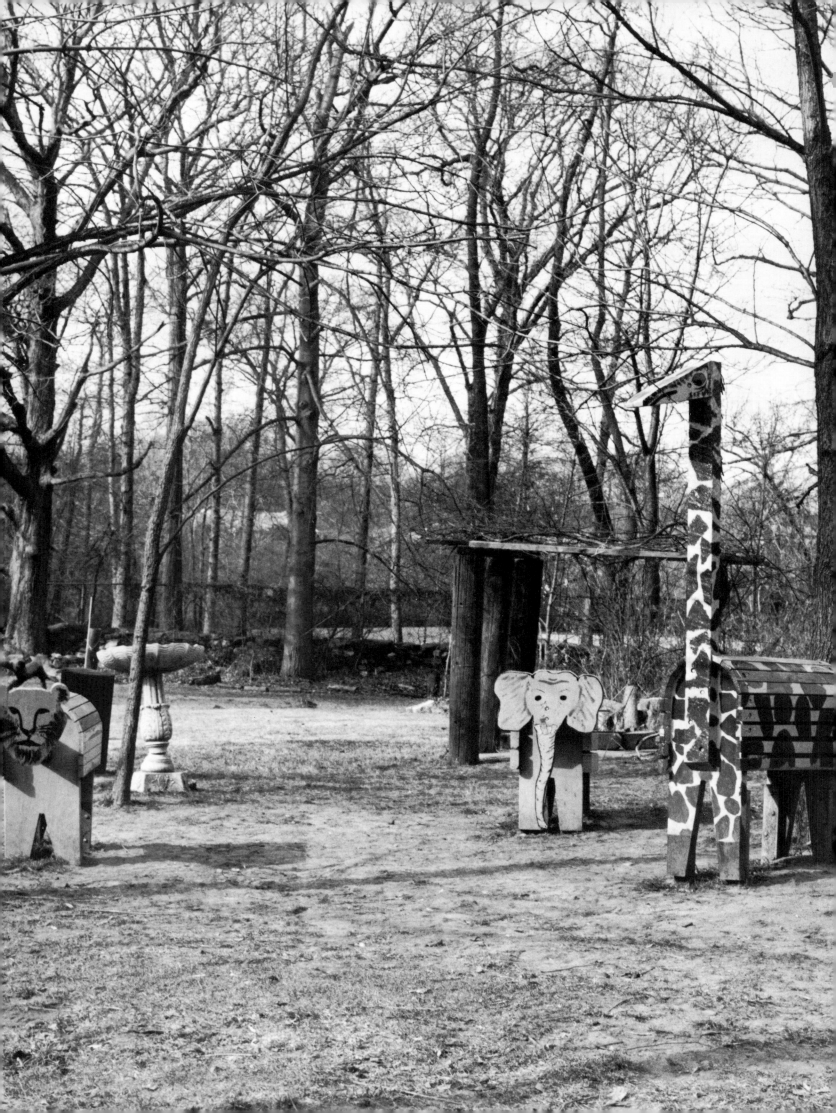

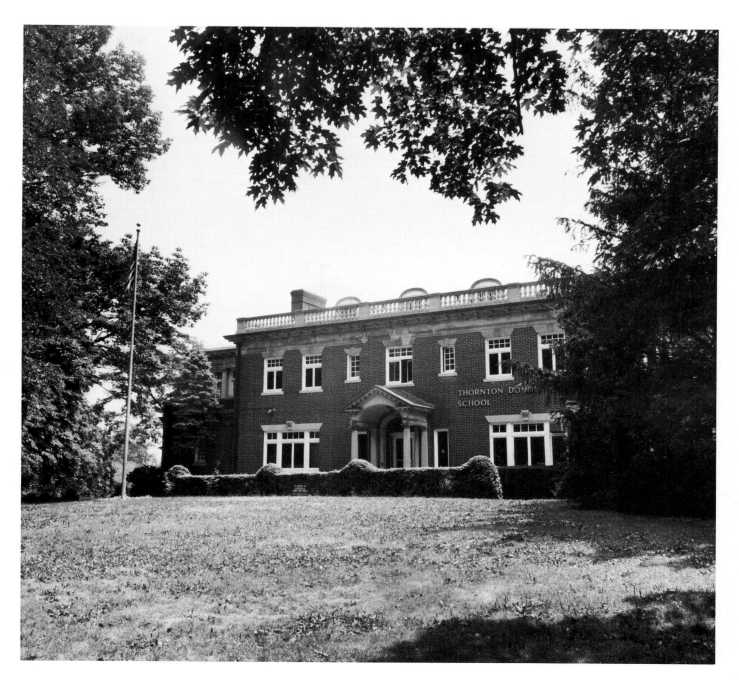

An imaginative playground (left) is one of the many creative features of the outstanding Hudson Country School on Quaker Ridge Road. Thornton Donovan School (above), opened in 1901, is the oldest private school in New Rochelle.

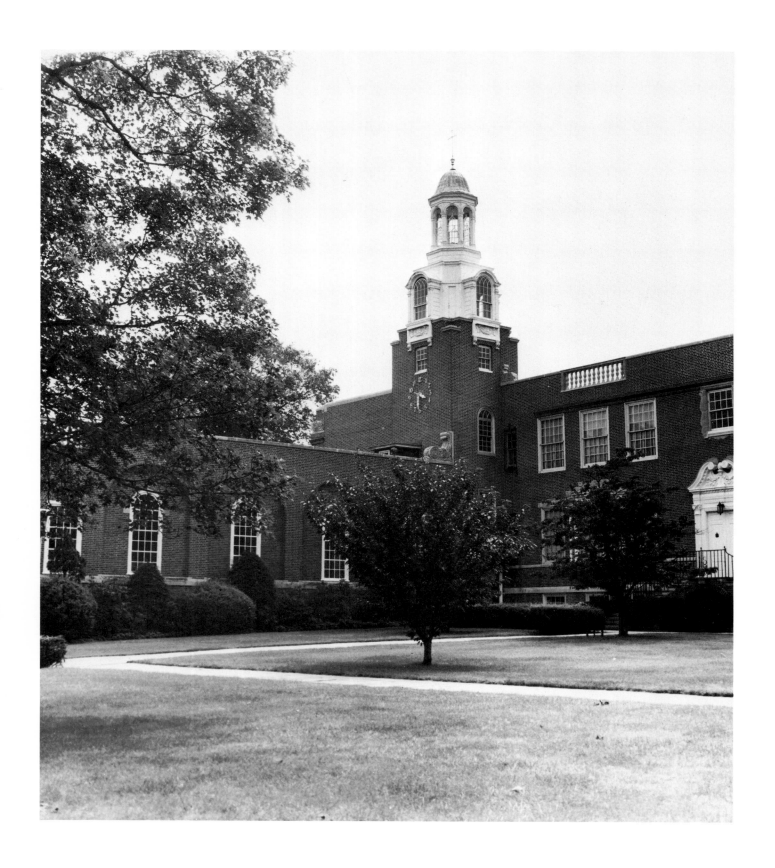

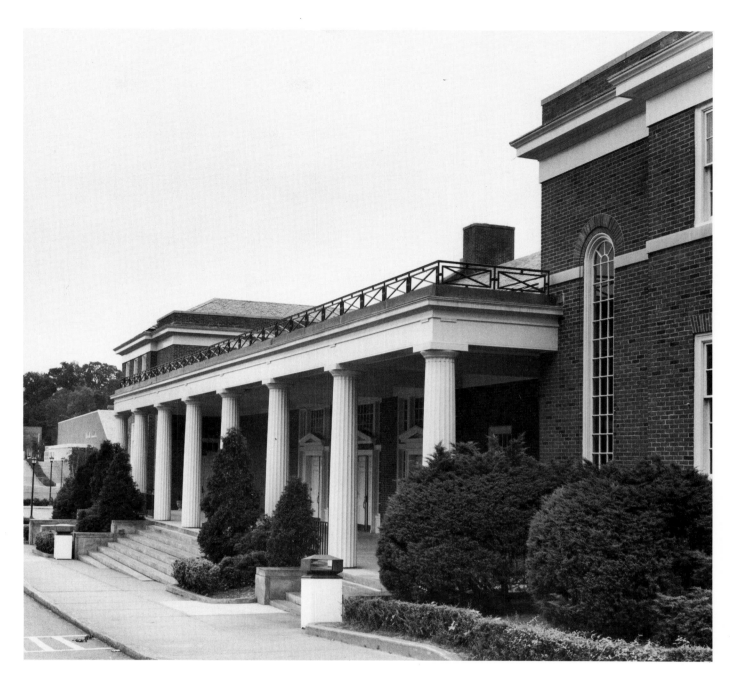

Spellman Hall (above) is part of Iona College's campus on North Avenue. Iona, an independent institution founded in 1940, offers a variety of courses to it's 6,000 undergraduate and graduate students. The Ursuline School for young women (left) is situated on North Avenue near the Hutchinson River Parkway. It was founded by the Sisters of St. Ursula.

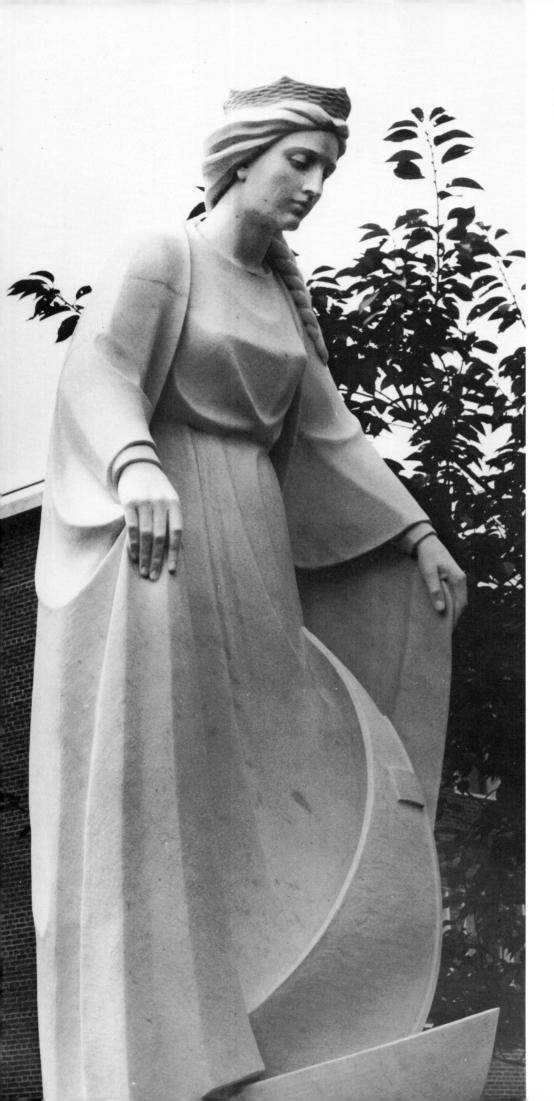

A statue of St. Ursula presides over the lawn at Ursuline Academy.

A statue of Saint Columba, founder of the Christian Brothers of Ireland, stands on the campus of Iona College.

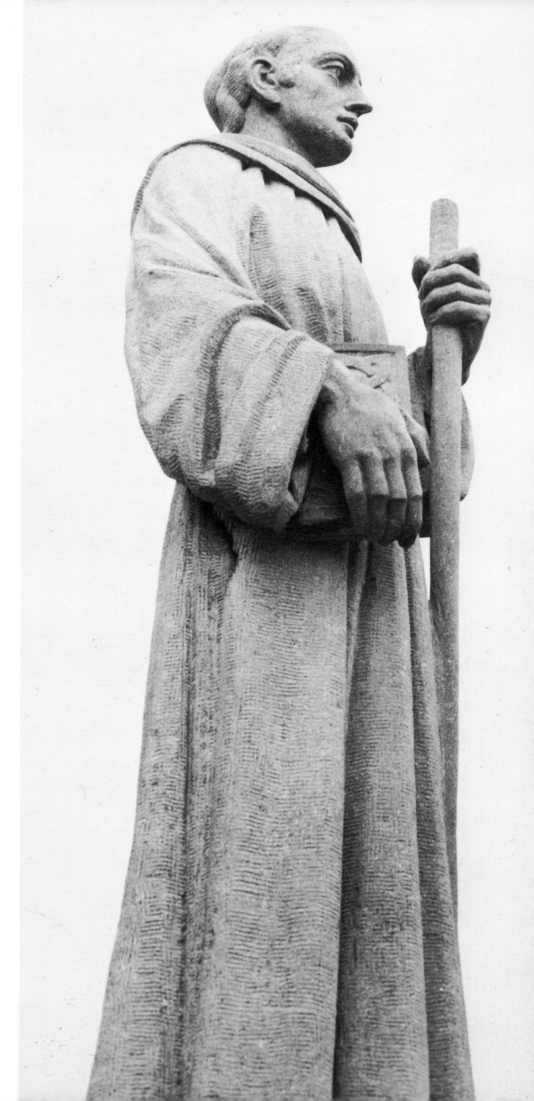

Page 177: Azaleas in full
bloom in front of the Twin
Lakes.

Page 178: New Rochelle
High School is a hand-
some building that can
be seen across the Twin
Lakes on North Avenue.
Built in 1926, the school
survived a major fire in the
1960s and has been expanded
several times. It was fash-
ioned after a French chateau.

Page 179: St. Paul's Episco-
pal Church on Mayflower
Avenue rises above the
spring foliage.

Page 180: St. Luke's United
Methodist Church, a simple
New England structure, is
located on Guion Place.

Page 181: Christ United
Methodist Church, on North
Avenue is a handsome
modern structure with a
soaring spire and sloping
curved roof. Its old ceme-
tery is an historic land-
mark of New Rochelle.

Page 182: The sunset casts a
purple glow on the snow-
covered Huguenot Park.

Page 183: The beautiful
bell-tower of the Church
of the Holy Family is seen
at a distance against the
blue winter sky.

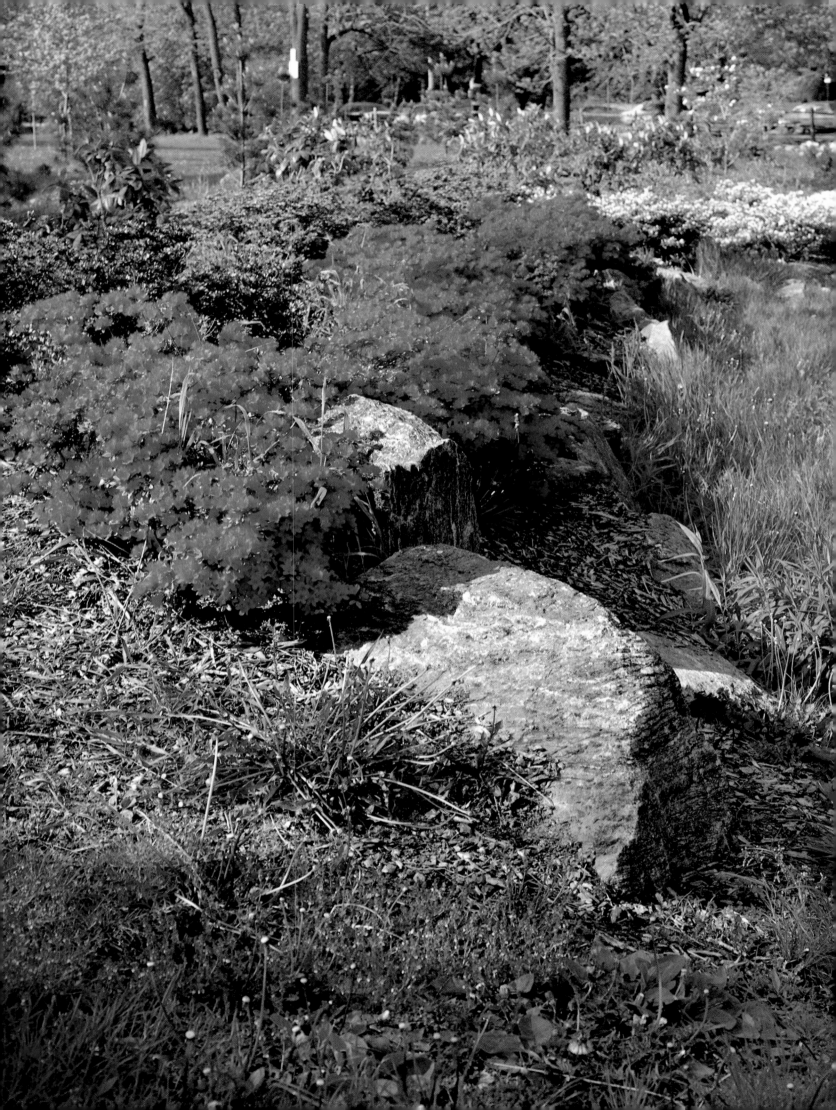

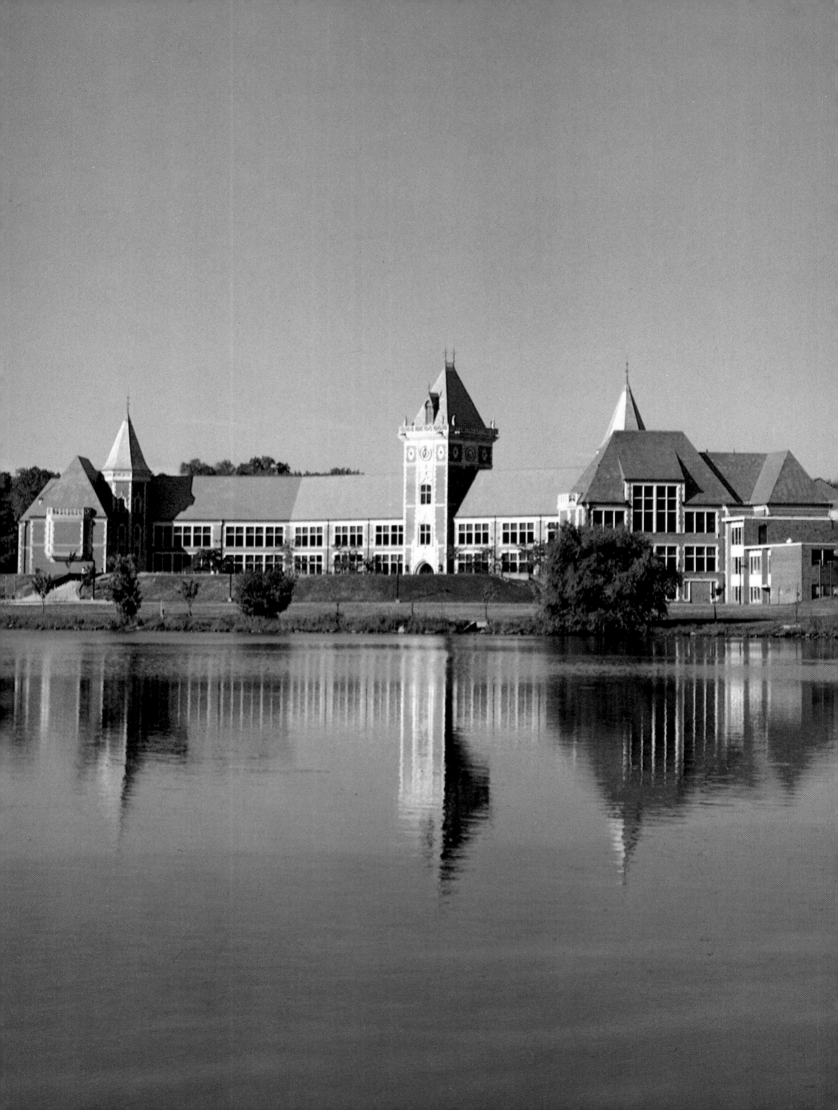

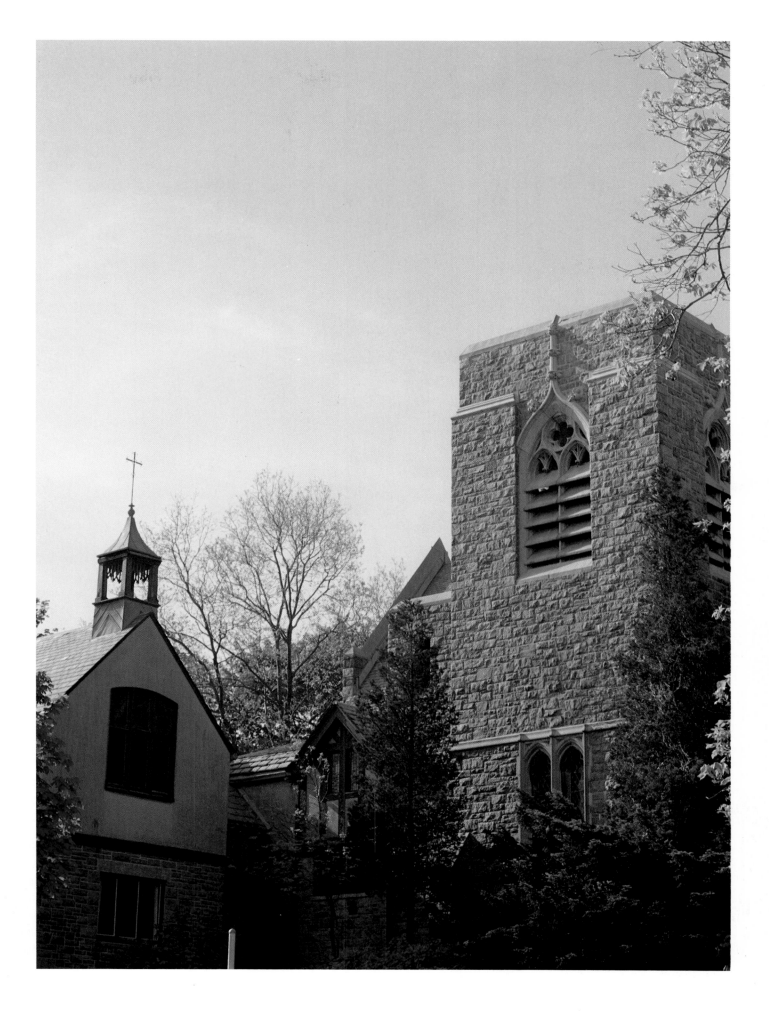

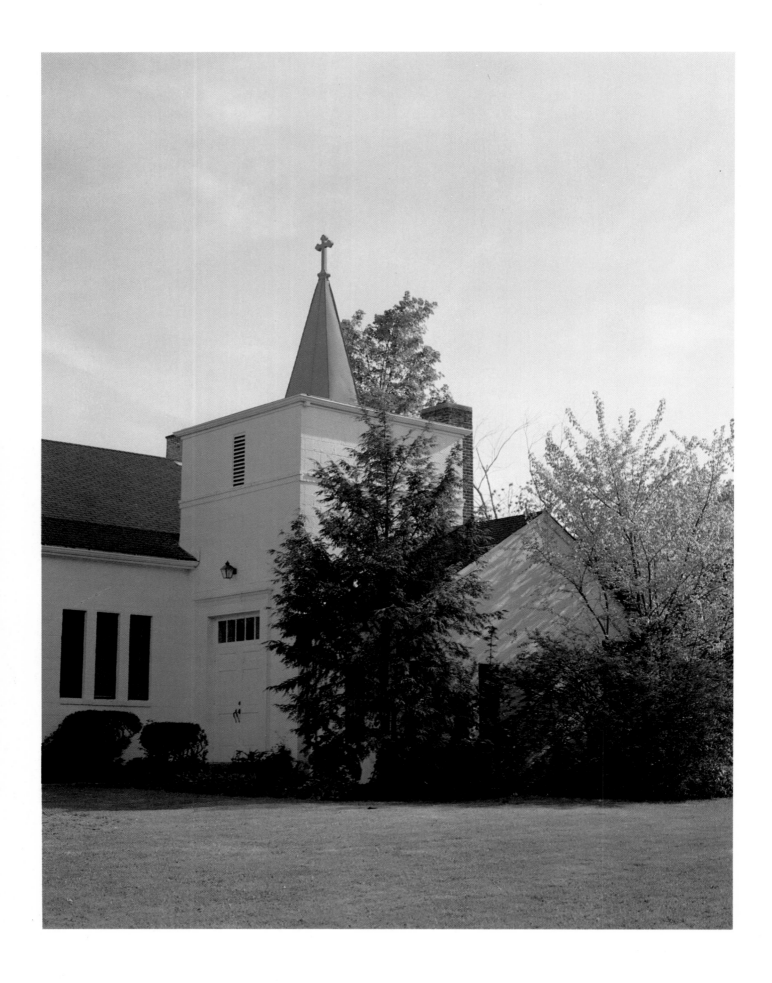

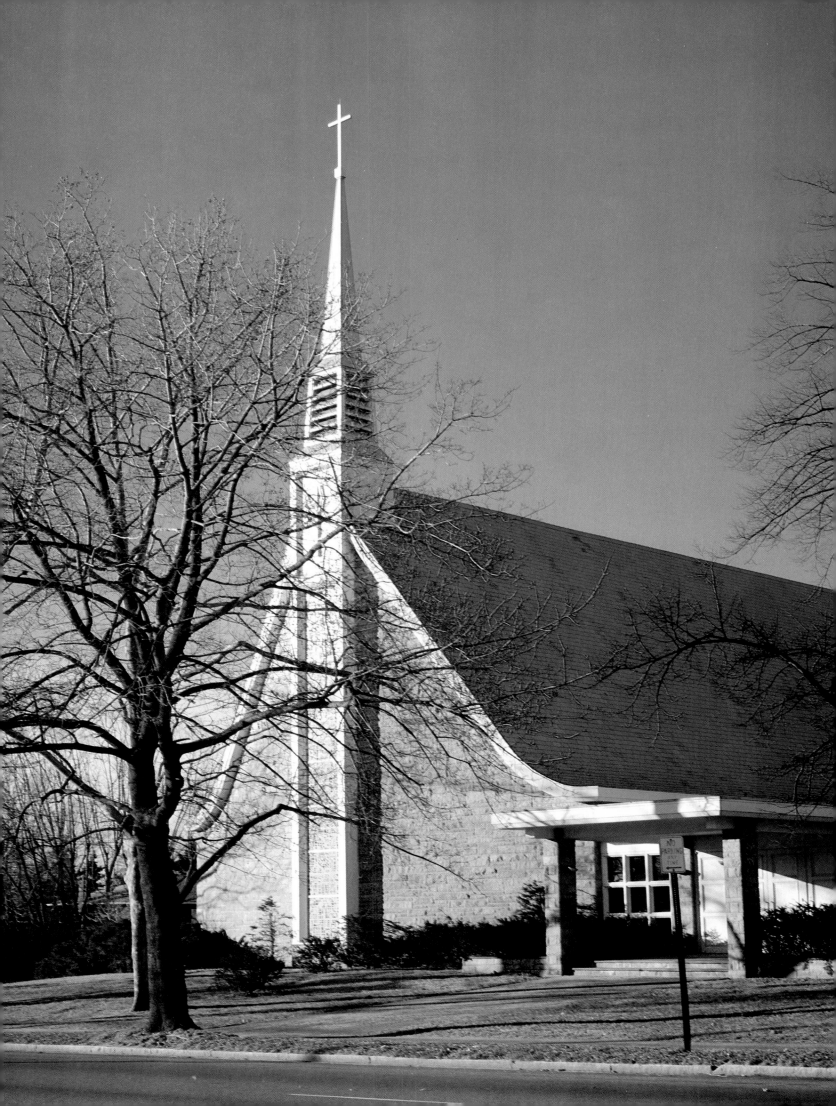

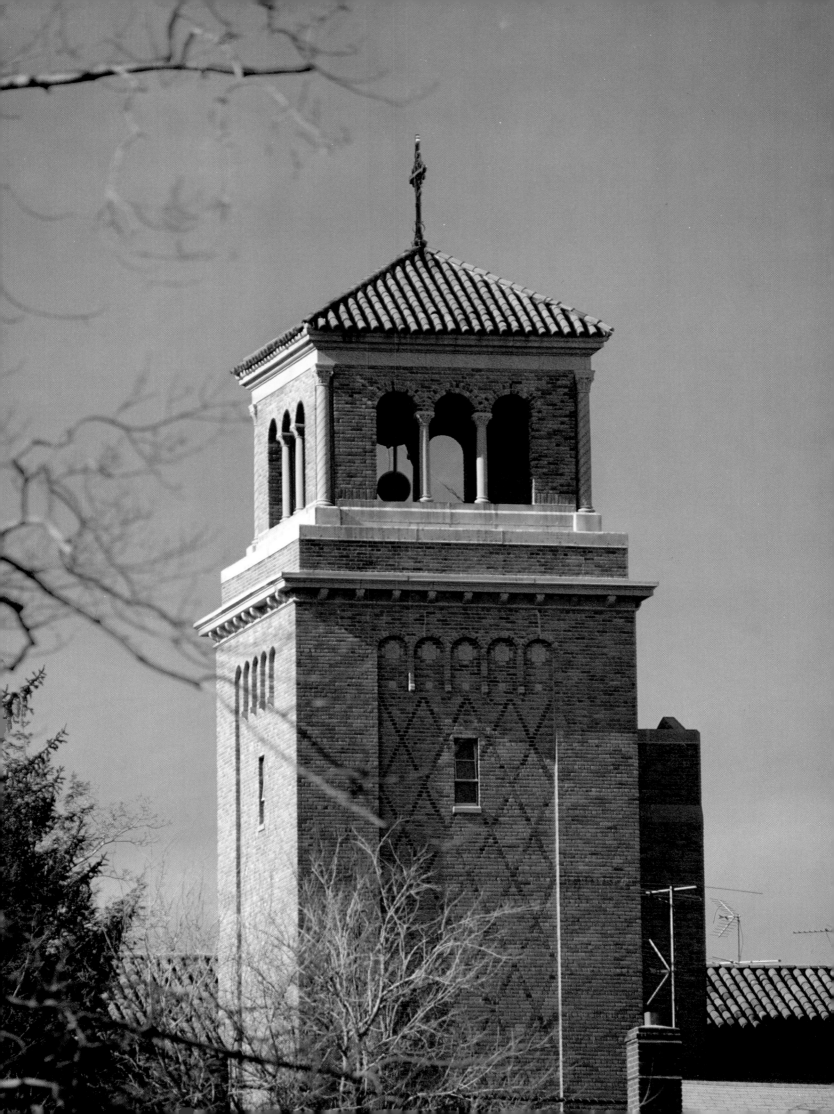

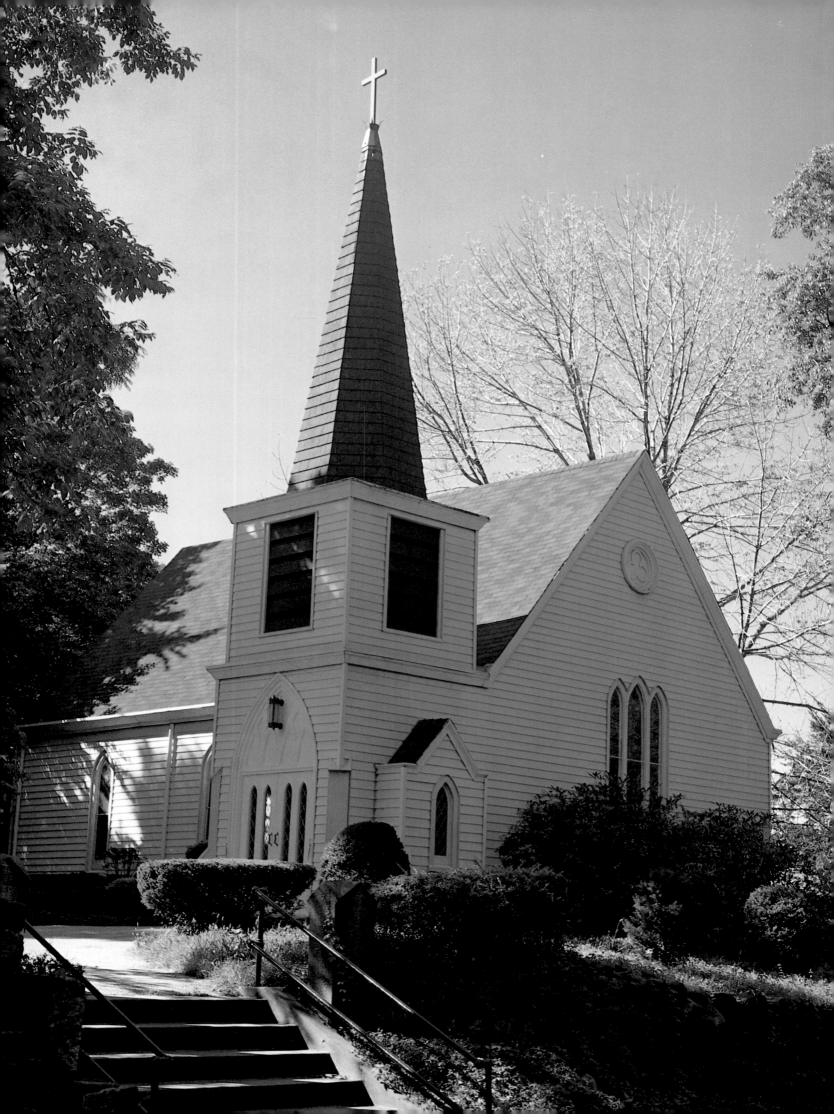

St. John Wilmot, a national historic landmark, is a fine Episcopal wood-shingled church located near the junction of Mill Road, North Avenue, and Wilmot Road.

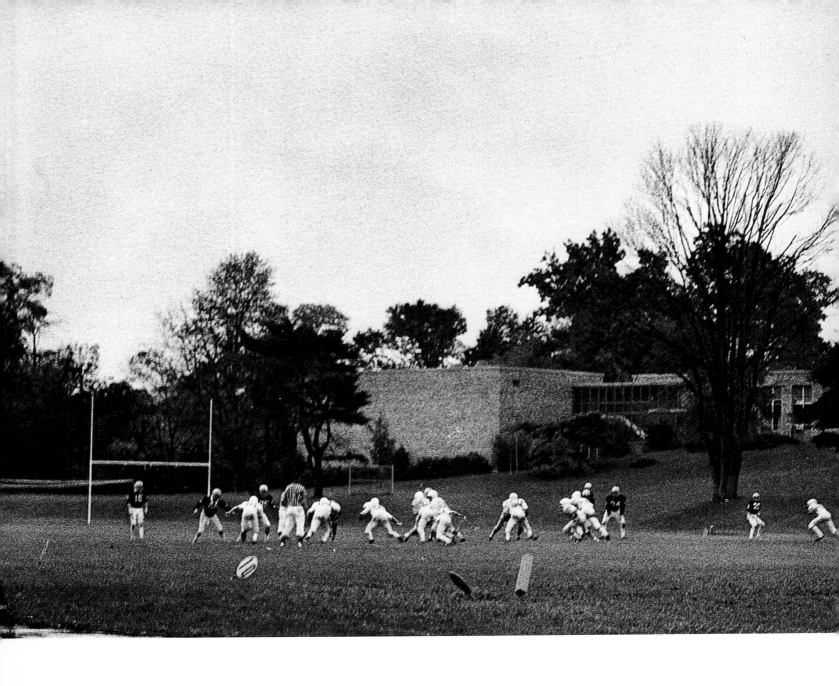

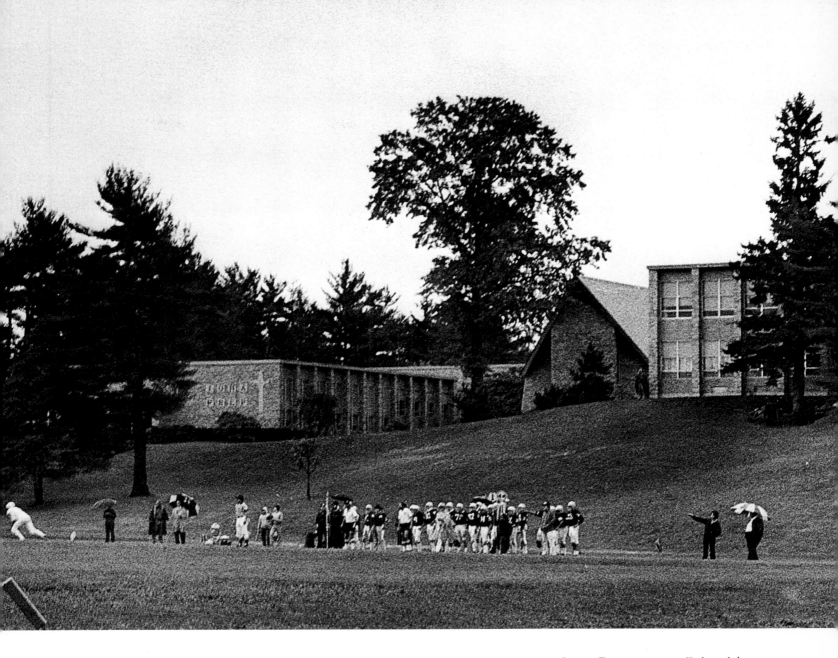

Iona Preparatory School is a private boys' high school relocated from Iona College's campus to Wilmot Road. One frequently sees teammates practicing on its excellent football field.

A castle is the center of the
College of New Rochelle in
the southern sector of the
City. Built in the late 1850s
by Simeon Leland, prom-
inent New York City inn-
keeper, the structure was
purchased by the Ursuline
nuns at the turn of the
century. Around it has grown
the attractive modern college
of today.

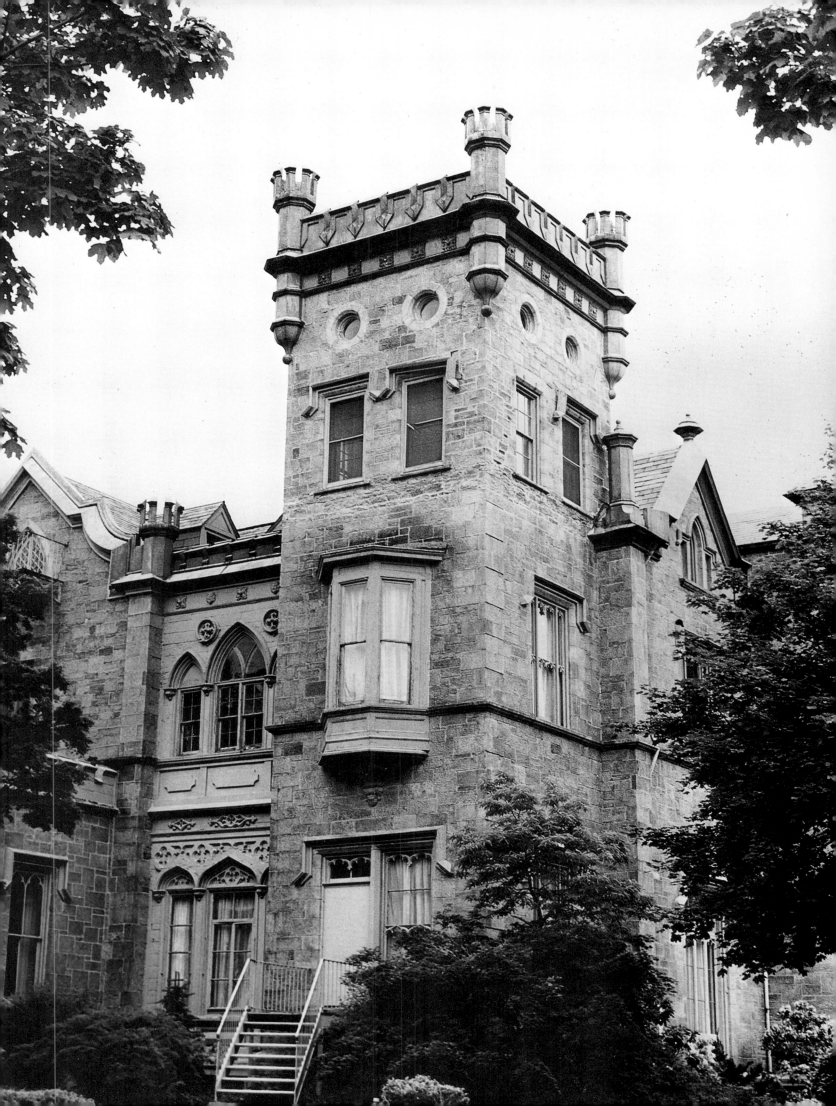

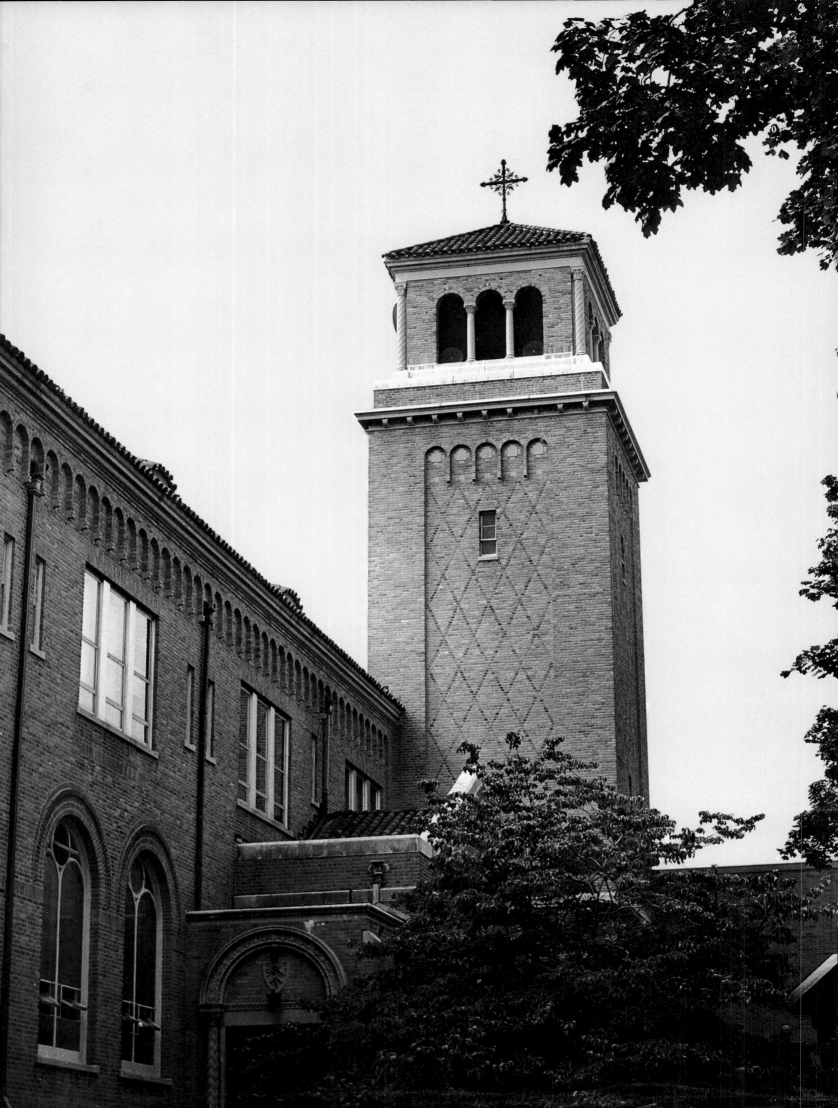

Churches and Temples

New Rochelle, founded by Huguenots fleeing religious persecution in France, has always been a religious community. Both Trinity Episcopal Parish and the Presbyterian Church date back to 1688. Christ United Methodist congregation originated in 1771; the earliest Roman Catholic Church, a predecessor of Blessed Sacrament, was built in 1848; and Anshe Sholom congregation, the first synagogue in Westchester, in 1896. The great tower of the Church of the Holy Family on Mayflower Avenue (left) is modeled after the architectural masterpieces of the Italian Renaissance.

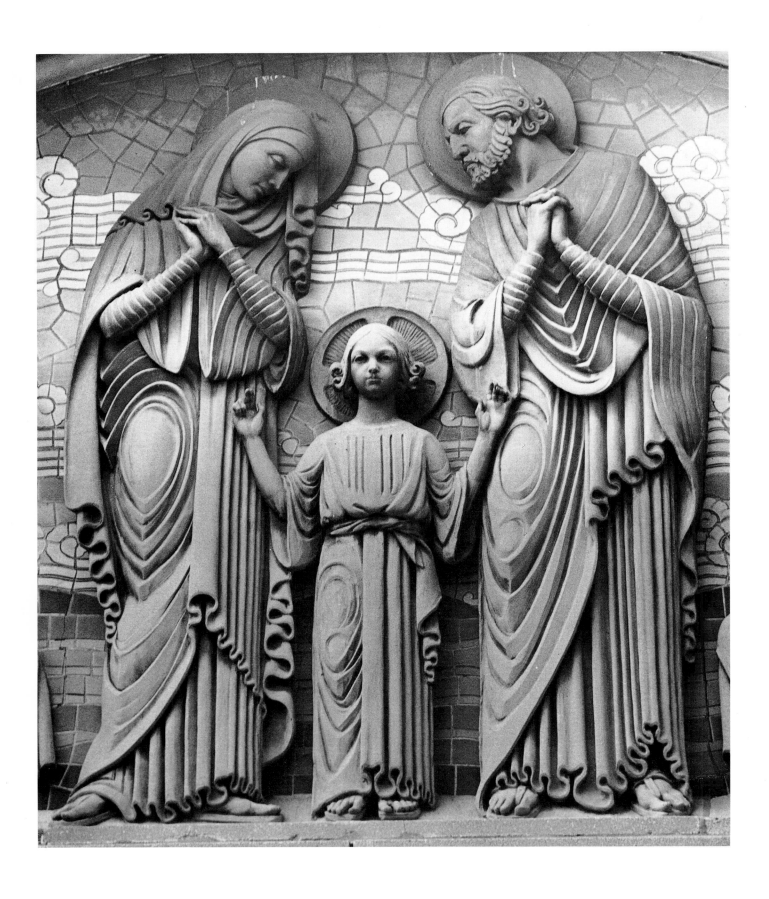

Sculptures on the facade of
the Church of the Holy
Family and in the garden
combine art and architecture.

St. Gabriel's Roman Catholic
Church (right) on Division
Street, seen through the
branches of an aged tree, is
located on a high promon-
tory overlooking the city.

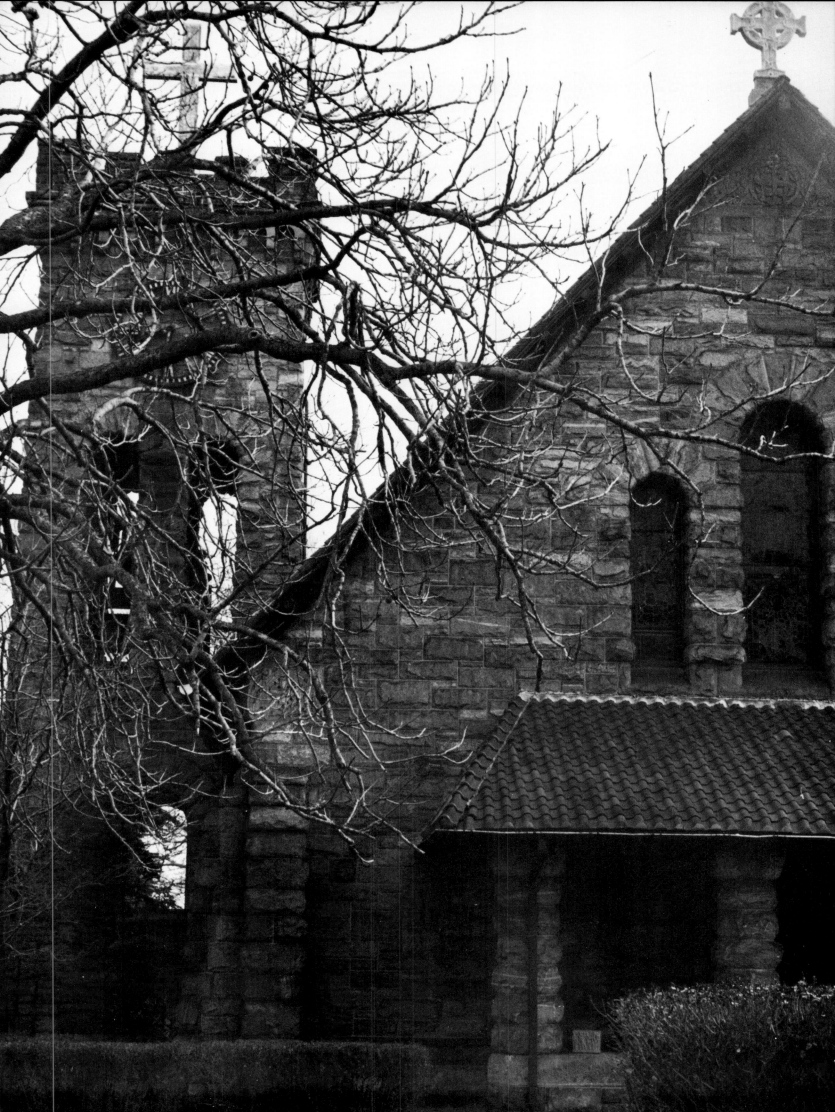

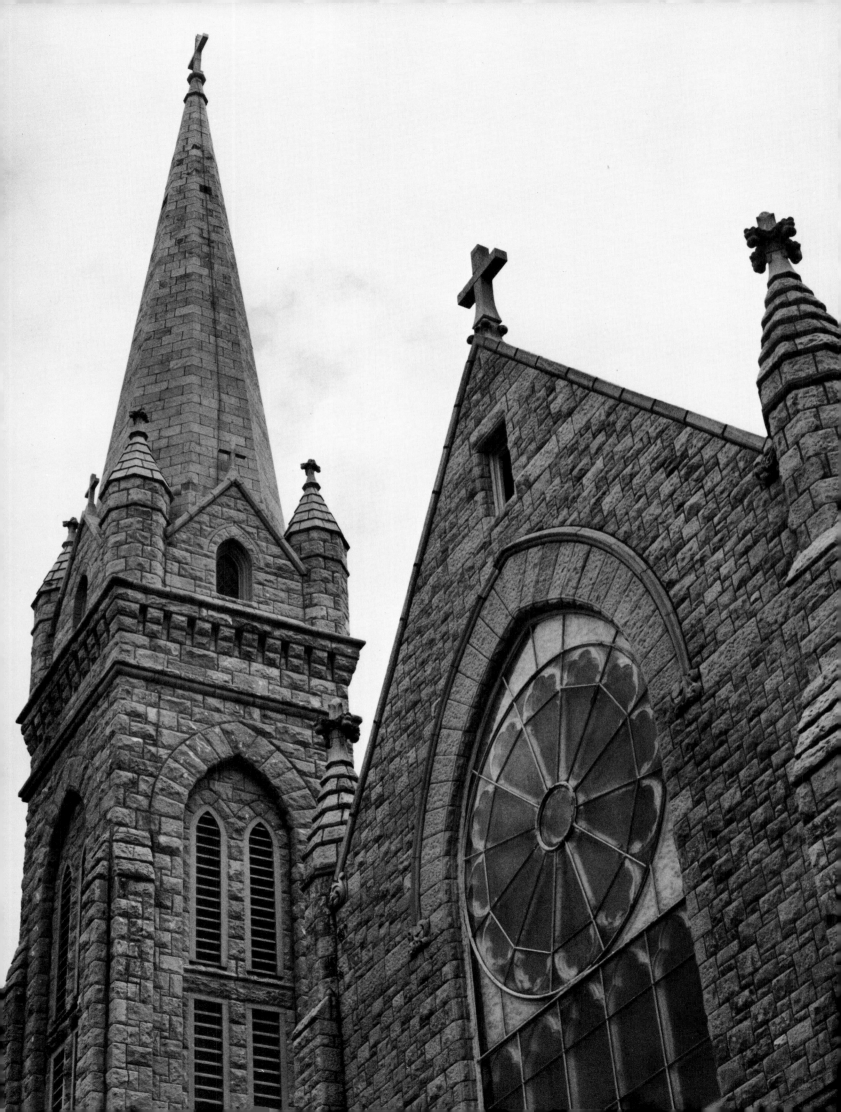

The Roman Catholic Church
of the Blessed Sacrament
(left) stands on Centre
Avenue. The oldest Catholic
congregation in the city, its
beginnings can be traced to
Irish immigrants who helped
found the parish.

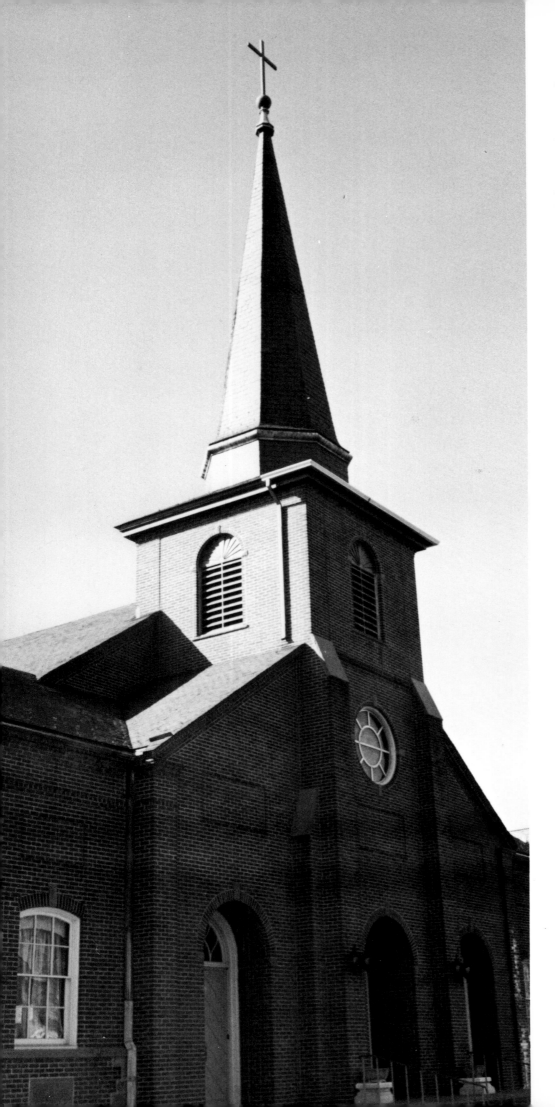

The Holy Name of Jesus Church (left) at Lispenard Avenue in New Rochelle's east end is located in a residential area near Stephenson School. St. Joseph's Catholic Church (right) on Washington Avenue and Fifth Street in New Rochelle's west end serves as a religious and social center for the Italian-American community.

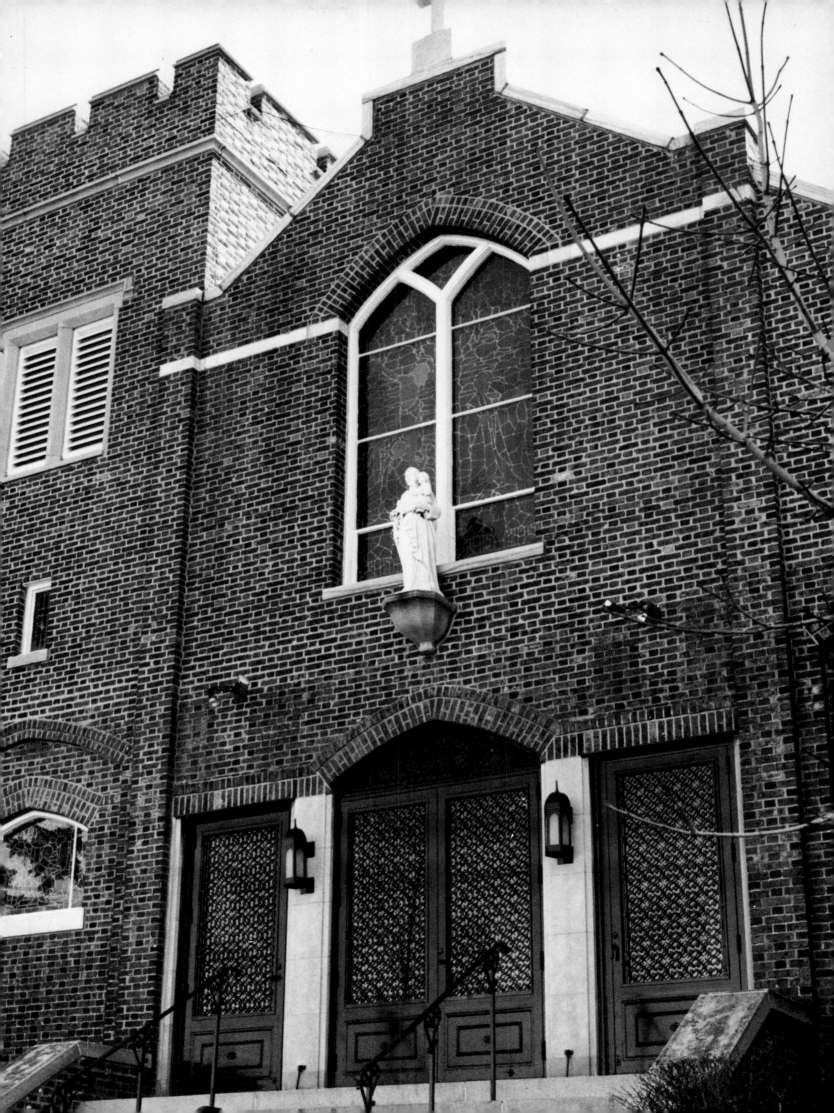

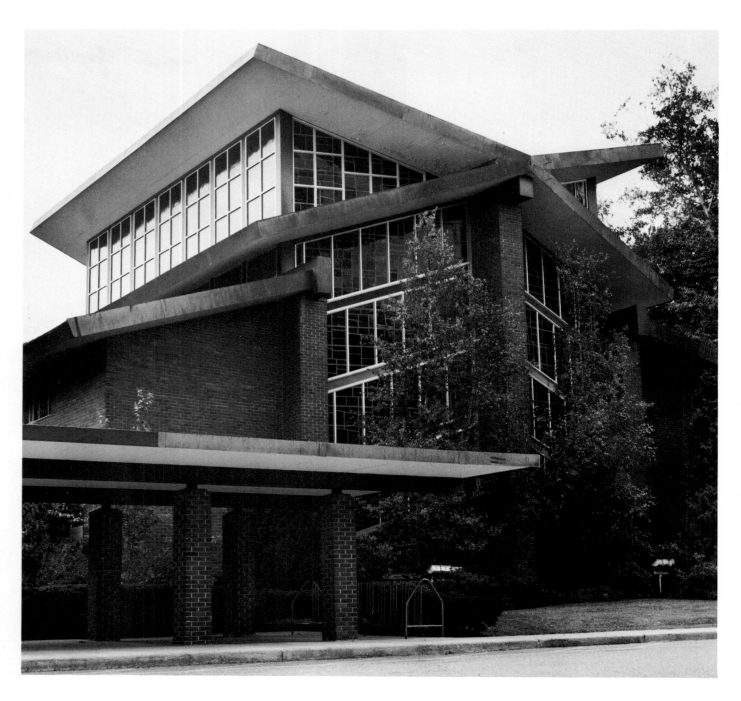

Temple Israel (above), a Reformed congregation, is located in a lovely secluded spot off Pinebrook Boulevard. Young Israel of Westchester (right), in what was formerly the old First Methodist Church, is an Orthodox congregation.

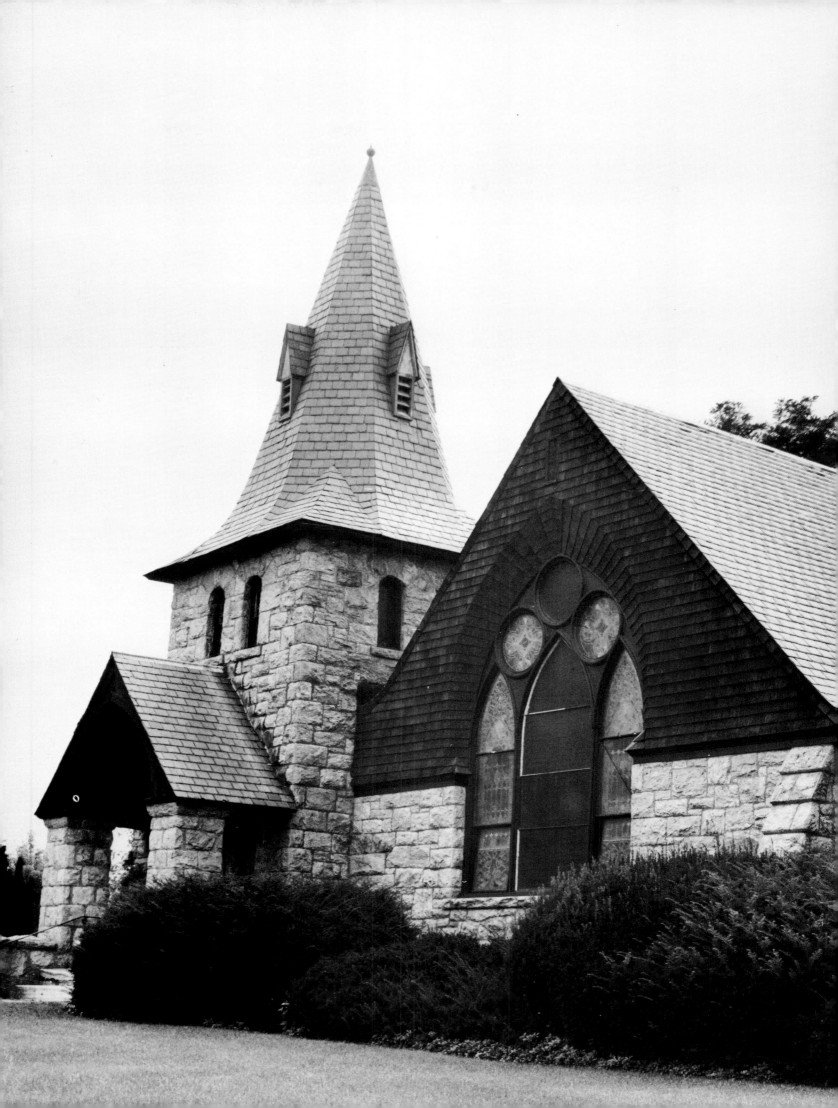

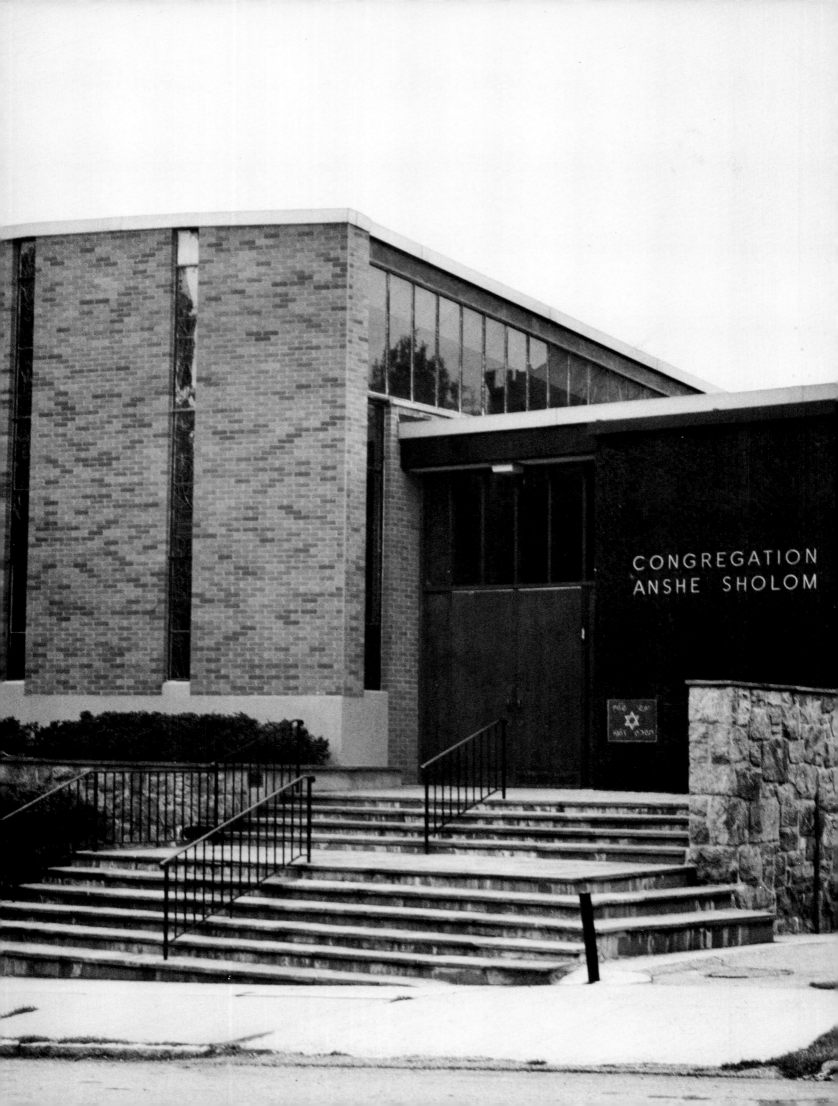

Anshe Sholom (left), the
oldest Jewish congregation in
New Rochelle, is now located
in a contemporary building
at the southern end of North
Avenue. Young Israel of
Scarsdale (above), the newest
synagogue in New Rochelle,
is an Orthodox congregation
located on Weaver Street
at the border of Scarsdale.

Beth El, a Conservative syna-
gogue and community center,
is a large complex located
on North Avenue at Quaker
Ridge Road.

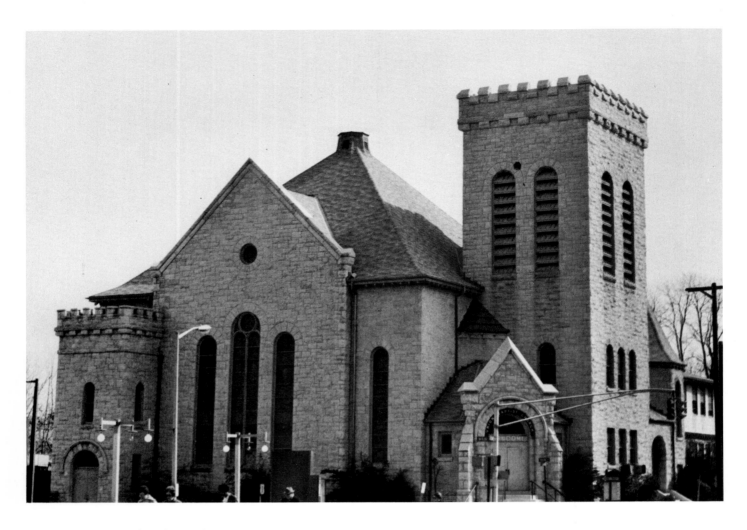

The Union Baptist Church
(above), across from the Mall
on Main Street, was formerly
the Salem Baptist Church. It
stands solidly in the midst of
the city with its remarkable
stone face providing a strik-
ing contrast to the surround-
ing commercial buildings.
Bethesda Baptist Church
(right), on Lincoln Avenue,
displays a variety of geo-
metric lines and shapes on
its facade.

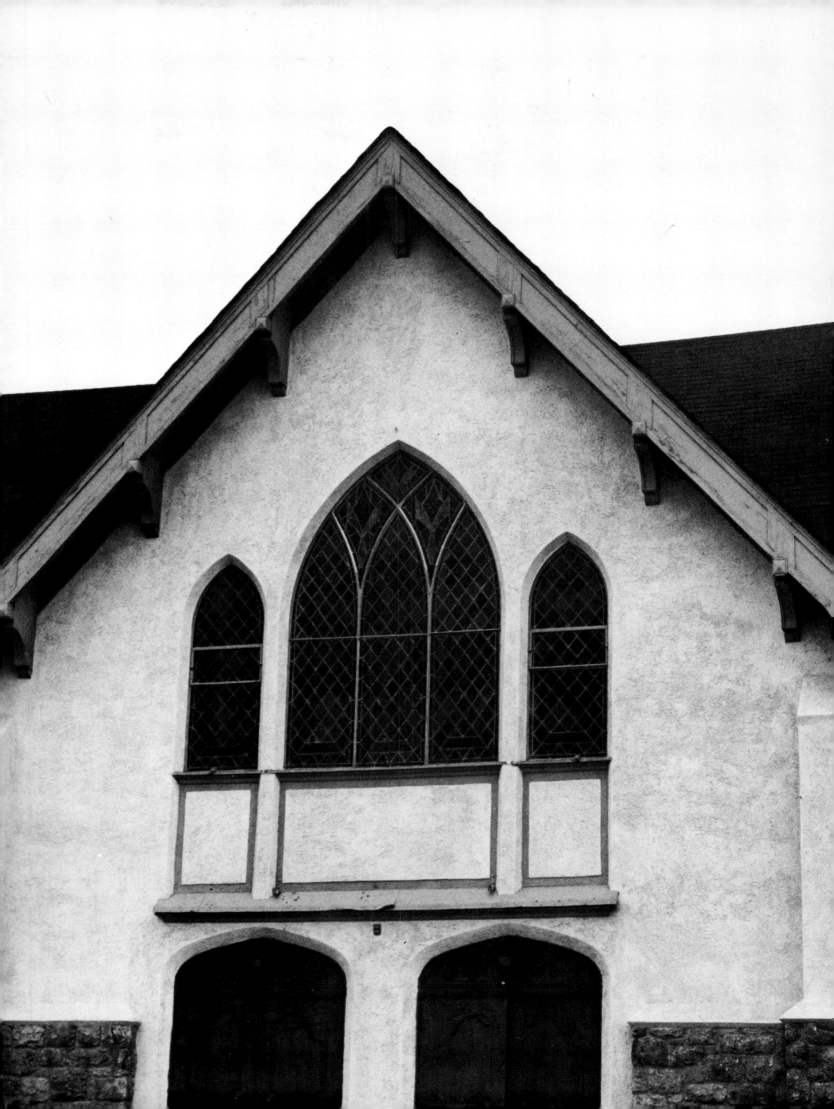

The Zion Baptist Church (left), an impressive stone edifice with brightly colored windows, is located on Lockwood Avenue. The Shiloh Baptist Church (right) stands near the corner of Lincoln and Webster Avenues.

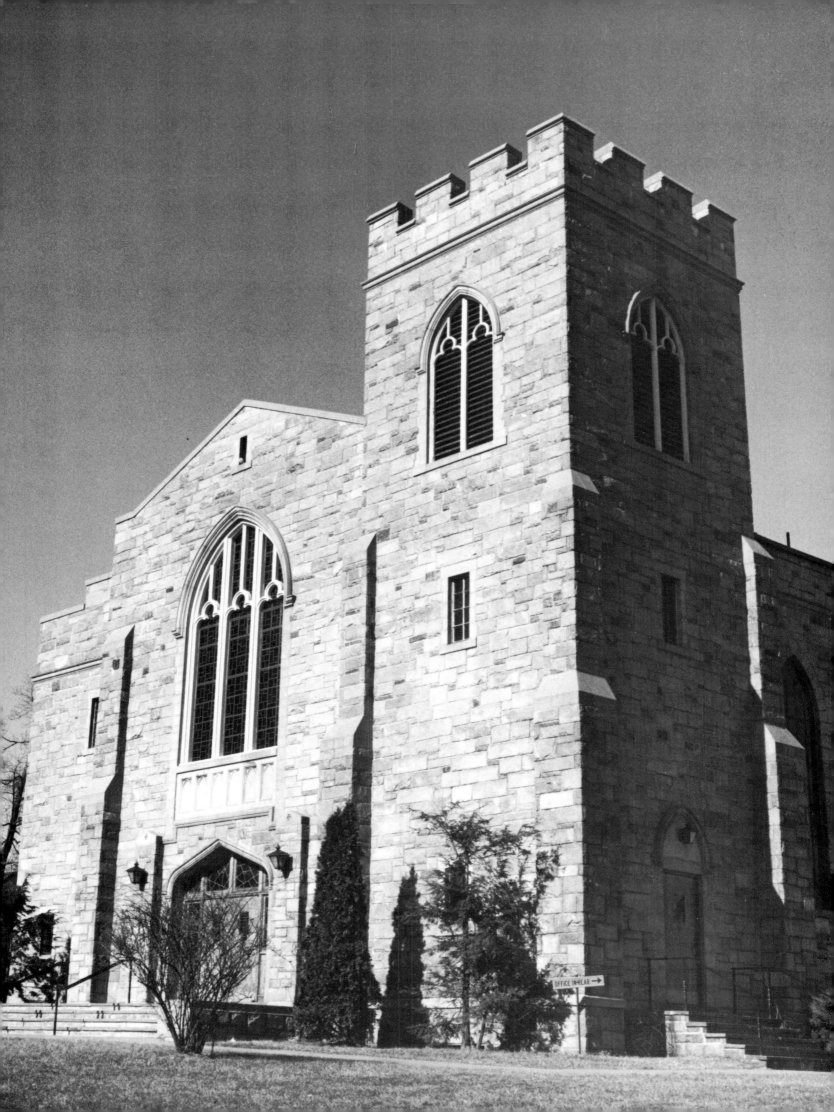

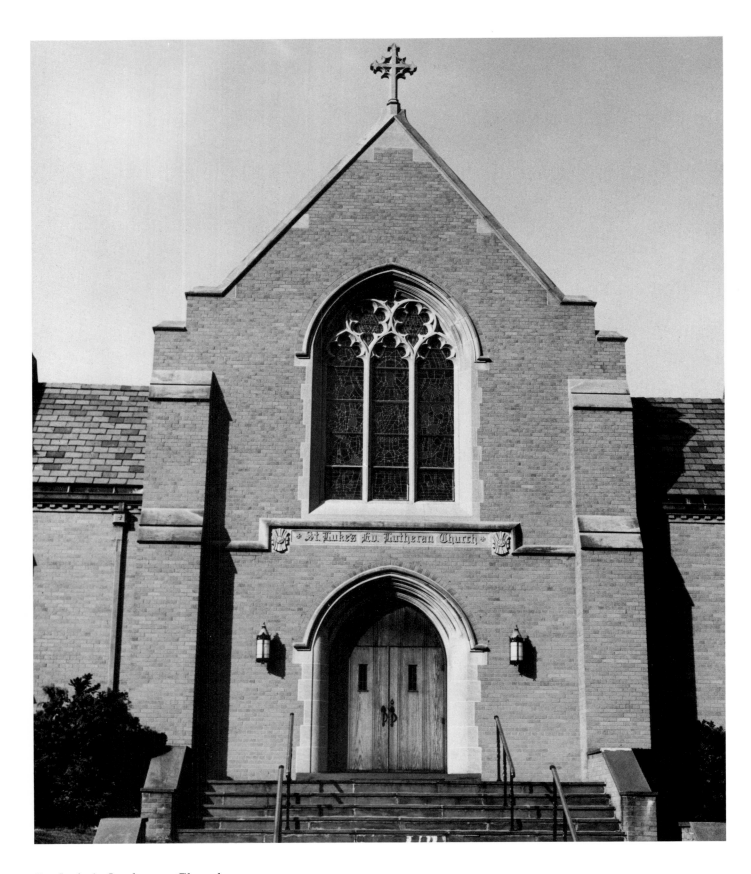

St. Luke's Lutheran Church
is located on Eastchester
Road. Until 1978, Christmas
services were given in
German.

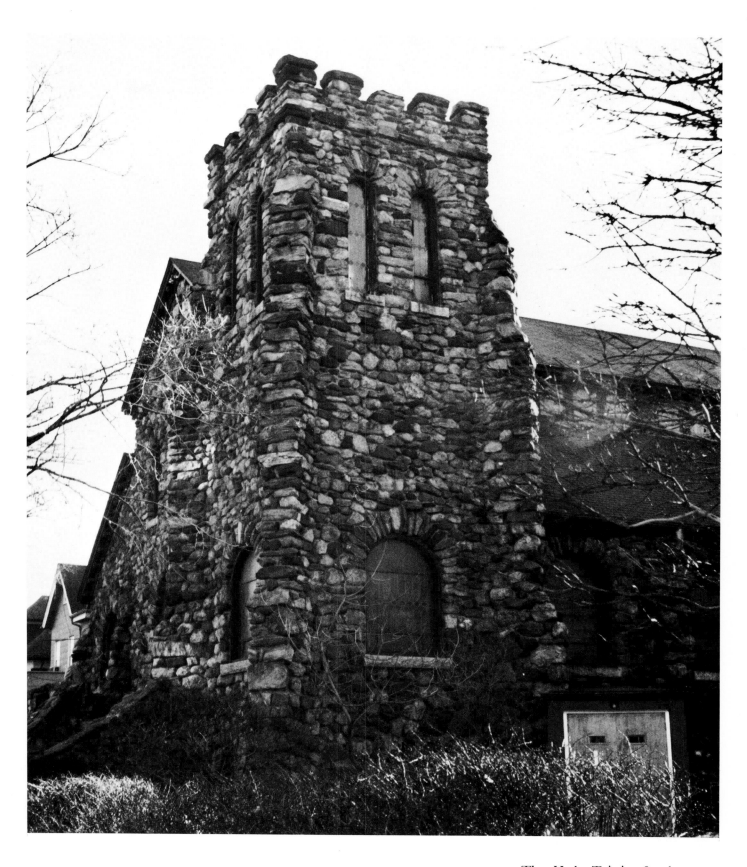

The Holy Trinity Lutheran Church on Lockwood Avenue, with its fine stonework, has the weathered look of an ancient cathedral.

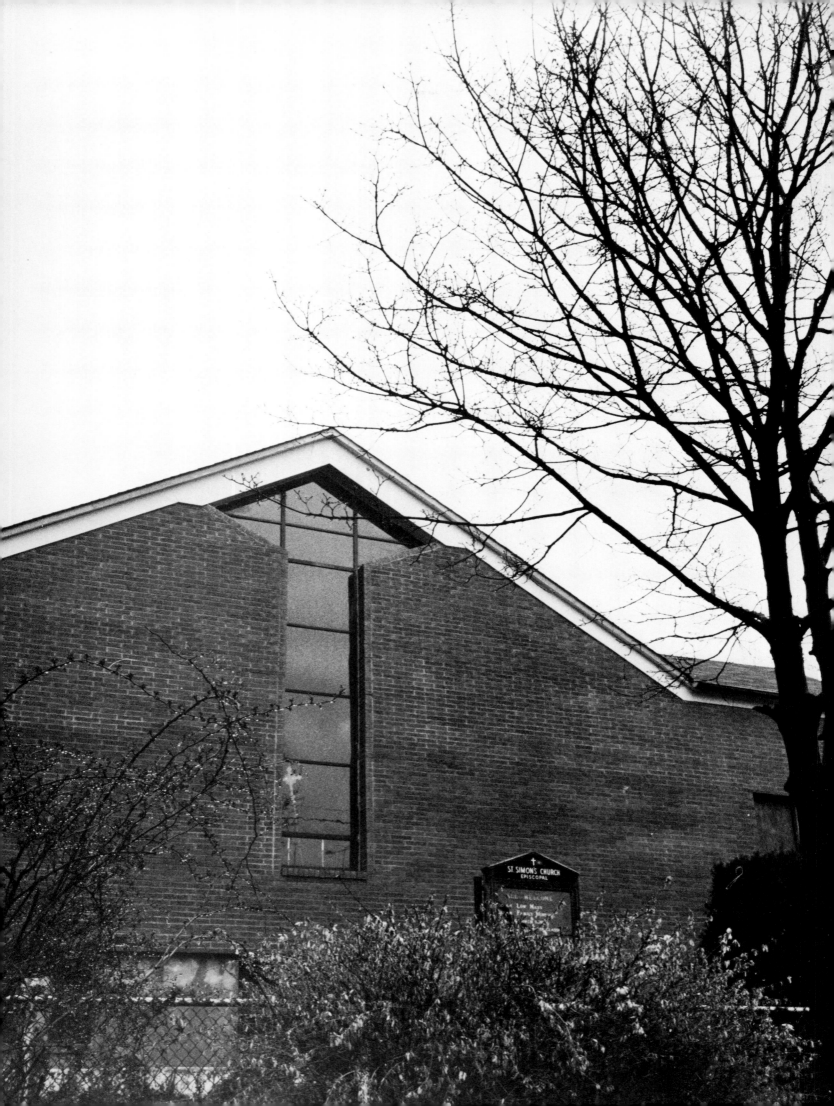

St. Simon Episcopal Church
(left), on Remington Place,
is a contemporary building
with a striking combination
of brick and glass. Trinity
Episcopal Church (right), at
Huguenot and Division
Streets, traces its origin
(1688) to the Huguenot
founders of New Rochelle.
The present structure is the
third built on or near the site.

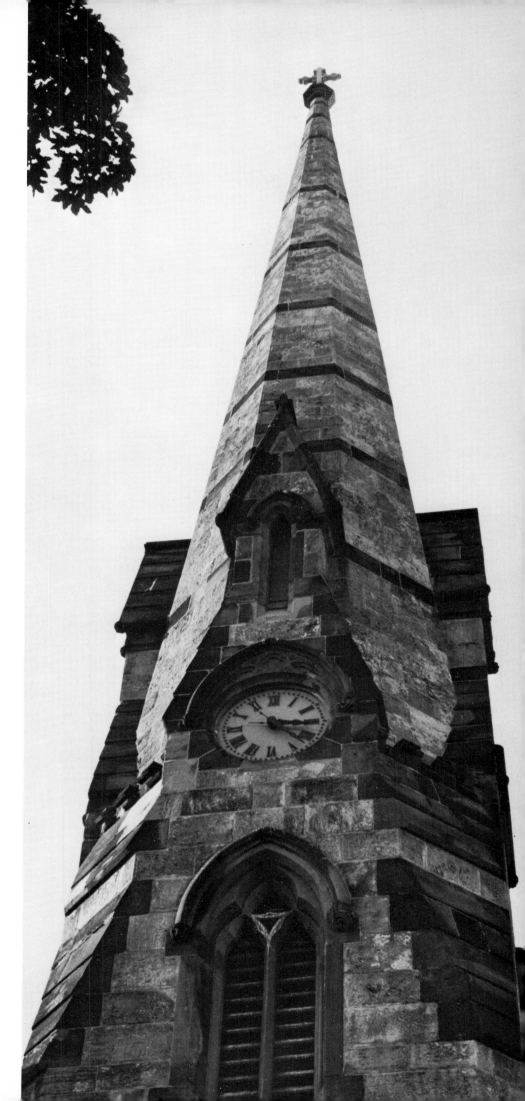

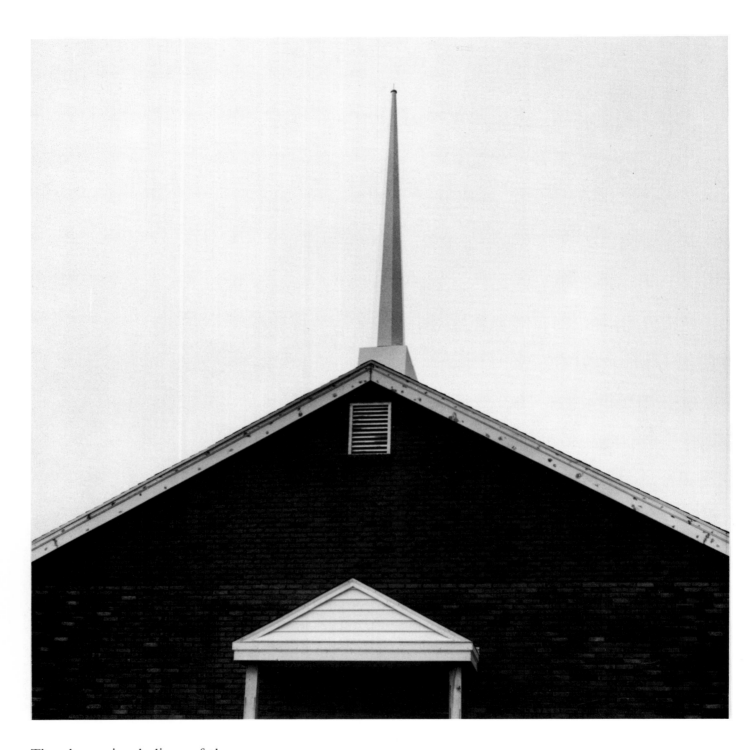

The clean, simple lines of the
Christian Tabernacle Church
on Webster Avenue reflect
New Rochelle's early Amer-
ican heritage.

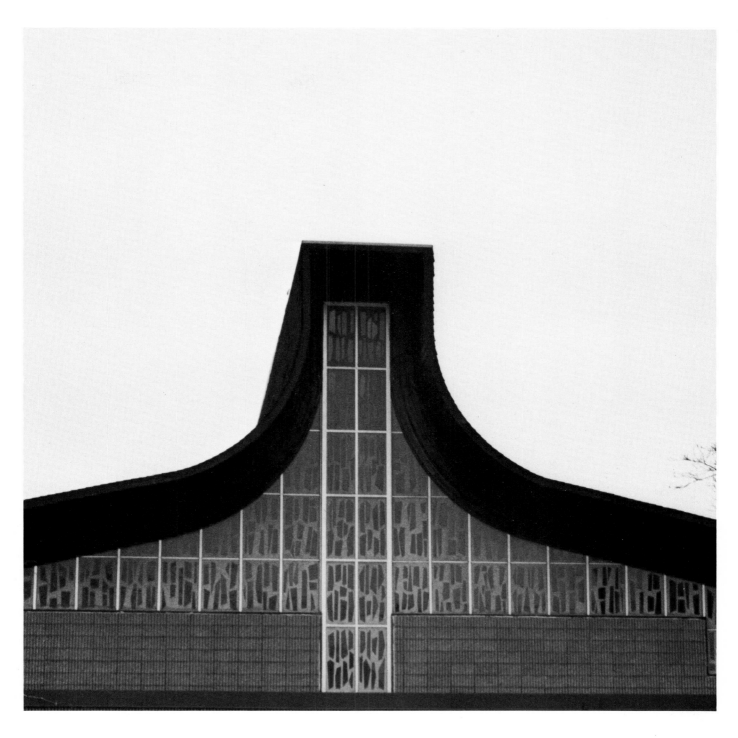

The bold, sweeping architecture of St. Catherine A.M.E. Zion Church, on Lincoln Avenue, expresses the contemporary spirit. The church houses an elaborate black history library.

The Church of God (above) with its imposing colonial entranceway is located on Locust Avenue. This building was originally constructed as a Christian Science Church. The Seventh Day Adventist Church (right) on Webster Avenue was the original home of Temple Israel.

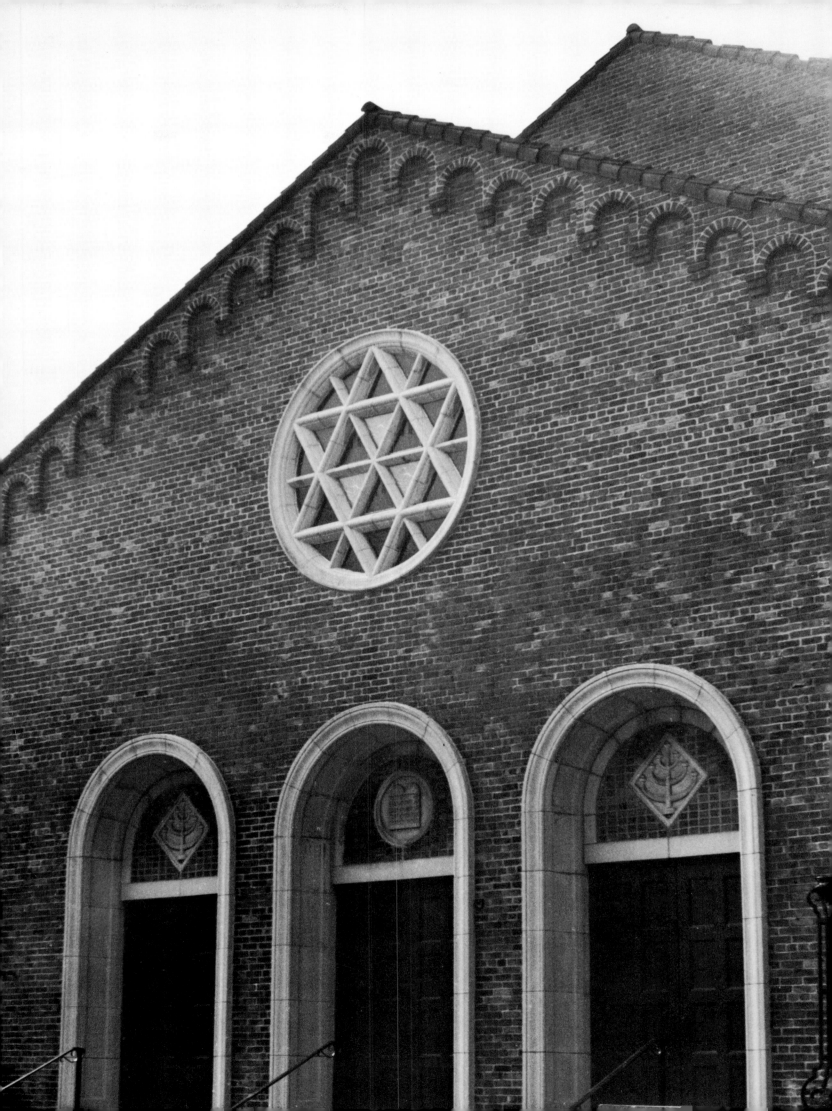

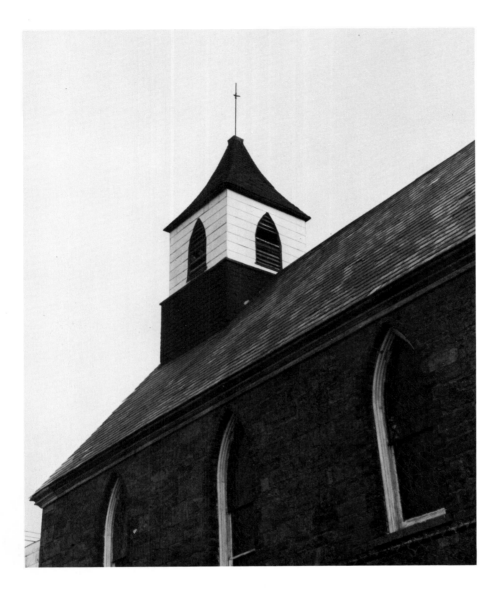

Two churches stand at opposite corners of Webster and Union Avenues: the Pentecostal House of Prayer, with its arched windows and tower (left); and the Assembly of God (right), with its angled rooftops.

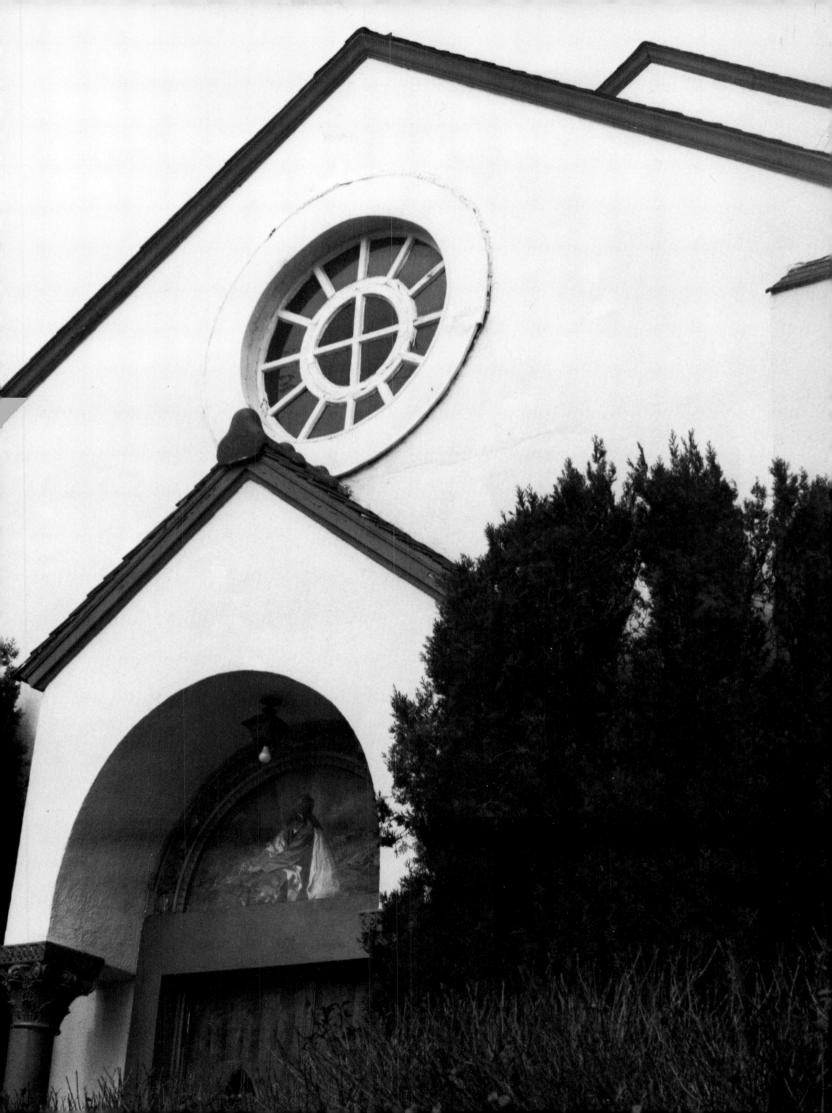

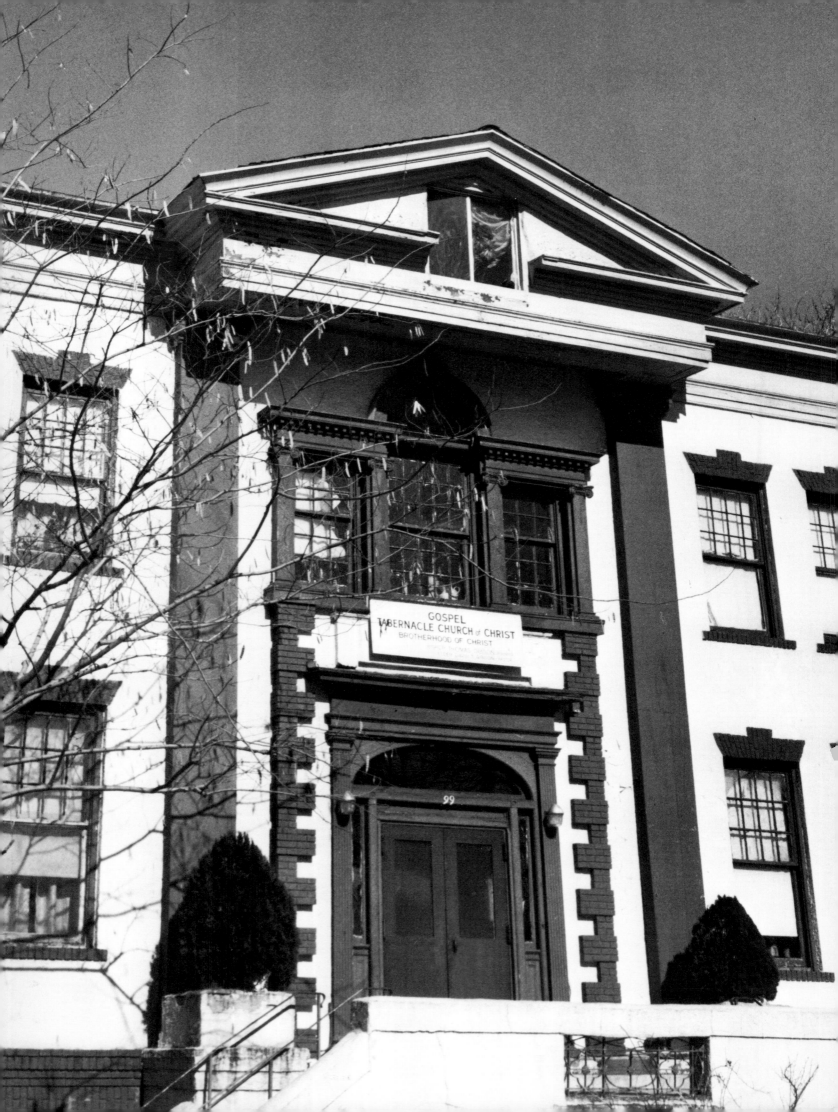

The Gospel Tabernacle
Church (left), with its warm
and friendly entranceway, is
located on Lincoln Avenue.
"Kingdom Hall" of New
Rochelle's Jehovah's
Witnesses is on Stratton
Road (above). In 1964,
members of the congregation
helped build the structure
by clearing the land for
excavation. The Jehovah's
Witnesses have been in New
Rochelle since 1927.

The Holy Trinity Greek Orthodox Church (below) is a striking contemporary building serving the vital Greek community in New Rochelle and much of Westchester County. It is at North Avenue and Mill Road at the border of Eastchester. The Presbyterian Church of New Rochelle (right) is an outstanding example of colonial architecture. It is located in a lovely setting on Pintard Avenue near Main Street. The building is in the National Registry of Historic Places.

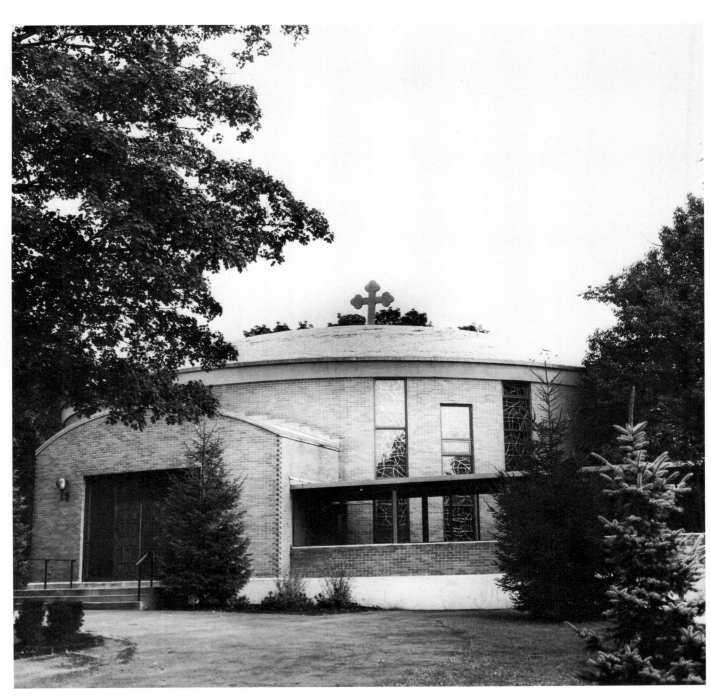

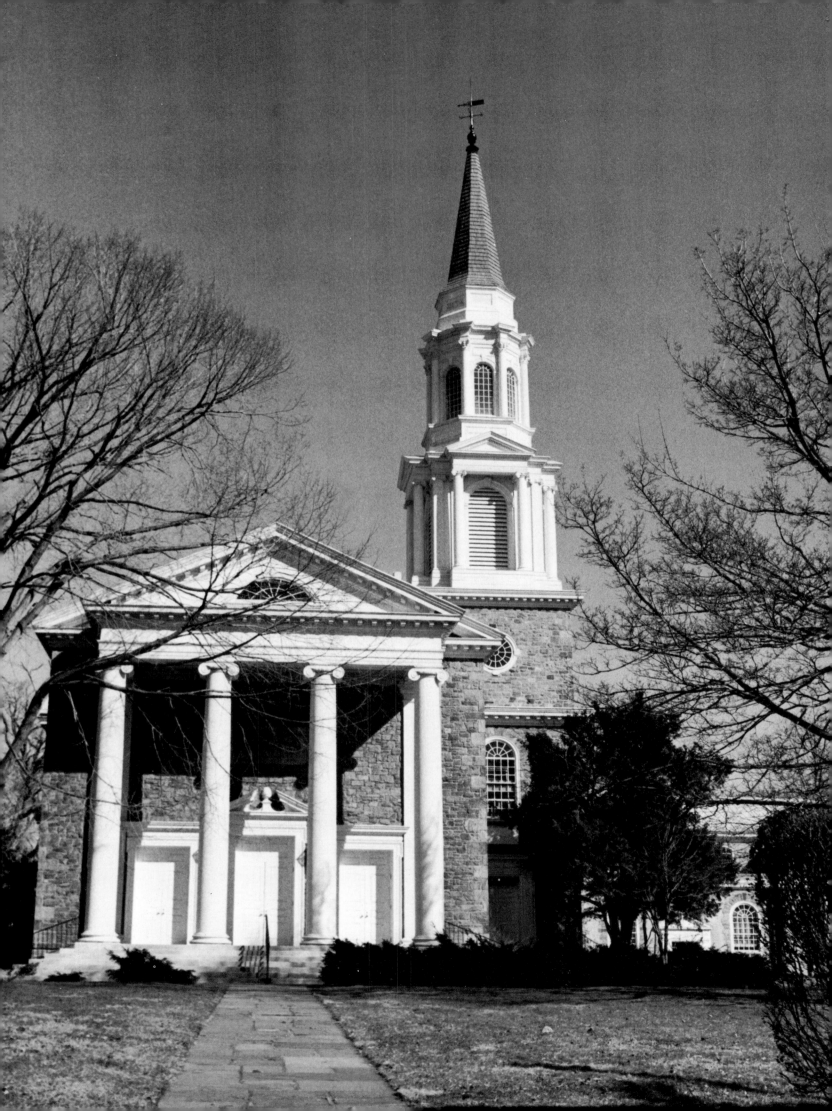